PATTERN DESIGN
A Period Design Sourcebook

Siân Evans

THE NATIONAL TRUST

First published in the United Kingdom in 2008 by
National Trust Books
10 Southcombe Street
London W14 0RA

An imprint of Anova Books Company Ltd

ISBN: 9781905400676

A CIP catalogue record for this book is available from the British
Library.

16 15 14 13 12 10 09 08
10 9 8 7 6 5 4 3 2 1

Reproduction by Rival Colour Ltd., UK
Printed and bound by SNP Leefung, China
Book Design by Lee-May Lim

This book can be ordered direct from the publisher at the website:
www.anovabooks.com, or try your local bookshop and National
Trust shops.

CONTENTS

Over the last two decades, there has been a profound new fascination with and appreciation for all aspects of life in the past. Alongside the current preoccupation with the social mores, buildings, fashions and technological achievements of former ages, there is a parallel resurgence of interest in the patterns, motifs and styles that comprised and defined the material culture of our history.

The initial appeal of an ordered and restrained Robert Adam interior or an Arts and Crafts fireplace is self-evident; they can be admired for their intrinsic decorative qualities, as they represent in three dimensions facets of domestic life as it was lived in those centuries and in those particular circles. But there is a more subtle significance to be deduced from these flashes of creativity and consummate craftsmanship. What remains in a historic setting tells us more about the lives of the people who created or commissioned them, if we choose to analyse it; what they admired, how they saw themselves and their position in the world. Historic designs offer a glorious source of inspiration for all varieties of creative professionals, whether pattern designers, architects, artists or illustrators, working in the twenty-first century.

Enormous decorative potential lies in the material holdings of the National Trust. The charity looks after hundreds of historic buildings, from humble Chartist cottages to opulent Renaissance-style mansions, Victorian pubs to medieval castles. The Trust exists to care for historic buildings and places of natural beauty, balancing public access with the necessity to conserve its sites in England, Wales and Northern Ireland. This provides ample and unparalleled opportunities for visitors to examine in person, and in detail, the kind of settings previously only accessible to the very wealthy.

Taken as a whole, the charity now cares for an almost encyclopedic collection of objects, far exceeding in number the art and artefacts held by any of our greatest museums. There are millions of artefacts, from the most lavish to the most humble. All of them are of some interest, many of them are patterned, and of those nearly 300 have been selected to appear in this book.

There is a certain democracy in the approach to inclusion here; the art and artefacts featured in this book range from Roman mosaic floors to medieval carvings, ornate bed-hangings to gem-encrusted cabinets, intricate stained glass to nursery friezes. Each of these objects was originally designed and made by someone for a variety of reasons – usually and primarily to fulfill a practical function, but also to enhance everyday life, and to reinforce a client's view of themselves or of their aspirations. The designs of the past tell us a great deal about the individuals that produced them – their sense of progress and development, their hopes and desires, their ambitions and sense of self.

This book provides an authoritative, if necessarily brief, historical overview of the major art and design movements to be found in the wide variety of properties cared for by the National Trust. The narrative is broadly chronological, but interwoven with specific thematic treatment of 'timeless' approaches to the issues of design, such as the enduring appeal of the Gothic style, or the particularly British fascination with the Far East across centuries. Within each section, pattern design is presented as a continuum, with relevant

examples selected from across all appropriate media; in so many cases, a pattern developed for one material, such as brocade, might easily be adapted for another use, such as wallpaper.

In terms of the source material, the book celebrates the frequent cross-fertilisation of pattern design, demonstrating how fine art and statuary often informed and inspired the applied arts. Issues of 'cultural shoplifting', the wholesale borrowing of the motifs and materials of other civilisations, are also explored. There is an awareness that designers and pattern-makers frequently referred to the styles and forms of previous eras, in response to their clients' passion for the past, whether it be classical antiquity or to hint at noble antecedents to raise their own social status; indeed, it would appear that historic revivalism has a long and honourable history when it comes to pattern design.

The artists and craftspeople of former eras relied on printed and illustrated sources as inspiration, and as a useful graphic device for consulting potential clients and agreeing an approach to particular commissions. In the same way, contemporary pattern designers, illustrators, artists and interior decorators can use this book as a source of images and motifs, colour schemes and reference material to inform their own work. The 'recycling' of the patterns of the past occurs across all cultures. In the same spirit, this book is intended to be a reference work, a compendium of visual ideas, cultural associations, motifs, symbolic meanings. Not all of the designs shown are out of copyright, but they are all intended as a starting point for further inspiration and reference. Above all, this book sets out to how a selection of the most imaginative and elegant pattern designs taken from some of the most historically important and beautiful places in Britain.

Detail from the 18th-century enamelled chest in the Lower Gallery. Anglesey Abbey, Cambridgeshire.

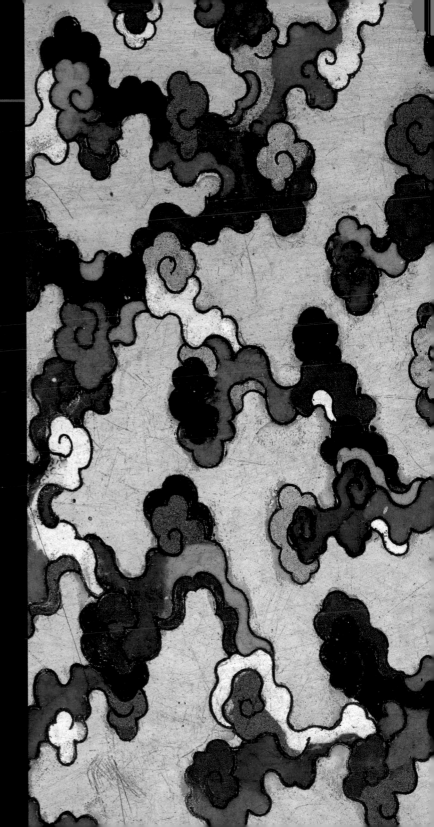

Geometric pattern is defined as a design depicting abstract, non-representational shapes, such as lines, circles, ellipses, triangles, rectangles and polygons. The simplest geometric patterns are regular repeat of an easily replicated motif.

A rectilinear design can be incorporated into any woven or interlocking materials, by exploiting contrasts in colour or texture. Stripes and checks are created in woven fabric by using contrasting threads in the warp and weft. Similar effects can be achieved in almost any medium, from decorative brickwork to the disposition of tiles, patchwork to parquetry.

A geometric structure can also be used as the framework or background to a more interpretive pattern. A simple lattice-work design, for example, makes an effective base to which pattern-makers can add more decorative elements. William Morris's first wallpaper design was 'Trellis', a pattern suggested by the rose-trellis in the garden of his Red House home in Bexleyheath. In designs of this nature, non-geometric patterns are repeated at regular intervals to give an overall ordered effect.

By contrast, there are infinite possibilities in the application of 'pure' geometry to pattern-making; designs based on interlocking circles, hexagons and polygons are intellectual exercises in the subdivision of space and form. The nature of human perception is such that we appreciate a sense of order and visual clarity in a decorated surface.

Abstract geometric patterns

Abstract geometric patterns are a means of decorating a surface with non-representational motifs.

Circles

Interlacing circles, combined with the intersection of other elements, provide a repetitive ground suitable for covering large areas. Used creatively, they produce tessellations – a repeat pattern of interlocking shapes that can be extended indefinitely.

Spirals

A geometrical design usually applied to architectural elements, the spiral is a complex form with aesthetic appeal derived from its innate sense of order and proportion.

Squares and rectangles

Subdividing a surface into quadrilaterals creates enormous potential for pattern-makers. The rectilinear foundation allows designers to 'play' with contrasting elements of colour and texture.

Hexagons

Hexagonal designs ensure an even coverage of the surface with no voids or empty spaces. They occur in nature, in both crystalline structures and organic ones, such as honeycombs, and are highly effective in creating all-over coverage in pattern-making such as patchwork and tiling.

Polygons

The intellectual rigour needed to understand complex geometry was central to the culture of Ancient Greece, and while Northern Europe was subsumed by the Dark Ages, Arabic cultures continued to study the discipline. There were also cultural reasons for the reliance on geometric pattern-making in the Arabic world; while the Koran contains no specific prohibition on figurative imagery, many interpretations of Islamic law have tended to discourage the use of realistic imagery as potentially idolatrous. The result was the development of a tradition of sophisticated abstract pattern-making, exploiting the decorative potential of complex geometry. European contact with the Middle East and Moorish Spain during the Middle

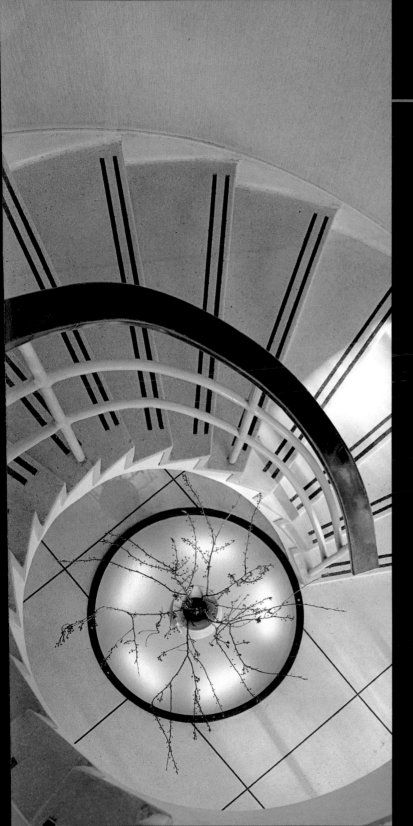

Ages brought about a new understanding of geometric design and pattern-making.

Chequerboard patterns

In principle, the chequerboard is among the simplest of geometric patterns, relying for its effect on the alternation of squares of two contrasting colours or textures. However, reproduced in lavish materials, it has great graphic impact, and chequerboard floors were often depicted by Renaissance artists to demonstrate their mastery of the rules of perspective. In addition, the convention of the chequerboard can be used to create an effect of even coverage of large areas.

Rhomboids and diamonds

The intersecting diagonals of trellis, lattice or guilloche patterns create rhomboids or diamonds, and act as a suitable framework for more exuberant free-form patterns.

Chevrons and herringbone patterns

Herringbone patterns are among the oldest in existence and originally derived from the practicalities of building methods. Robust and pleasing to the eye, they were stylised as chevrons, bold graphic diagonals, in the Middle Ages and remained in popularity through the Tudor era, possibly because of their associations with the conventions of heraldry. As a result, they found new favour among some pattern makers in the Gothic Revival style, and were particularly favoured by Arts and Crafts designers.

View looking down the spiral staircase, designed by Patrick Gwynne. Concrete with terrazzo finish and large sunken uplighter at base. The Homewood, Surrey.

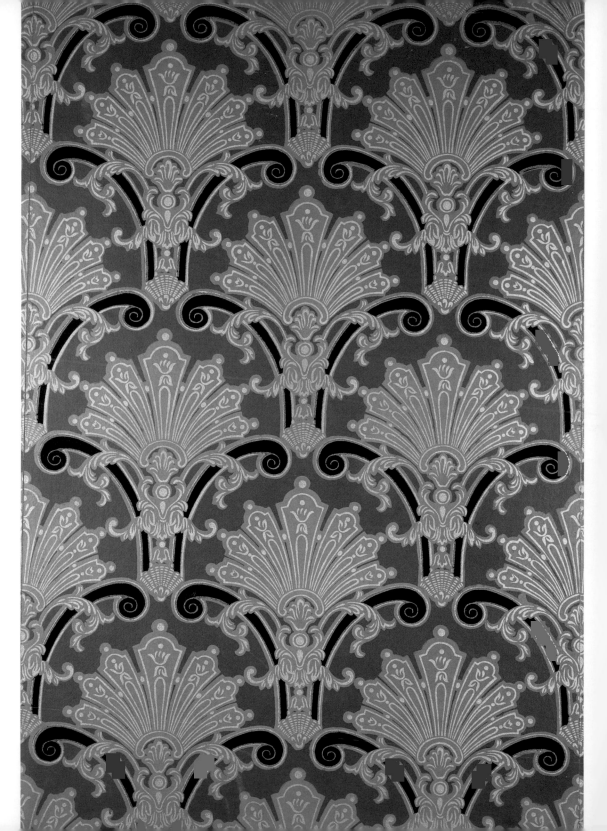

Reproduction wallpaper (1977) exactly matches the original Victorian design. Dunster Castle, Somerset.

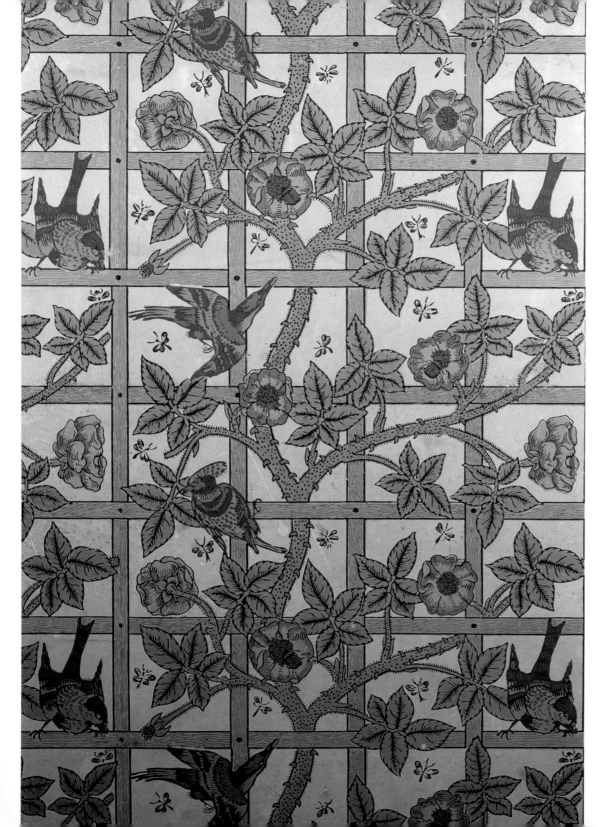

'Trellis' wallpaper (1862) was inspired by the gardens at Red House. It was the first wallpaper designed by William Morris and incorporated birds drawn by Philip Webb. The pattern was available from Morris & Co. in a number of colourways. Red House, Bexleyheath, London.

Detail of the upstairs landing ceiling. In 1860 the plasterwork was pricked in an all-over pattern, and curvilinear designs in red and blue were painted by William Morris, Philip Webb and their friends. Hand-painted decoration of this type, in imitation of medieval techniques, was an integral feature of the Morris's newly built marital home. Red House, Bexleyheath, London

Ceiling decoration in William Morris's upstairs studio c. 1860. Red House, Bexleyheath, London.

Detail of an early 20th-century Axminster carpet in the style of Charles Rennie Mackintosh. Llanerchaeron, Ceredigion.

Detail from the border of a carpet design by Marion Dorn, c. 1930. Coleton
Fishacre, Devon.

A design of interlocking circles in a detail from the encaustic tiles on a hall stove, installed in 1858. It shows the influence of the mid-Victorian Gothic Revival. Hughenden Manor, Buckinghamshire.

Detail of wallpaper featuring a design of interlocking circles and green crosses in the bedroom off the Brown Gallery. Lacock Abbey, Wiltshire.

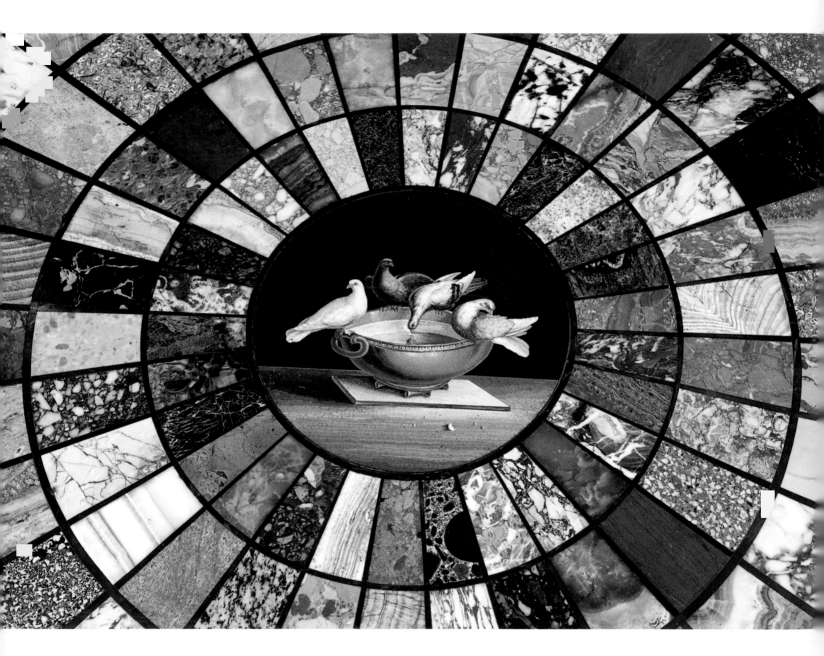

Detail of a circular mid-18th-century micro-mosaic tabletop with inlaid specimen marbles. The central scene of doves derives from a model discovered at Hadrian's villa in 1737. Ickworth House, Suffolk.

Despite its rustic, hand-crafted quality, there is a sophistication to the geometric forms within a limited colour range in this mid-Victorian woolllen tablecloth. Carlyle's House, London.

Rectangular panels appear to 'frame' each of the central square motifs and are combined to give a chequerboard effect on these fireplace tiles, which date from the library extension in 1878.
Peckover House, Cambridgeshire.

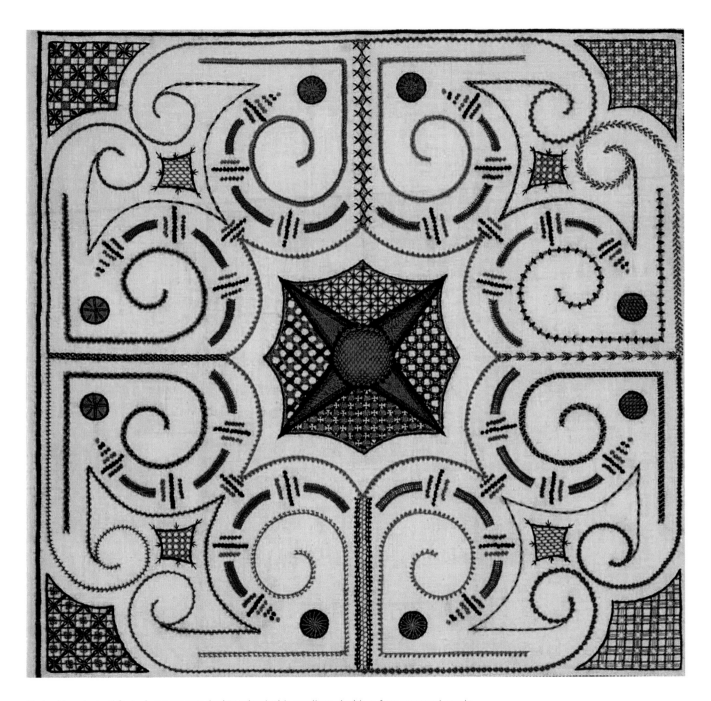

Embroidered panel featuring a square design edged with scrolls and with a four-cornered star in the centre. This 20th-century panel is from the Turret Dressing Room at Sunnycroft, Shropshire.

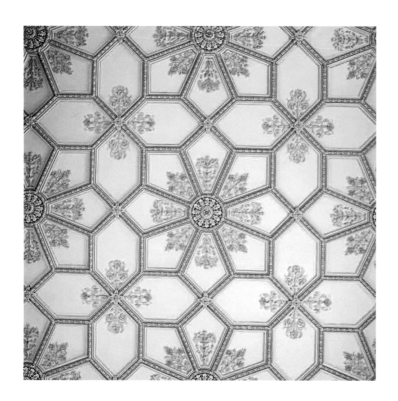

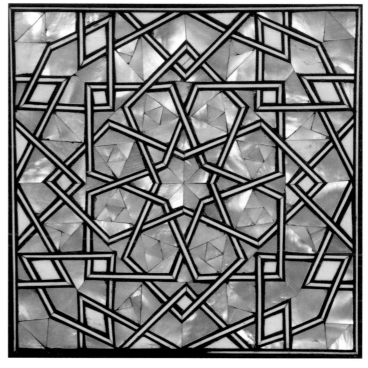

A plasterwork ceiling in the Elizabethan Revival style, by Thomas Willement, c. 1830s. Charlecote Park, Warwickshire.

Late 19th-century Moorish coffee table, with inlaid mother-of-pearl and ivory. Standen, West Sussex.

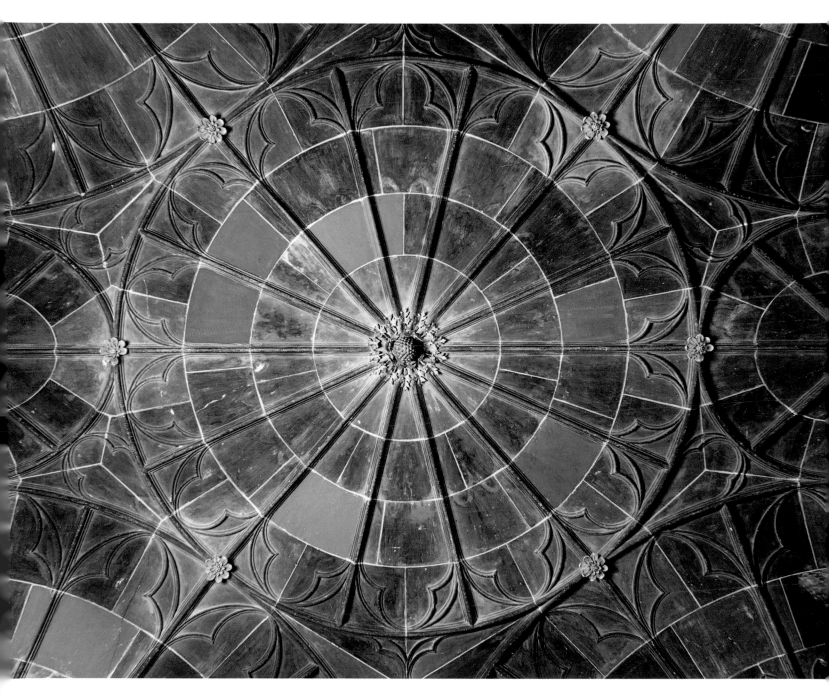

Detail from the neo-Gothic fan-vaulted plasterwork ceiling, installed
in a 16th-century hall in the 1780s. Coughton Court, Warwickshire.

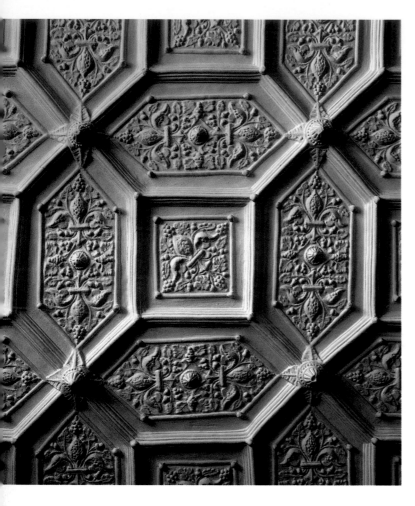

Elongated hexagonal and square panels in a 17th-century plasterwork ceiling. East Riddlesden Hall, West Yorkshire.

The hexagonal glass panes of one of a pair of 1850s Japanese temple lanterns. Snowshill Manor, Gloucestershire.

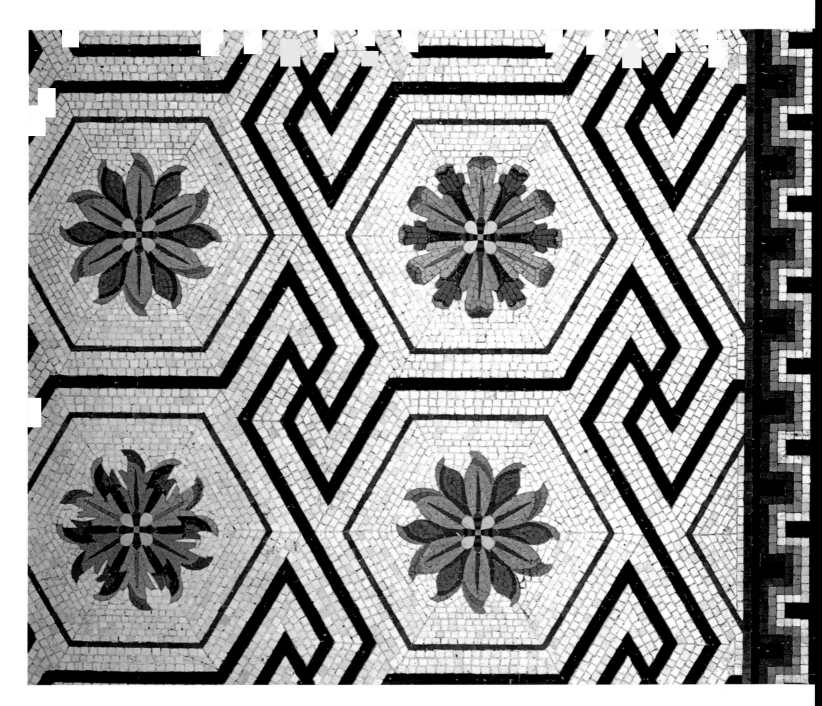

The mosaic top of an intricately patterned gilt table in the style
of Giuseppe Bonzanigo, c. 1790. Attingham Park, Shropshire.

The skylight and plasterwork dome of the Grand Staircase, built in Neo-Norman style between 1820 and 1837, Penrhyn Castle, Gwynedd.

Detail of the Drawing Room ceiling with a repeating pattern of octagons. It was designed by Robert Adam in the 1760s. Osterley Park, Middlesex.

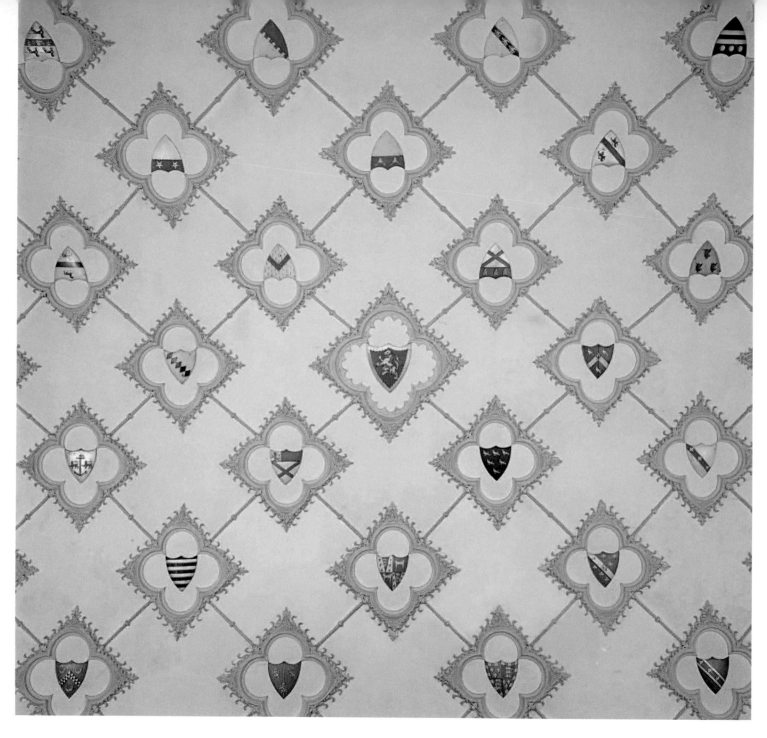

Detail from the Hall ceiling, emblazoned with the coats of arms of
John Ivory Talbot and friends in 1756. Lacock Abbey, Wiltshire.

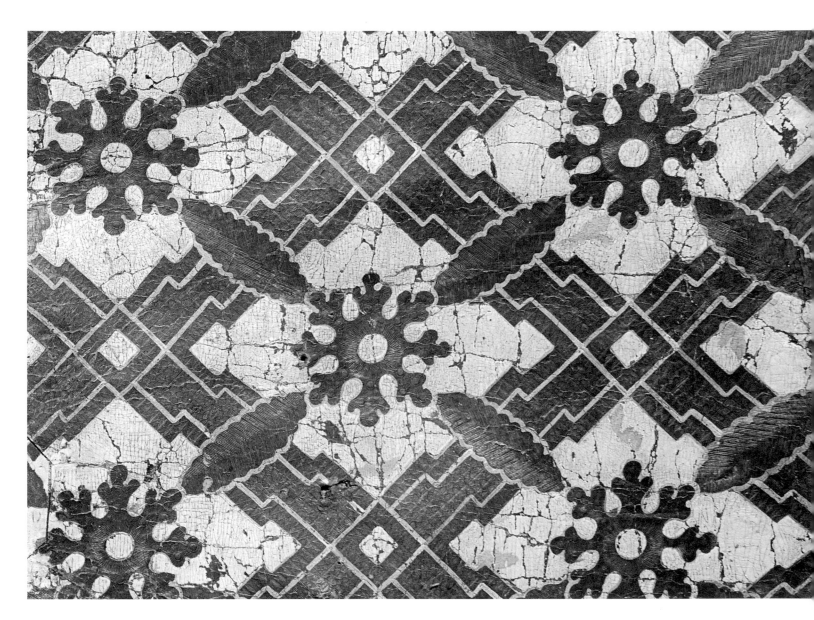

A gilt-leather wall hanging in the Marble Dining Room from around
1756. Ham House, Richmond-upon-Thames.

Cultures have their own individual mythologies, and the closer a society lives to the natural world, the more likely they are to tell tales of mythical and supernatural creatures, and to depict them in their art and artefacts.

Mythical creatures abound in early cultures. The enduring legends of dragons and giant serpents, which occur so often in diverse mythologies, may have been evolved by story-tellers puzzled by their occasional discoveries of the fossil remains of prehistoric creatures. Extinct species certainly survive in oral history for hundreds of years after their demise, particularly among peoples who had cause to fear them. Maritime populations, such as the Greeks, the Japanese and the British, often tell of sea-monsters and mermaids, while land-locked nations such as the Germanic peoples tended to fear – and portray – spirits of forests and mountains.

Even sources believed to be authoritative about the rich diversity of the natural world could be misinterpreted, or unequivocally misinformed. Pliny's *Natural Histories*, written in 77AD, remained the prime source of information about the natural world for the following 1500 years, yet contained learned treatises on werewolves, basilisks and manticores. *The Etymologiae*, a huge encyclopedia orchestrated by Isidore of Seville (c. 560–636) was plundered for its somewhat fanciful zoological entries by the compilers of medieval volumes that were known as *Bestiarum Vocabulum*, or compendia of beasts. Reflecting the oral history of their times, imaginary creatures were often portrayed in the decorative arts for their pattern potential.

There was a consistent fascination with winged mythological or legendary creatures, particularly those of the classical world. The myths and legends of ancient Greece and Rome were rediscovered and revived during the Renaissance era, and avidly read across Europe. Supernatural creatures took on mystical values; Pegasus, the winged horse of Greek mythology, was a symbol of poetry and inspiration. The gryphon, or griffin, was a large predatory composite monster, which sported wings, the head of an eagle, and the hindparts and tail of a lion. Gryphons were believed to have a protective function – the superstition still exists in Wales that a pair of gryphons can protect a house from robbers. The phoenix was so associated with its legendary ability to be reborn from flames that it was eventually adopted as the symbol of fire insurance companies.

There were also those intriguing creatures related by word-of-mouth, but not actually seen by the artist; these would be depicted with varying degrees of anatomical accuracy. Some of these beasts are evidently the product of the creative imagination.

Monsters

Human, or partially human, monsters particularly exercised the creative imagination. From Grendel, the half-human monster slaughtered by Beowulf, to the more benign influence of the 'Green Man', a very ancient and mysterious figure of pre-Christian paganism, the decorative arts often featured the more outlandish figures of folklore. Mermaids were believed to lure the unwary, and gargoyles were employed to frighten off the devil.

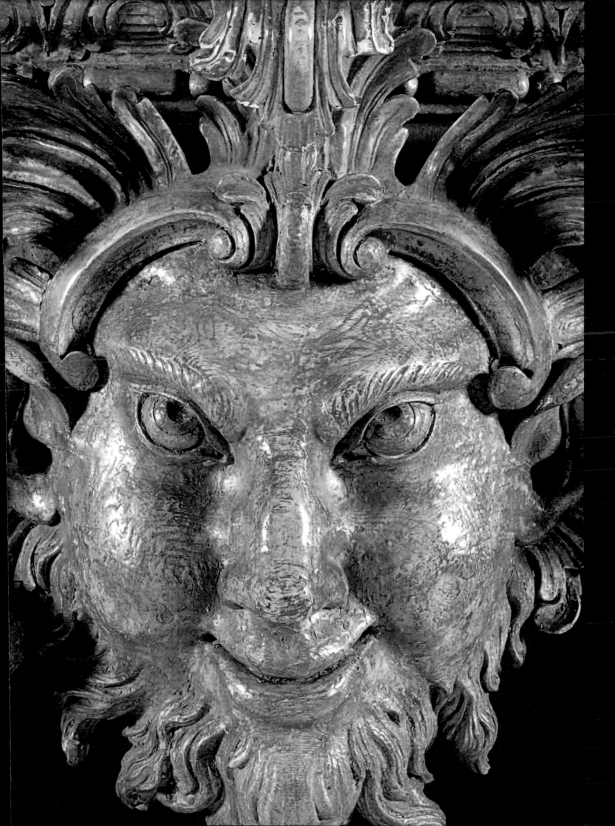

Carved face in the centre of the
George II giltwood pier table.
Anglesey Abbey, Cambridgeshire

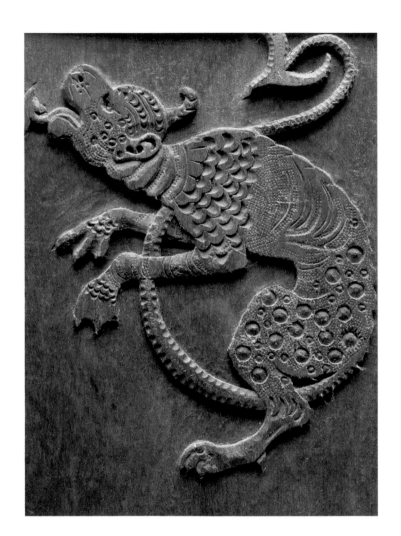

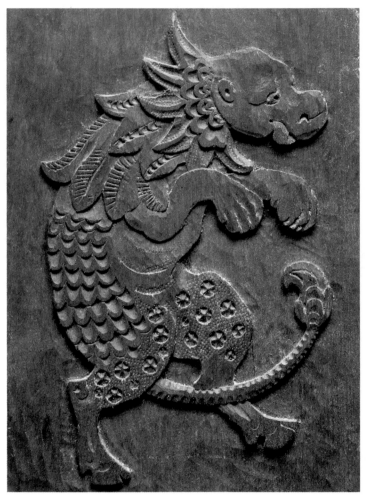

Carved wooden panels depicting mythical beasts, c. 1534. Bradley Manor, Devon.

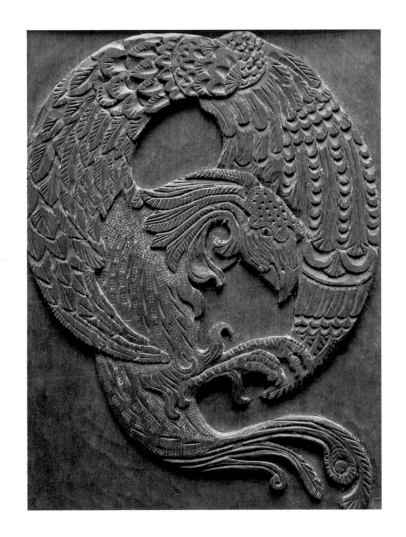
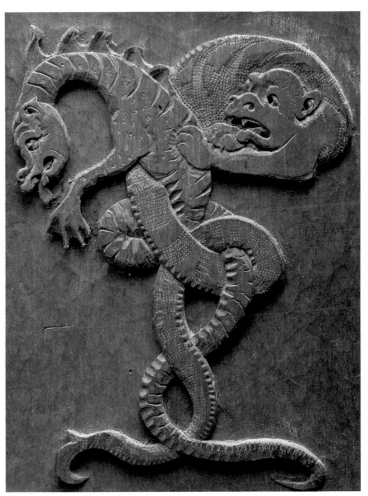

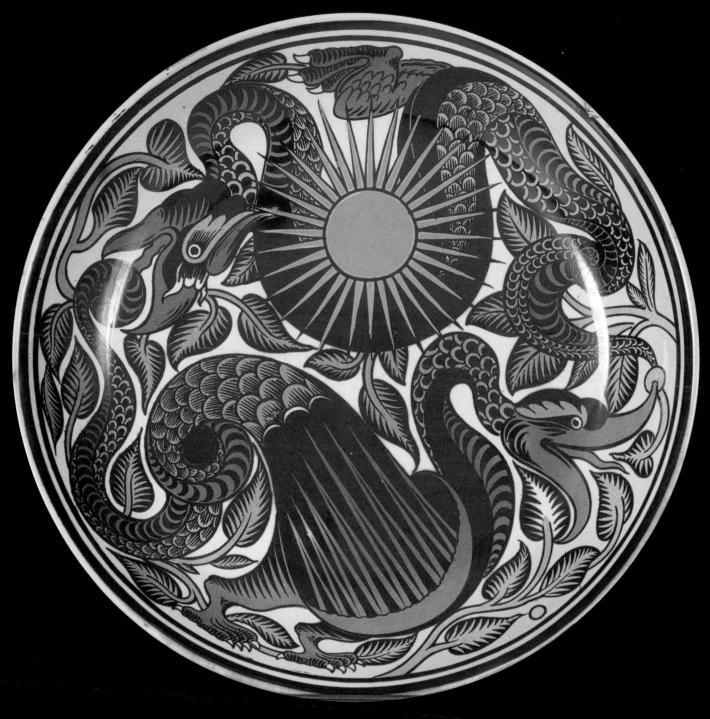

William de Morgan lusterware charger, decorated with mythical serpents c. 1890. Standen, West Sussex.

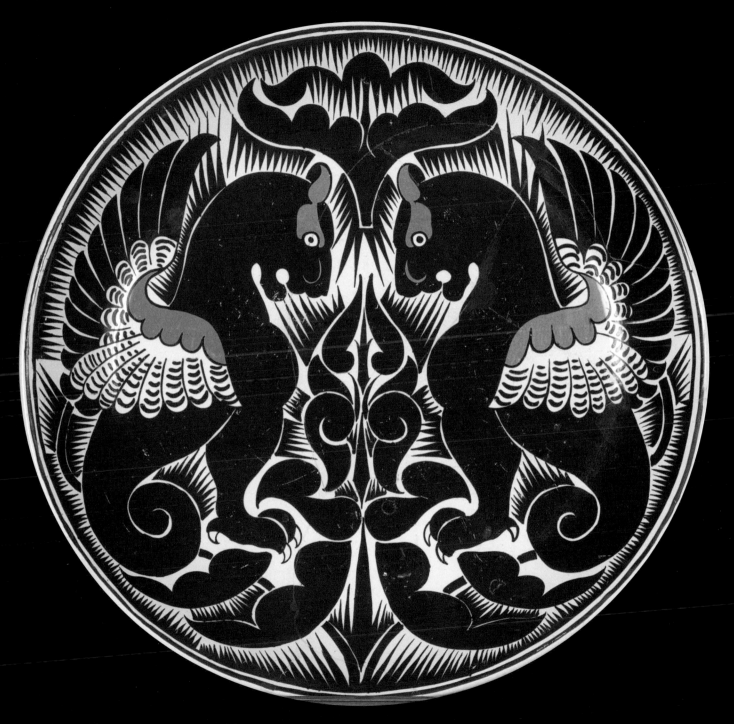

William de Morgan lustreware charger decorated with winged
leopards c. 1890. Standen, West Sussex.

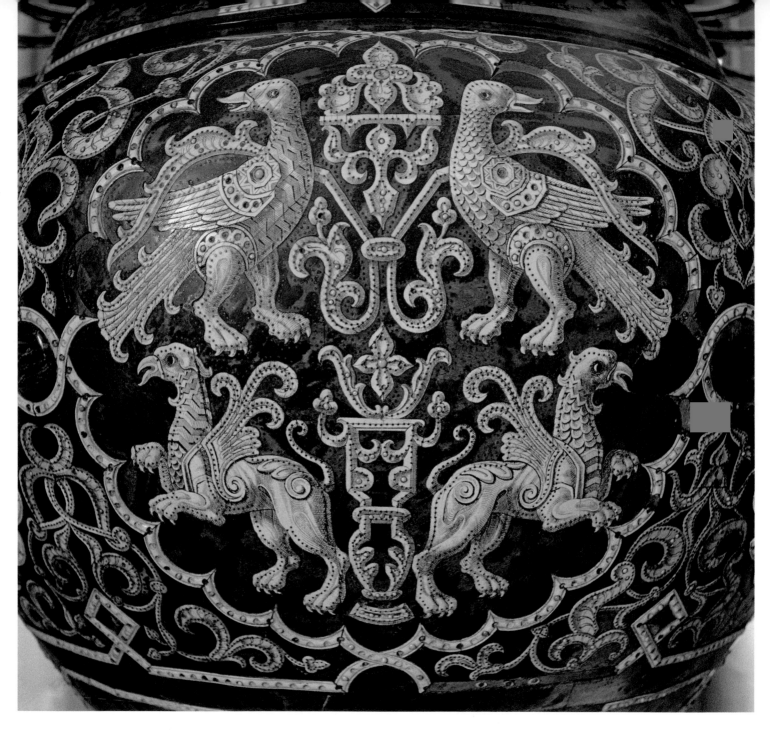

Detail of large vase decorated with gryphons and phoenixes.
Nostell Priory, West Yorkshire.

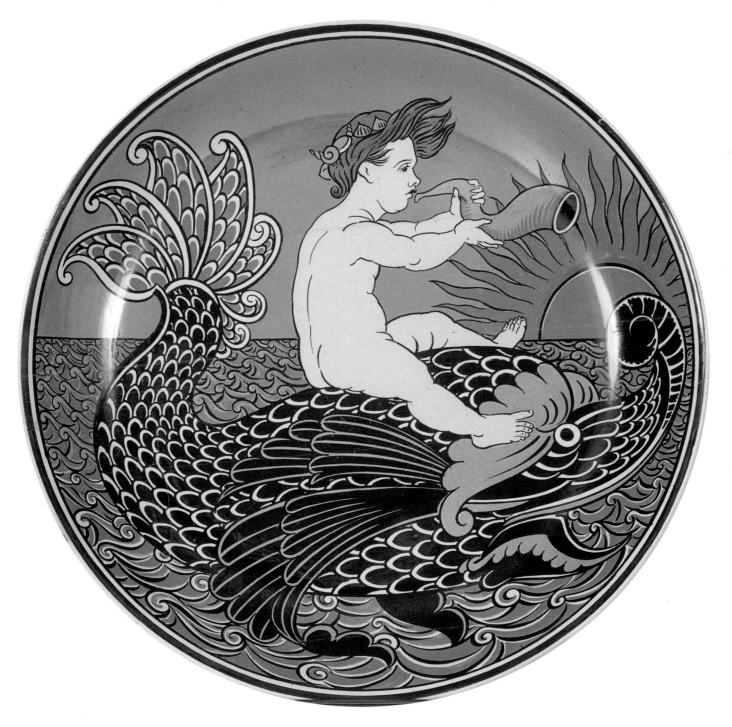

A cherubic figure riding a sea-creature, on a lustreware charger
designed by William de Morgan. Standen, West Sussex.

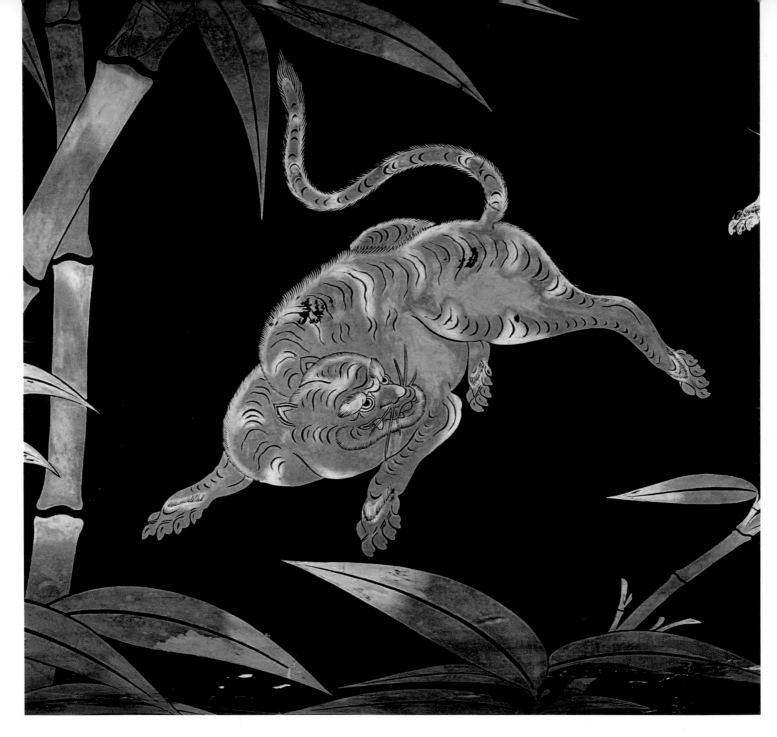

Detail of a tiger in inlaid mother-of-pearl, inside a lacquered
Japanese chest, c. 1600. Chirk Castle, Wrexham.

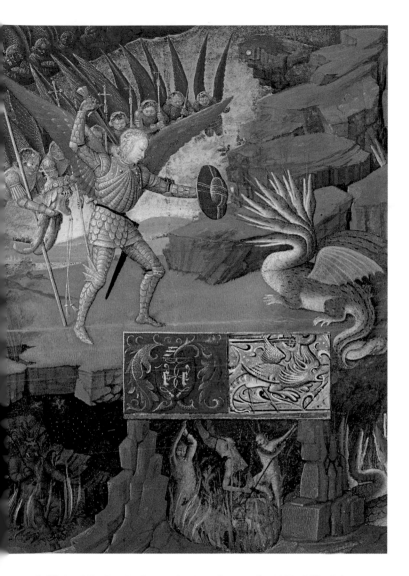

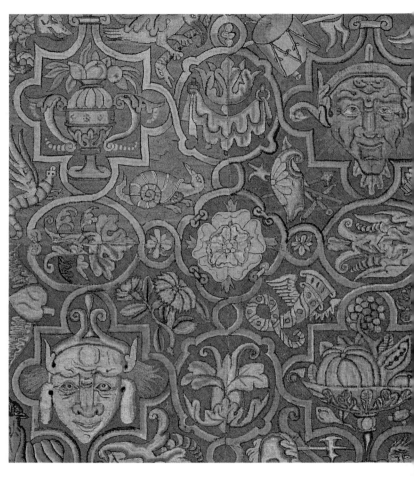

St Michael Slaying the Dragon by Jean Fouquet (c. 1452–60). Miniature from a page of a Book of Hours called *Les Heures d'Étienne Chevalier*, which was broken up in the 18th century. Upton House, Warwickshire.

A small table carpet (late 16th century) hand-embroidered in minute stitches, with a design of grotesque masks and a Tudor rose. Hardwick Hall, Derbyshire.

Plant and floral motifs are a perennial form of decoration. The astonishing wealth of shape and colour visible in the world of horticulture and botany formed and inspired pattern-makers for millennia and continues to be a rich resource for all areas of two-dimensional three-dimensional design.

The changing treatment of flowers and plant forms on patterned surfaces an indication of the aesthetic and aspirational values of each era times of strife, the promotion of certain floral symbols denoted political and dynastic allegiances. There was a gradual move from identifiable native species, as seen in the 'mille fleurs' borders of illustrated medieval manuscripts, to more stylised 'generic' plant forms, exploited for their decorative appeal. The adoption of symmetrical and even abstract floral designs, coupled with arabesques can be attributed to the influence of highly sophisticated Middle Eastern patterns on ceramics, reinterpreted by traders, merchants and silk weavers in Italy and France.

With the invention of printing and the spread of illustrated books, followed by the early advances made in botanical studies and classification in the 17th century, it became easier for pattern-makers and artists to refer to accurate representations of plants they were unlikely to encounter in real life. The dissemination of factual knowledge about the world coincided with an appetite for the designs of other cultures, and informed and influenced ornament.

The growth of trade with India and China provoked further stimulus British and French textile manufacturers were quick to copy the designs found on Chinese imports and Indian calicoes, so much so that trade in traditional woven fabrics was adversely affected. However domestic demand was so great that in the 1770s the British government lifted their previous restrictions on the importing of Indian cotton chintzes.

Technological improvement also had an effect: printed fabrics and wallpapers tended to be hand-blocked, a craft-based activity which required great skill. The more complex the pattern, the more numerous the colours, the greater the risk of error. The development of copperplate printing in the 1750s allowed British manufacturers to increase their output, reduce their costs and improve the quality of their designs. Patterned materials suddenly became more affordable for the lower classes as well as the wealthy. Consequently the Victorian era heralded a change in scale of patterns – exuberant designs, depicting 'larger than life' florals in a rich complexity of colours.

Any analysis of floral patterns is complex, so the subject is treated by the makers' approach to surface decoration, followed by recurrent and popular motifs.

STYLISED FLORALS

Designers and artists have always relied on the decorative possibilities of generic flowers and foliage, motifs not instantly identifiable as belonging to a particular species, as this gives their imagination free range.

CHINTZ AND PAISLEY

The visual impact of imported Indian floral textiles on the domestic scene is hard to over-estimate. Those quintessentially British designs chintz and paisley actually originated in the sub-Continent and found favour with the fashionable in Britain through trade and the desire for novelty. Chintz is forever seen as the 'fabric of Empire' and is almost a cliché in grand country houses. Chintz comes from a Hindi word, in itself derived from the Sanskrit 'chitra', meaning multi-coloured. The brilliant colours and complex motifs were block-printed on calico, an unbleached medium-weight woven cotton, which made them very suitable for interior textiles. Chintz textiles were extensively produced in India from around 1600 till 1800.

The Diary of Samuel Pepys, Saturday 5 September 1663

> '…my wife and I to Cornhill, and after many tryalls bought my wife a chintz, that is, a painted Indian Callico, for to line her new study, which is very pretty…'

The 'boteh' or paisley motif so familiar from Indian textiles and much copied in the 19th century, is believed to have originated in ancient Babylon as a tear-drop shape, symbolising the growing shoot of a date palm. As the peoples of the Middle East depended in many cases on these resilient trees for food, shelter, drink and raw materials, the rapid-growing shoot of their favourite plant came to represent a 'tree of life' motif to them.

'Paisley' motifs are British interpretations of 'boteh' patterns found on imported Indian textiles, especially those originating in Kashmir. They acquired their name because enterprising textile manufacturers in Paisley met the public demand for these fashionable and expensive imports by producing much more affordable woven shawls and scarves imitating the design. As the Paisley manufacturers faced stiff competition from Norwich or Edinburgh, it is intriguing to think that the famous motif might have borne the names of those cities instead.

SPRIGS

Nosegays or sprigs of assorted flowers, apparently scattered at random over a decorated surface, were particularly popular in the late eighteenth and early nineteenth centuries. They have symbolic associations with tokens of affection, and the choice of flowers is related to the intricate subtleties of the 'Language of Flowers'.

URNS AND VASES

The passion for still-life paintings that swept Britain in the Jacobean era led to a vogue for creating patterns based on the conventions found in those paintings. The most accomplished Dutch still-life masters would depict, often with astonishing accuracy, a mass of blooms displayed in a vase or urn. Within the design, the container acts as a contrast to the exuberance of the floral motifs.

ROUNDELS AND MEDALLIONS

Enclosing floral motifs within carefully defined parameters allows pattern-makers creative liberty within a regular structure. Consequently, floral 'cartouches' have remained a popular pattern-making convention to the present day.

CLIMBERS

For predominantly vertical surfaces, such as wallpapers and wallhangings, pattern makers have traditionally relied on plant forms to give a basic structure to the area to be decorated. Stems, trunks and foliage provide a visually pleasing framework, and a practical device for developing the decorative scheme.

TREE OF LIFE

The Tree of Life has been a popular theme among pattern-makers since the Dark Ages. Myths and legends, such as those of the Norsemen, liken the creation of the world to a gigantic tree, with all plant and animal life dependent on it and therefore depicted within its branches. The Tree of Life has associations with fecundity and plenty.

FOLIAGE

Contrasting leaves from different plant forms offer enormous pattern potential to designers, artists and makers.

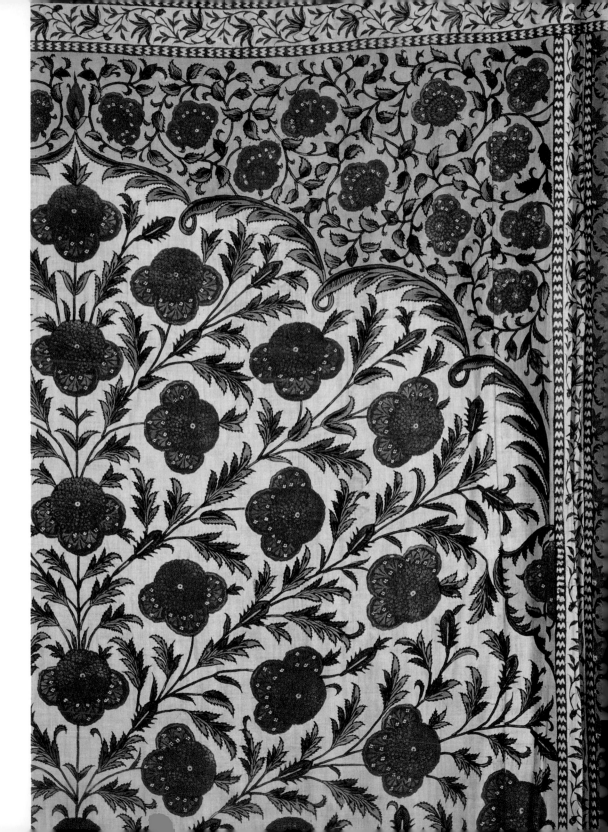

Details of a decorative print on
Sultan Tipu's tent (c. 1725–50).
Powis Castle, Powys.

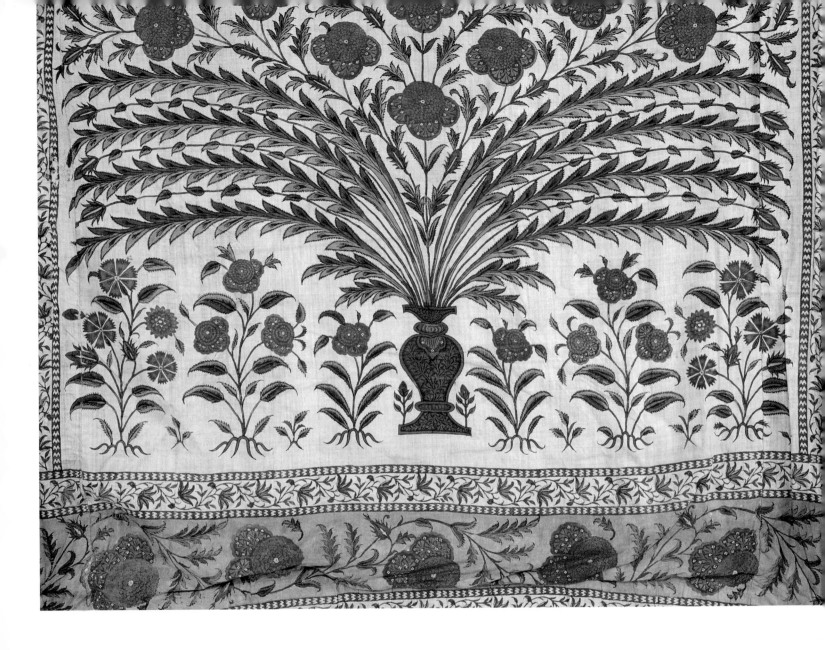

Brightly coloured chintz. Detail of Sultan Tipu's Tent (c. 1725–50)
in the Clive of India Museum. Powis Castle, Powys.

Eton Rural fabric (early 20th century), featuring poppies. Mr Straw's House, Nottinghamshire.

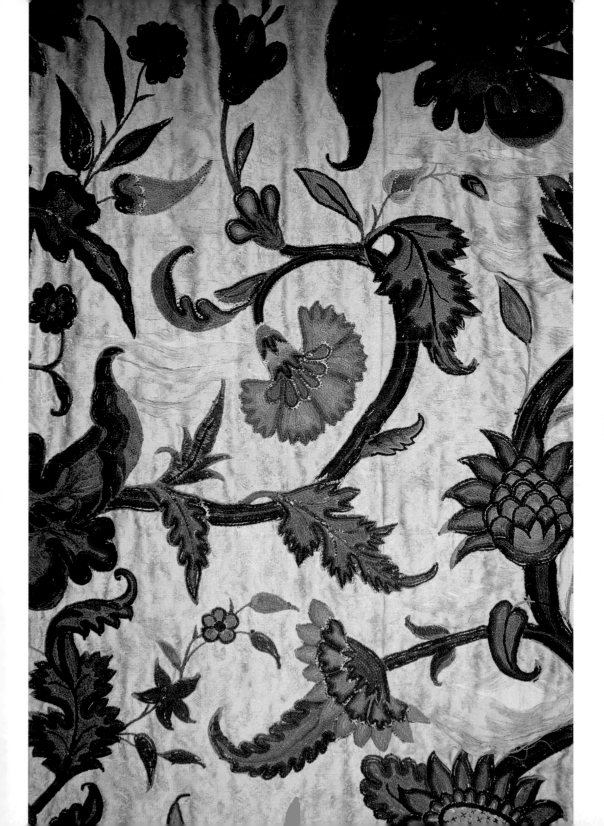

Detail from a 17th-century crewelwork bed hanging. Snowshill Manor, Gloucestershire.

A fragment of brightly coloured
18th-century wallpaper, found in
an attic, with an excise stamp on
the reverse which dates it as
1712–14. The influence from
Indian chintz is undeniable, with
its intricate design, brilliant
colours and paisley motif-shaped
leaves. Erddig, Wrexham.

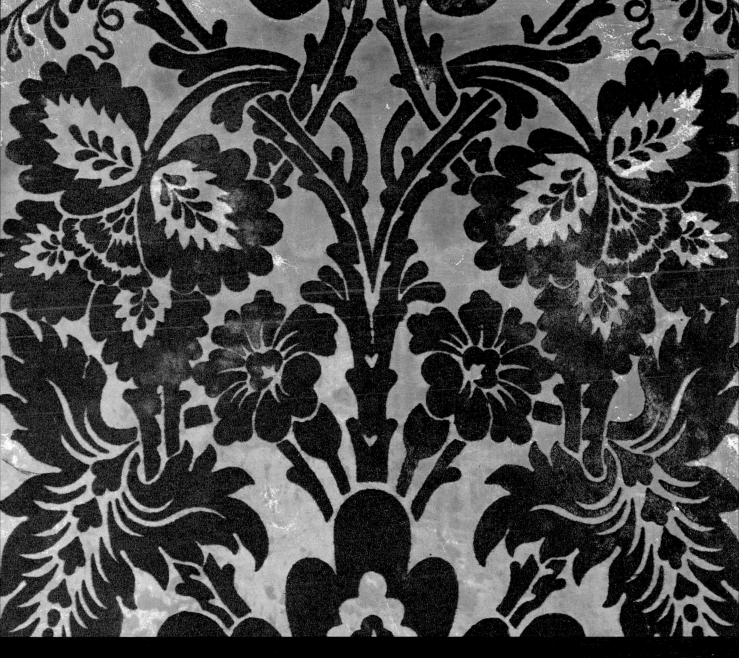

An 18th-century flock wallpaper, showing the strong influence of more expensive Italian silk damasks. Ormesby Hall, Redcar & Cleveland.

Detail of the flock wallpaper in the Drawing Room, which was introduced by the National Trust since the house's acquisition in 1931. Montacute House, Somerset.

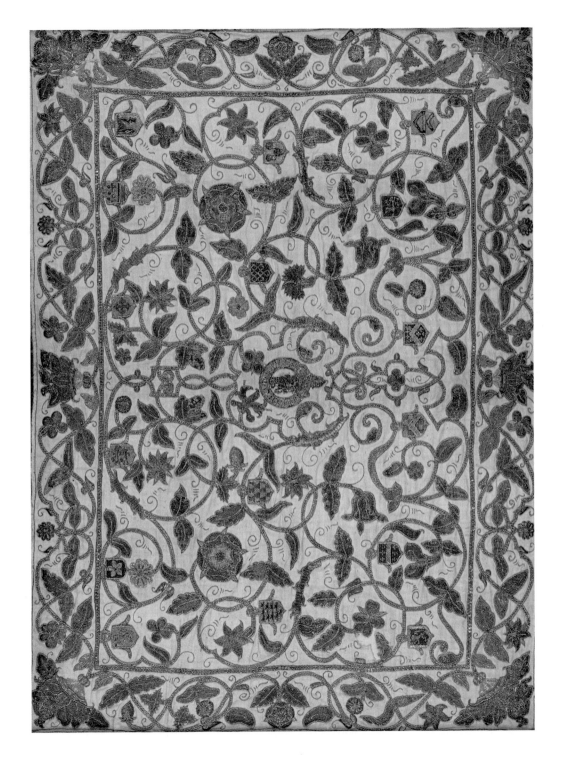

English embroidered cushion cover c. 1559–88, set in a frame. The flowers and the coat of arms form a complex symmetrical pattern. Petworth House, West Sussex.

Stencilled wall decoration applied by hand c. 1908. The design was based on a 16th-century scheme in nearby St. William's College. Treasurer's House, York.

Detail of a stencil decoration in two shades of blue on a cream wall in the 1840s interior of the Birmingham Back to Backs.

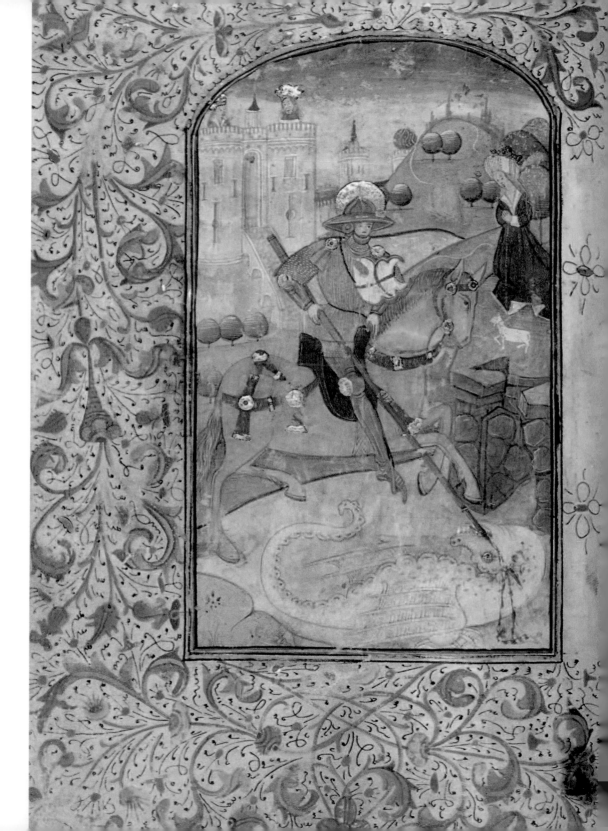

An illuminated page in a 15th-century Book of Hours, a prayerbook. The illustration depicts St George slaying the dragon. The decorative border is filled with scrolling arabesques and abstract representations of plant and floral forms. Powis Castle, Powys.

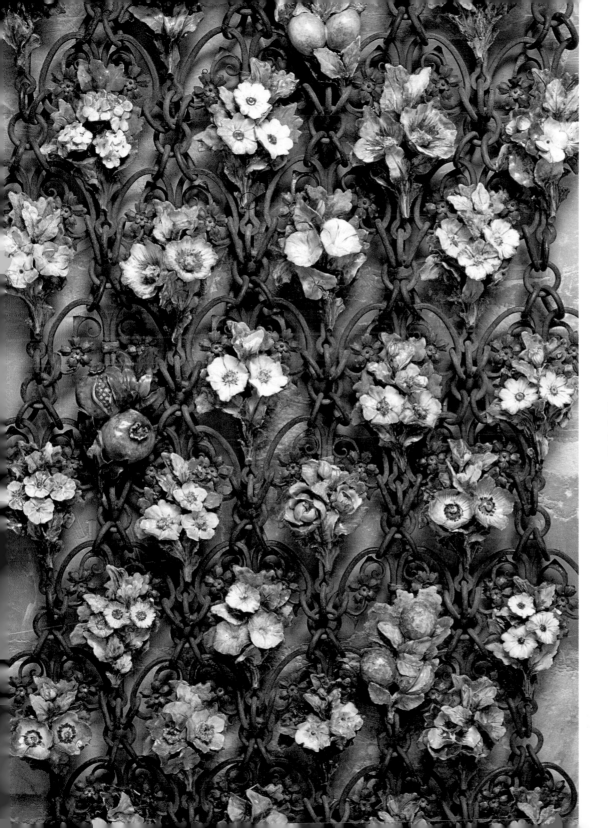

North Italian chain-link screen decorated with ceramic fruit and flowers. Anglesey Abbey, Cambridgeshire.

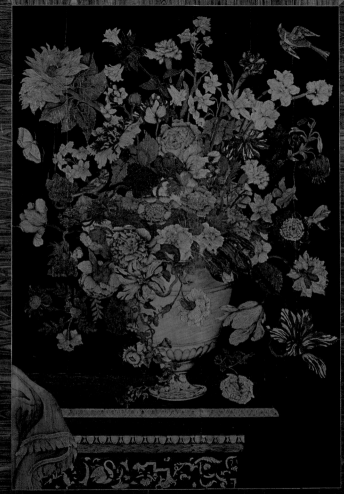

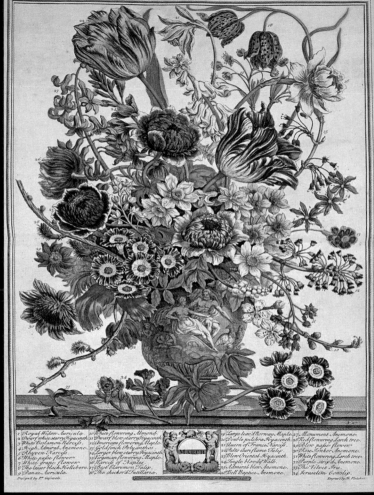

Detail of a panel from Dutch cabinet decorated with floral marquetry, probably by Jan van Mekeren, c. 1690. Charlecote Park, Warwickshire.

'March', from Robert Furber's *Twelve Months of Flowers*, published in 1730. Kingston Lacy, Dorset.

Walnut veneer marquetry games table top in the Drawing Room. Hughenden Manor, Buckinghamshire.

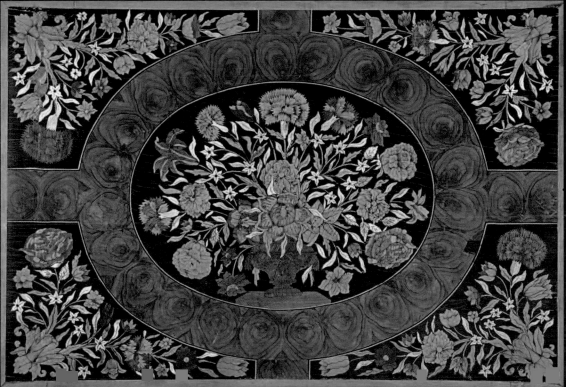

Detail of a marquetry tabletop. Clandon Park, Surrey.

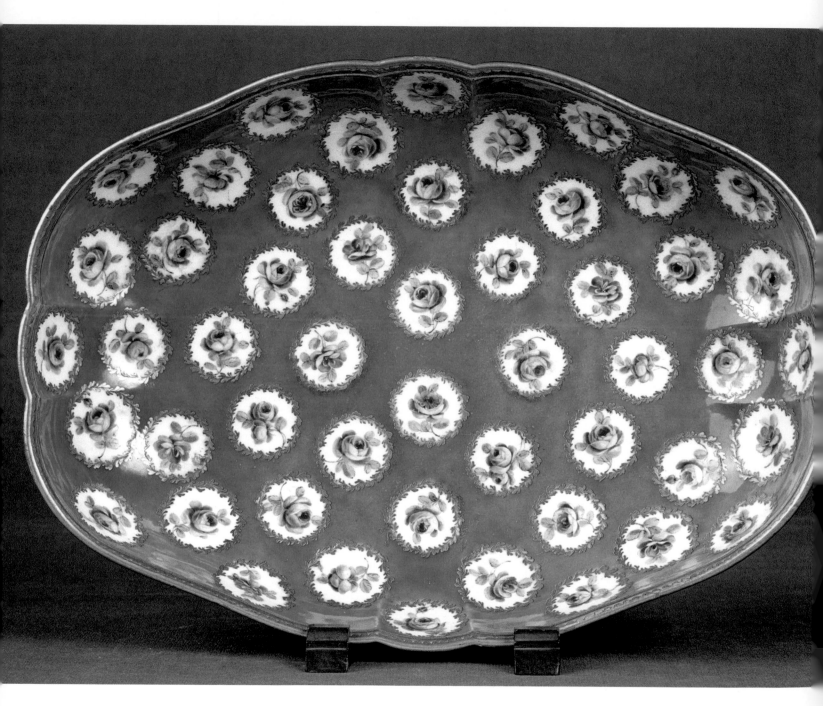

An 18th-century Sèvres basin decorated with a repeating pattern of medallions with roses. Clandon Park, Surrey.

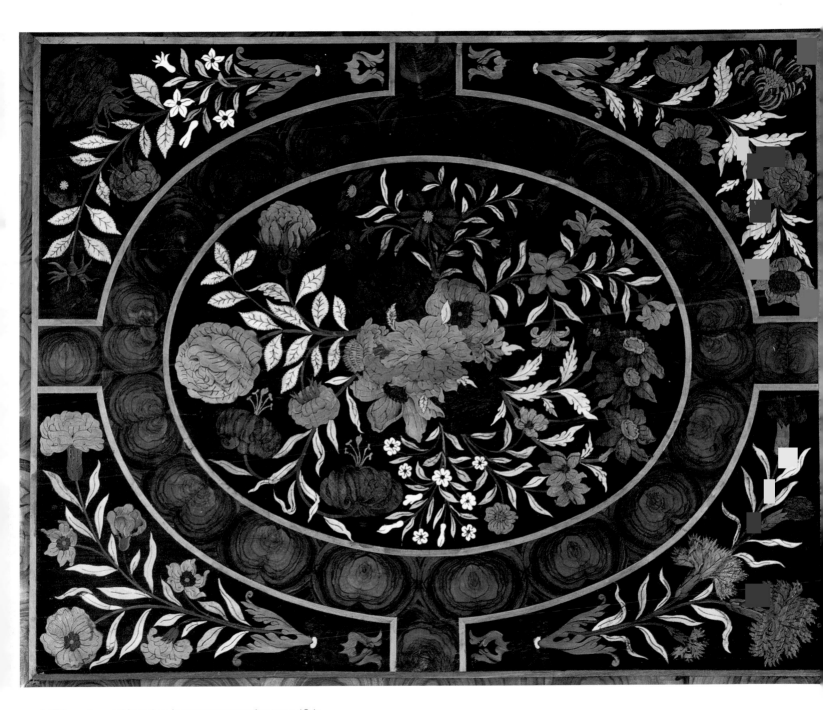

A 17th-century cabinet door in marquetry used to top a 19th-century walnut centre-table. Each panel depicts a different flower, but the overall effect is harmonious. Kingston Lacy, Dorset.

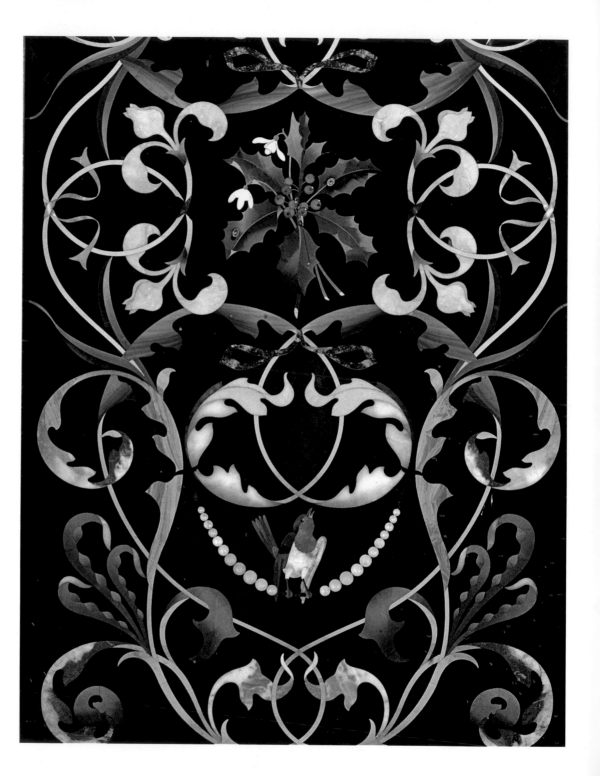

Detail of a Florentine pietra dura panel from a cabinet, 1850, in the Spanish Room. Kingston Lacy, Dorset.

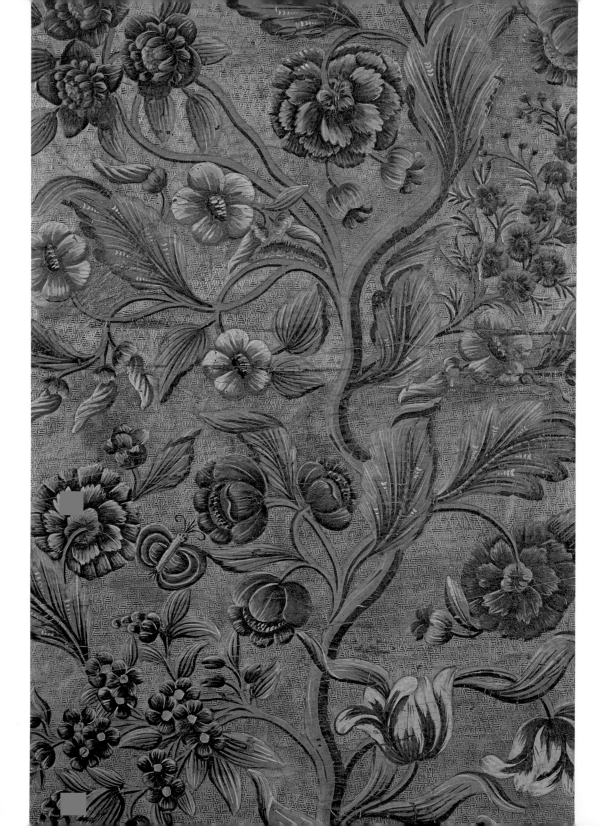

Detail of an 18th-century Chinese-style screen made from Spanish leather. Clandon Park, Surrey.

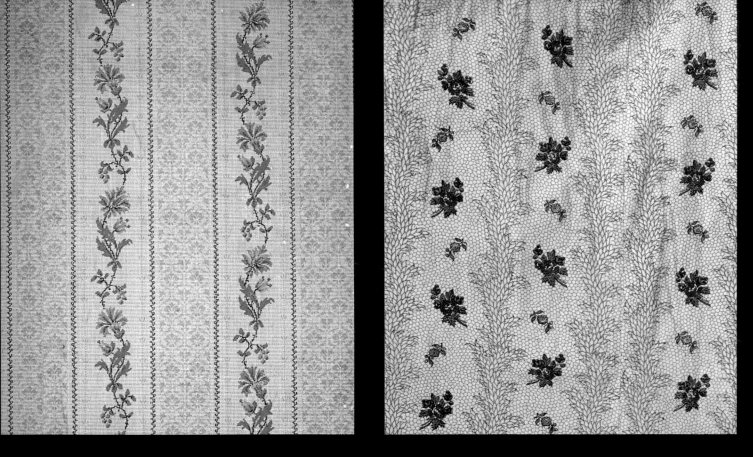

Early 19th-century wallpaper in a servant's bedroom. Stripes of climbing flowers alternate with more abstract verticals. Llanerchaeron, Ceredigion.

A printed dress cotton from around 1770, combining sprigs of red flowers with vertical bands of white leaves. Berrington Hall, Herefordshire.

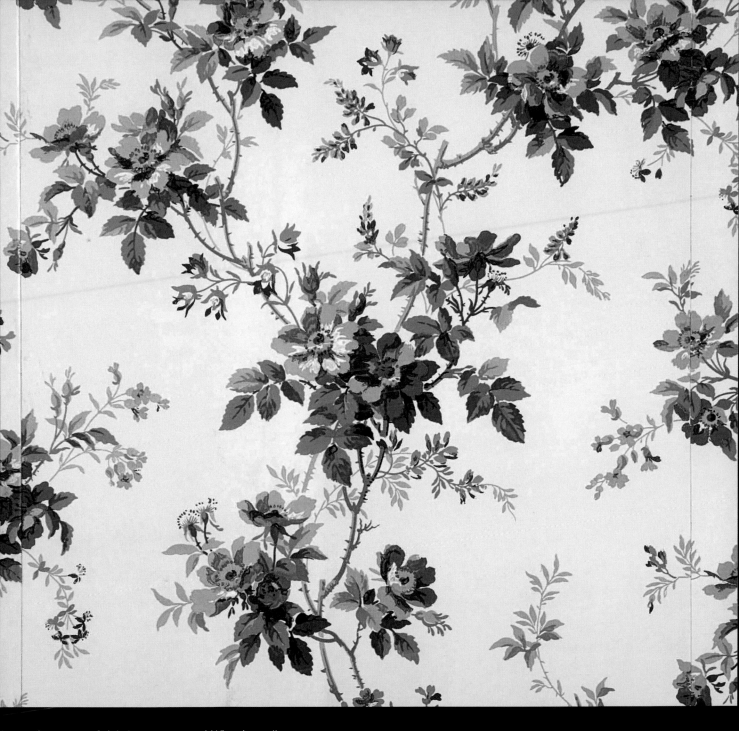

A repeating pattern of pink dog roses on a mid-Victorian wallpaper in the Parlour of Carlyle's House, London.

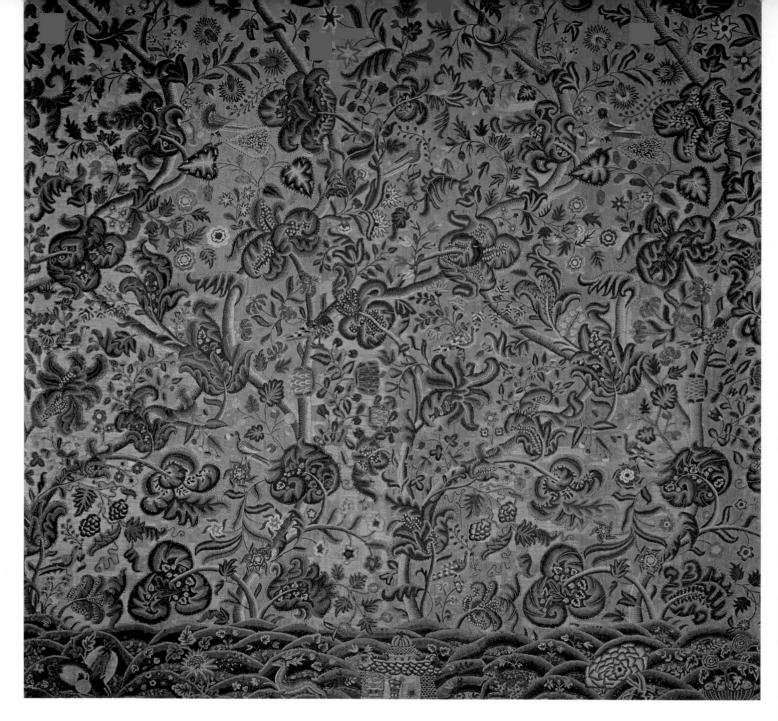

A section from a late 17th- or early 18th-century crewelwork bed
hanging, depicting the Tree of Life. Florence Court, Co. Fermanagh.

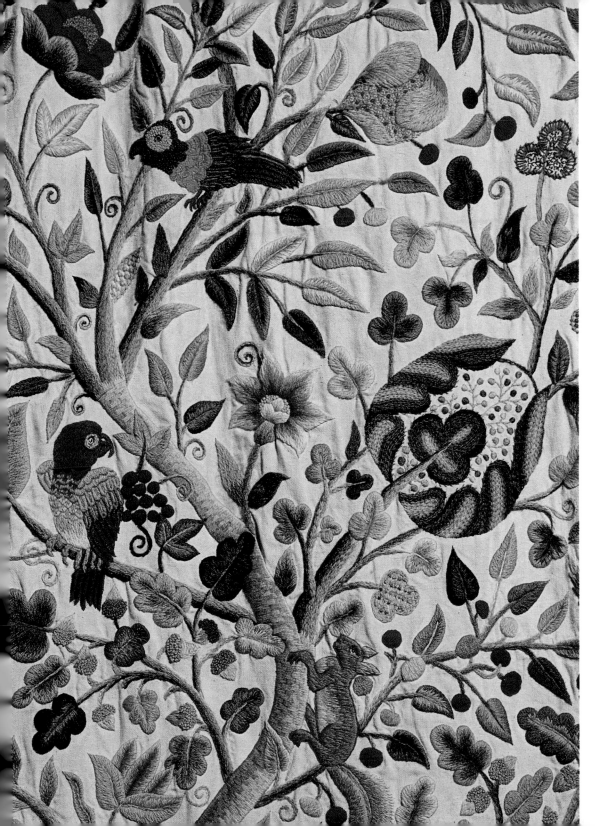

Tree of Life crewelwork bed-hanging, embroidered by Rachel Kay-Shuttleworth, c. 1910–1918. The pattern was inspired by Jacobean floral motifs and coats of arms. Gawthorpe Hall, Lancashire.

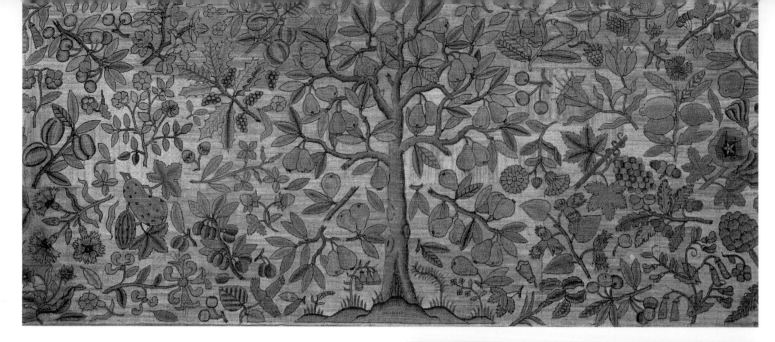

Long cushion cover depicting a pear tree, overladen branches
breaking under the weight, surrounded by various flowers, fruits
and vegetables. Date unknown, first recorded in 1601 inventory.
Hardwick Hall, Derbyshire.

Detail of a long cushion cover, embroidered in long-armed
cross-stitch, depicting oak leaves on crimson background.
Hardwick Hall, Derbyshire.

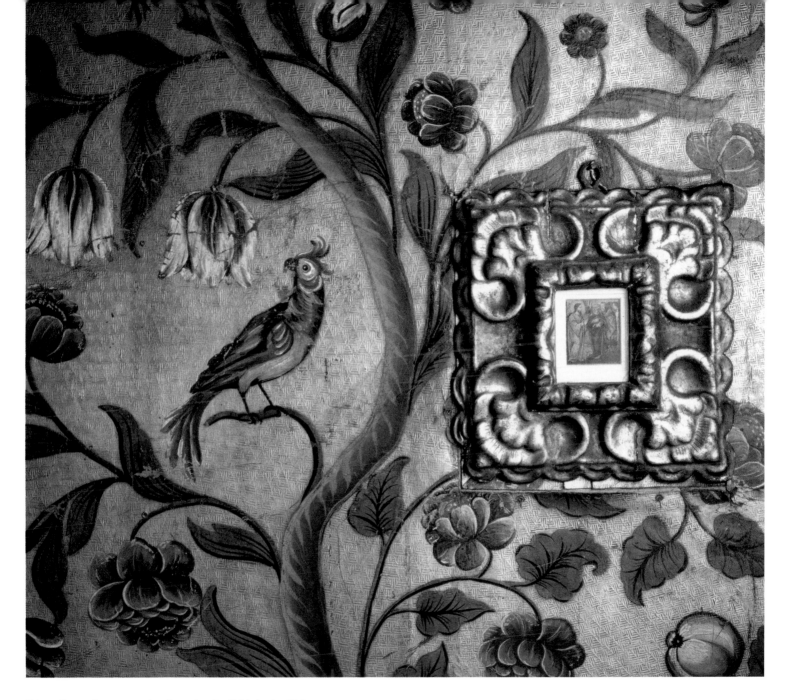

This wall covering was made of panels of calfskin in the 18th century. A framed illuminated miniature of Christ and his disciples appears to hang from a branch of the painted tree. Bateman's, East Sussex.

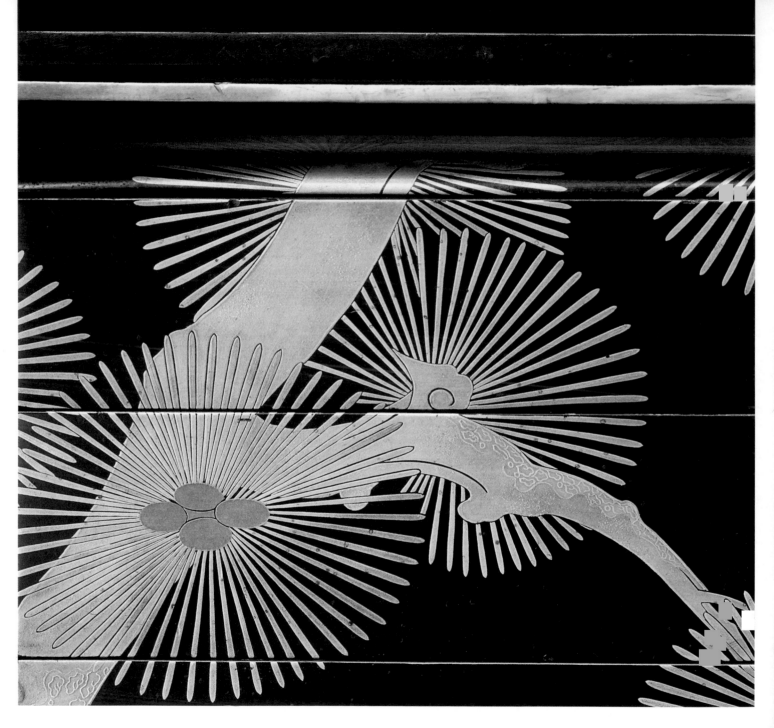

Pine needles depicted on a 19th-century Japanese picnic box.
Snowshill Manor, Gloucestershire.

Edwardian stained-glass window
with a stylised design of abstract
floral form. Mr Straw's House,
Nottinghamshire.

A detail of the blue and white wallpaper, reproduced from the original 19th-century paper. Petworth House, West Sussex.

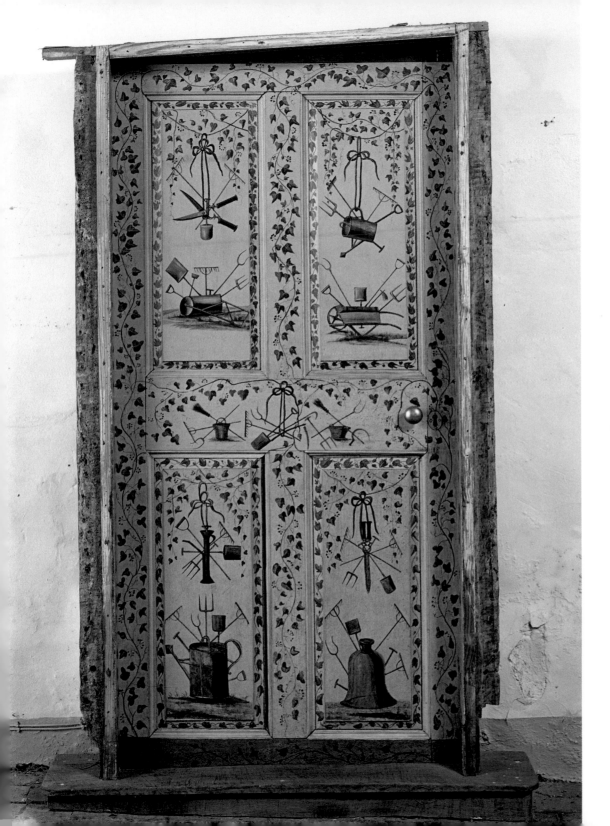

Moll's Door, painted by Mary Dorothea Wolryche Whitmore in the early 19th century, depicting garden tools and leaves. Dudmaston, Shropshire.

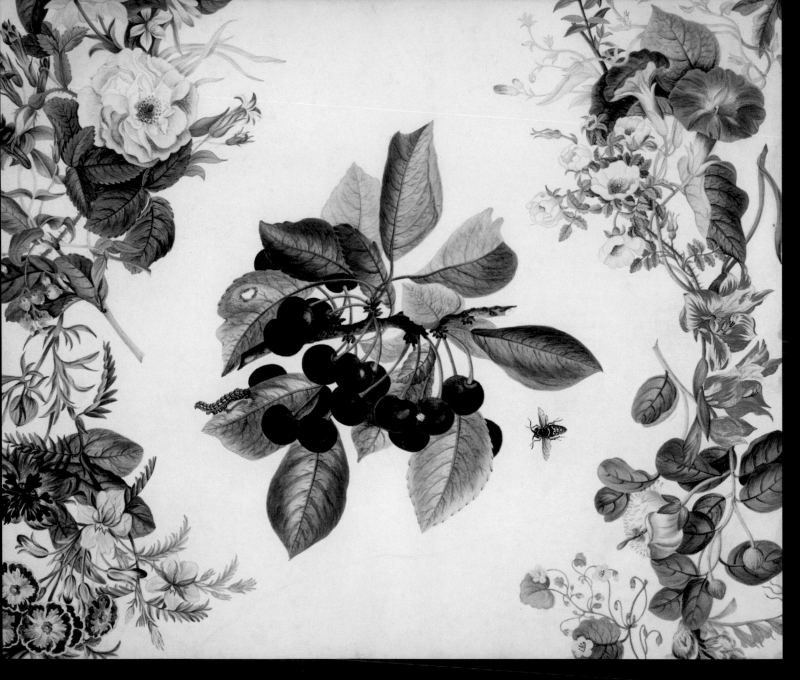

Detail from a decorated table-top (1813) with three ceramic tiles hand painted
to show cherries, bees and flowers. Hughenden Manor, Buckinghamshire.

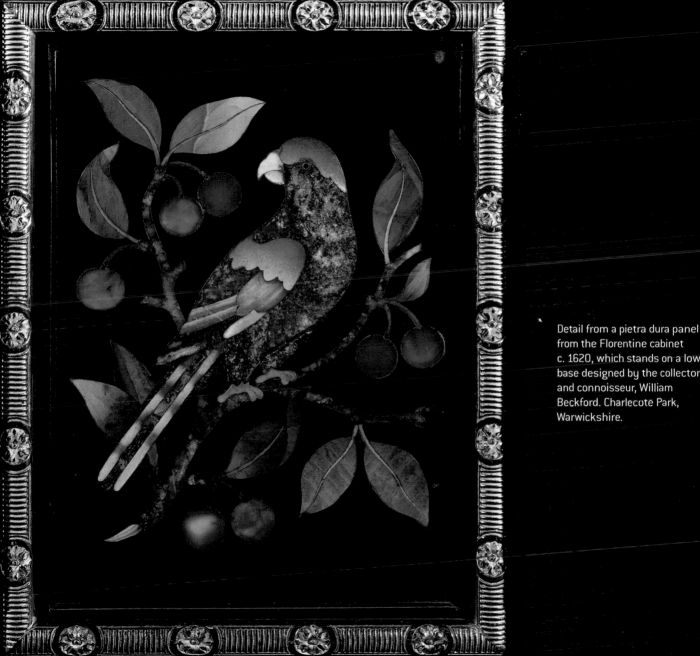

Detail from a pietra dura panel
from the Florentine cabinet
c. 1620, which stands on a low
base designed by the collector
and connoisseur, William
Beckford. Charlecote Park,
Warwickshire.

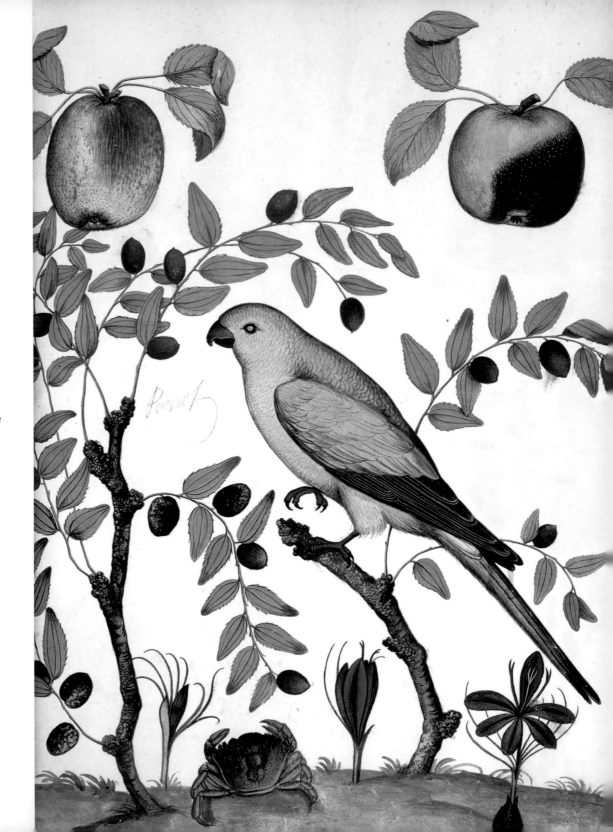

A 17th-century Italian drawing of birds, after Italian naturalist Ulisse Aldrovandi in a book of the same period, depicting a parrot, a crab and two apples. Ickworth House, Suffolk.

Printed cretonne fabric wall hanging, depicting a bird of paradise
in a pomegranate tree, 1872. Belton House, Lincolnshire.

Detail from an Aubusson carpet,
commissioned in 1839.
Belton House, Lincolnshire.

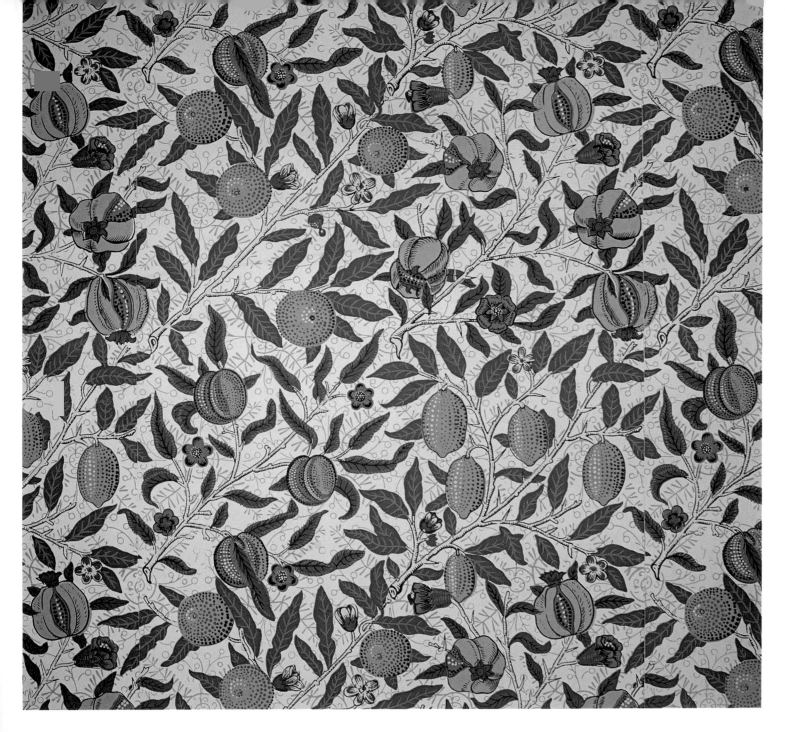

Medieval in inspiration, 'Pomegranate' wallpaper, designed by William Morris in 1866 for Morris & Co., was used to decorate the Yellow Bedroom at Cragside in the 1890s. Cragside, Northumberland.

Heraldry originated from the need to be able to identify leading participants on the battlefield. In the thick of a skirmish, life-or-death decisions were made on the ability of soldiers distinguishing friend from foe. Knights would wear distinctive colours and symbols on their tabards, loose fabric garments which were worn over suits of armour, and they also sported them on their shields. The footmen and archers supporting a particular knight would also wear his 'coat of arms', or battle-dress; an early example of 'team colours'.

The coat of arms began to be used as a hereditary device in England in the mid-12th century. What started as a practical method of identification rapidly evolved into a status symbol, rigorously restricted to the use of the land-owning and aristocratic classes. Families entitled to bear arms were keen to have them on display, whether flying as a pennant from the highest point of the manor-house, or displayed in churches and religious institutions, as indications of practical support and piety on the part of the arms-bearing household. Coats of arms could be depicted in a wide variety of media; textiles, carvings, paintings, enamel or even stained glass.

By the Renaissance, heraldry had evolved a rich symbolic language of meaning and association. The discipline was regulated by professional officers-at-arms, and ennoblement or preferment was in the gift of the monarch. There were strict rules on the use of colours, metals and patterns. The shield, or escutcheon, denoted a male holder of the coat of arms. A lozenge shape denoted a titled woman. Clerics of noble birth either used the lozenge or a cartouche – a circle or oval – for their coat of arms. When dynastic marriages occurred between titled families, elements from the wife's coat of arms would be added into the husband's.

The crest above a coat of arms often denotes the helmet worn by the knight in battle – in many families' coats of arms, this has survived. The crown, as might be expected, denoted royalty, or seigniorial authority.

An entire menagerie of 'supporters' had specific symbolic values; the unicorn represented extreme courage, the dragon was a valiant defender of treasure, the griffin stands for a character who would chose death over capture, and the greyhound represents courage, vigilance and loyalty.

Until the beginning of the 18th century, monograms were largely the preserve of the aristocracy and royalty, and were used to denote ownership or patronage. The publication in 1726 of Samuel Sympson's *A New Book of Cyphers* offered examples of intertwined initials, and became highly fashionable, especially among those of a 'Gothick' persuasion. The blend of initial letters with heraldic devices personalised the possessions of individuals, and gave further scope to pattern-makers.

Heraldic shield, commemorating the marriage of
Sir John Chichester of Raleigh and Margaret
Beaumont in 1505. Arlington Court, Devon.

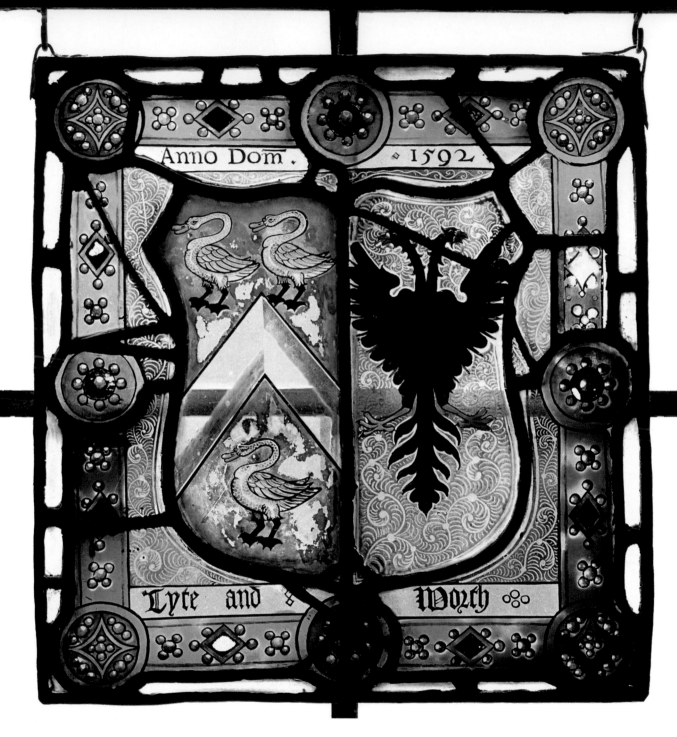

Stained-glass coat of arms of the Lyte family, 16th century. Lytes Cary Manor, Somerset.

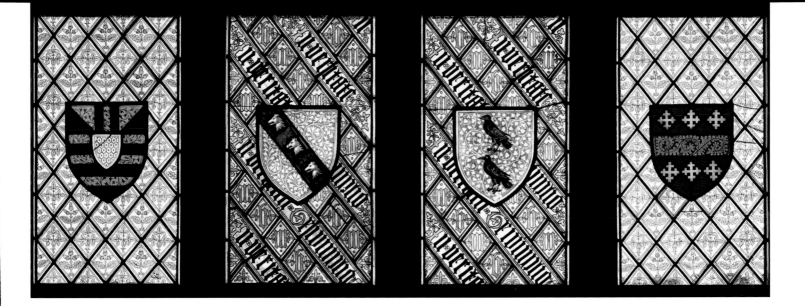

Stained glass windows, showing the Myddelton family's heraldic history, designed by Augustus Pugin in the late 1840s in the Cromwell Hall. Chirk Castle, Wrexham.

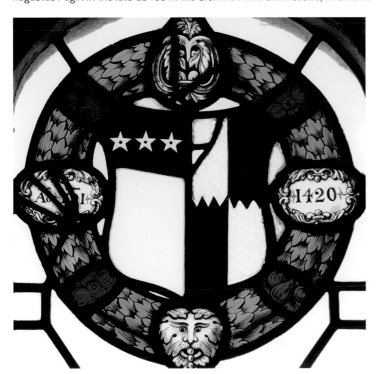
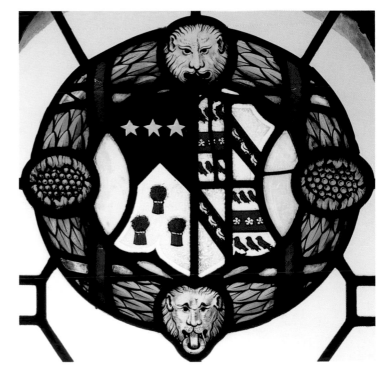

Stained-glass roundels and coats of arms commemorating the marriages of the Throckmorton family, c. 1830. Coughton Court, Warwickshire.

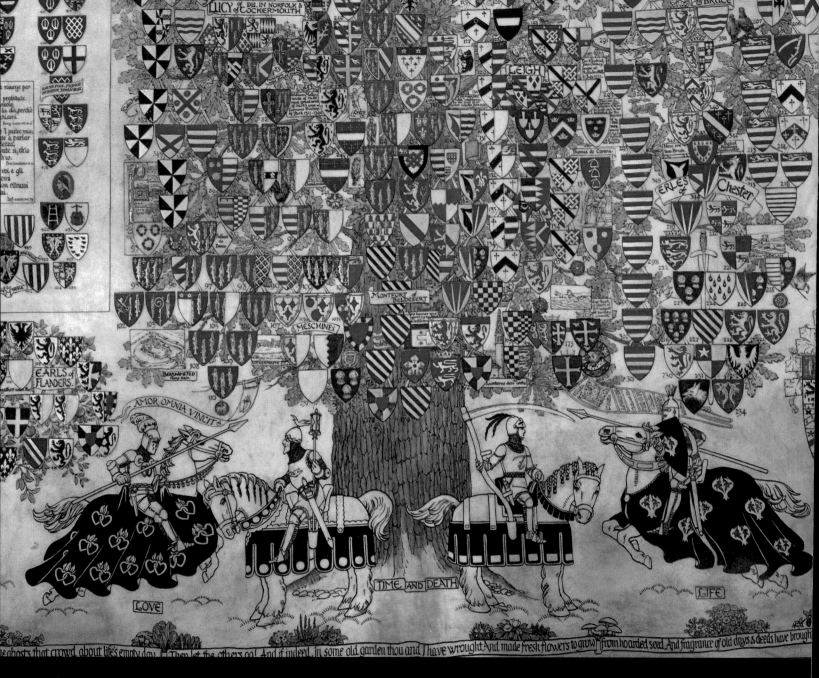

Detail of heraldic family tree on goatskin, showing the lineage of the Lucy family. Charlecote Park, Warwickshire.

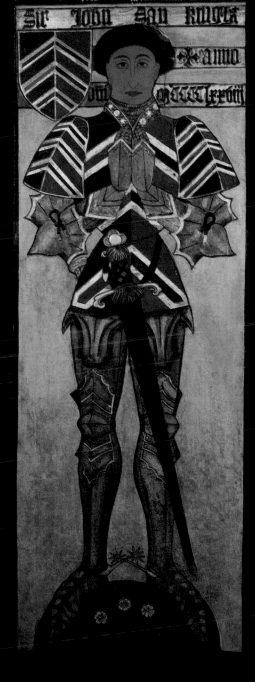
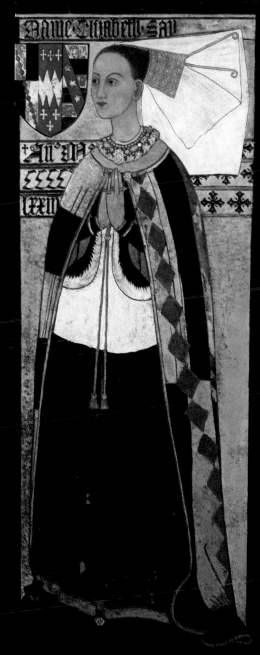

Sir John and Dame Elizabeth Say.
A pair of heraldic paintings, taken
from brass rubbings at
Broxbourne Church, Hampshire
and coloured in 1901 by
Wentworth Huysh. Snowshill
Manor, Gloucestershire.

A scagliola table top c. 1730, depicting the coat of arms of Sir Robert Walpole, Prime Minister and father of Horace Walpole. The Vyne, Hampshire.

Banner of the Duke of Cambridge, originally from his stall at St George's Chapel, Windsor, where it hung with those of the other members of the Order of the Garter, c. 1786. Snowshill Manor, Gloucestershire.

Detail of the shield of John le Fremon, who held land leased by the Abbey of Winchcombe in the early 14th century. Snowshill Manor, Gloucestershire.

Early Victorian Minton encaustic tiles in the Medieval Revival style, incorporating the Myddleton Biddulph monogram. Chirk Castle, Wrexham.

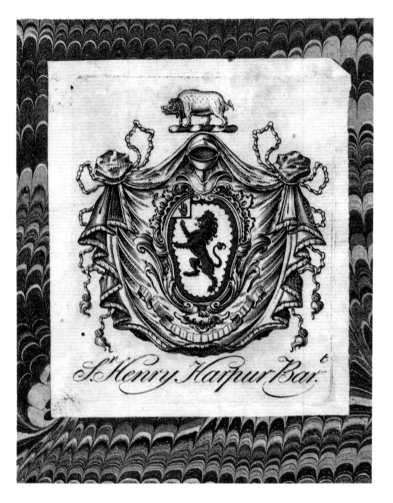

Detail of a monogram design engraved on one of a pair of tea canisters in silver gilt (1754). The initials are those of George Booth, 2nd Earl of Warrington, surmounted by an earl's coronet. Dunham Massey, Cheshire.

Library bookplate of the 5th Baronet, Sir Henry Harpur, from the first half of the 18th century. Calke Abbey, Derbyshire.

RENAISSANCE

Inspired by the art and architecture of ancient Rome, the Renaissance style originated in Italy in the 14th century, and gradually spread across the whole of Europe. The invention of printing in the late 15th century revolutionised the spread of learning. Literacy was no longer confined solely to the clergy and aristocracy, and books, while not easily affordable to most, were no longer laboriously hand-crafted objects of great rarity and immense value. Engraved books of Renaissance motifs provided invaluable source material for English artists and designers. Foreign artists and artisans working in London were also influential in introducing the style.

The new styles of decoration came to England in the 16th century, coinciding with the grip on power of the Tudor dynasty, and the schism with the Church of Rome. Consequently, the emphasis was on secular subjects for motifs and pattern-making, rather than the religious art of previous centuries. There was a new interest in the classical forms of ornament under the influence of European Renaissance. The dominant style was mostly Roman rather than Greek, for the practical reason that Italy in the ascendant was better-known and more respected than distant and rather more decadent Greece. In addition, the works of Palladio were much admired in Britain, and his strong architectural themes and depictions of perspective were highly influential.

In the fields of interior and architectural design, there was a strong trend towards the use of geometric patterns, with chequered marble floors, decorative brickwork, wooden panelling, marquetry, parquetry, and decorative tiling.

The dominant personalities of the Tudor monarchs and their various political and personal vicissitudes were central to Renaissance England. It was a matter of supreme importance to the dynasty to establish their 'divine right to rule', by presenting themselves as suitably majestic. In an era of constant plots against the throne and threats of treason, it was also wise for the aristocracy to avow their allegiance, by using the Tudor rose motif, by commissioning lavish portraits of the monarchs, and by getting in step with the 'new learning' fashionable at Court.

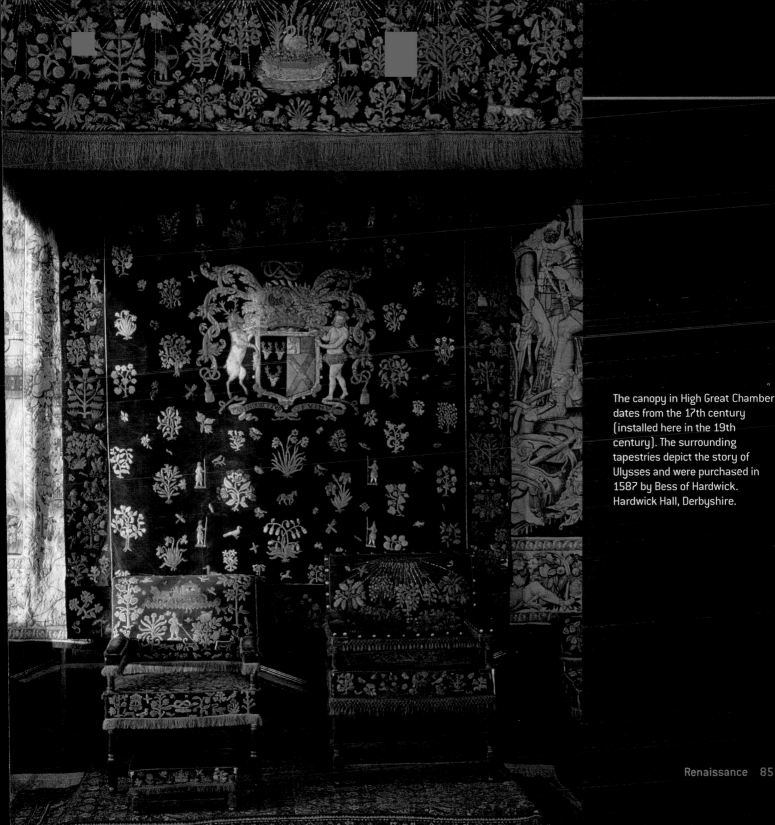

The canopy in High Great Chamber dates from the 17th century (installed here in the 19th century). The surrounding tapestries depict the story of Ulysses and were purchased in 1587 by Bess of Hardwick. Hardwick Hall, Derbyshire.

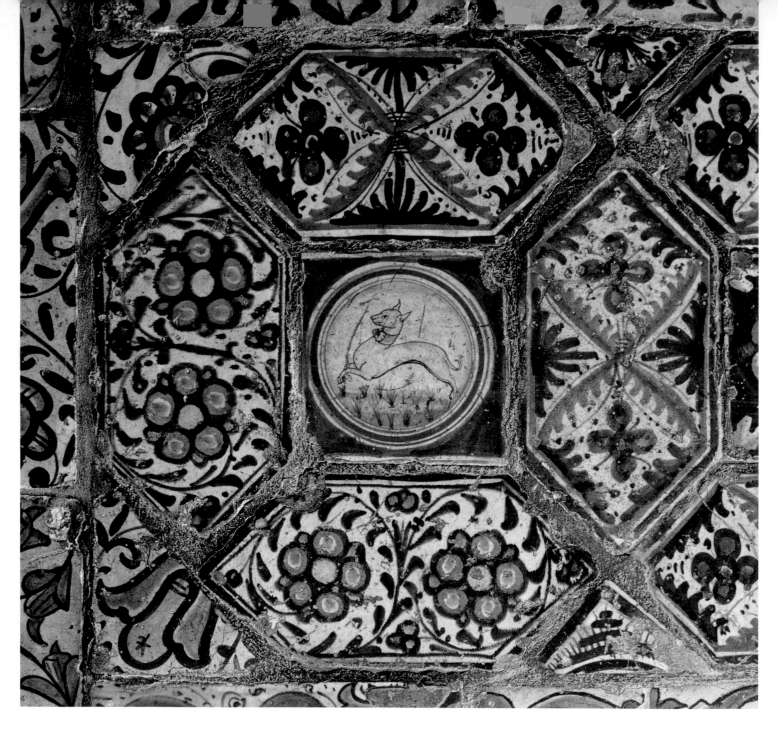

Majolica (tin-glazed earthenware) floor tiles from c. 1520–22 in the Chapel at The Vyne, Hampshire.

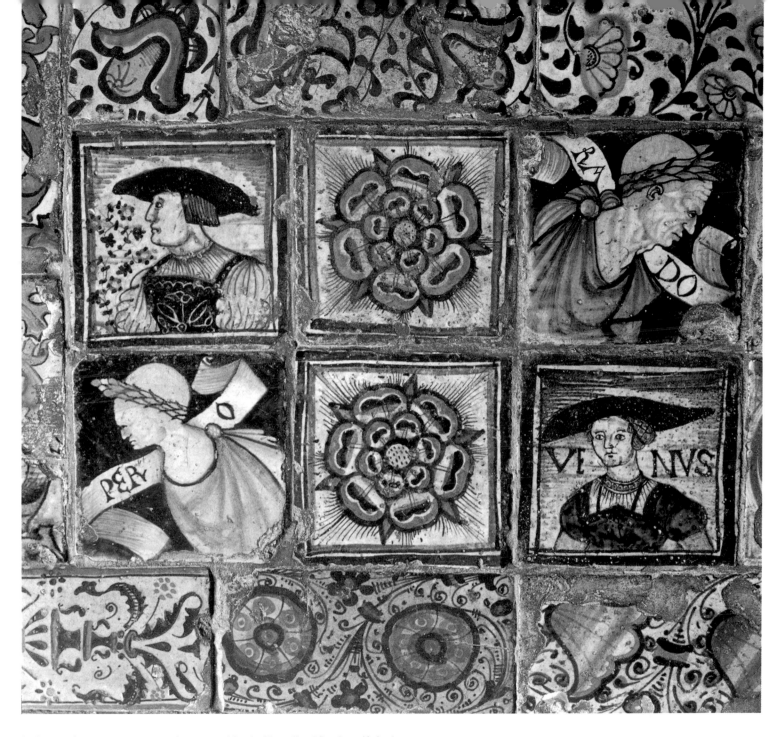

Antique and contemporary portraits are combined with stylised floral motifs in the Flemish floor tiles in the Chapel at The Vyne, Hampshire.

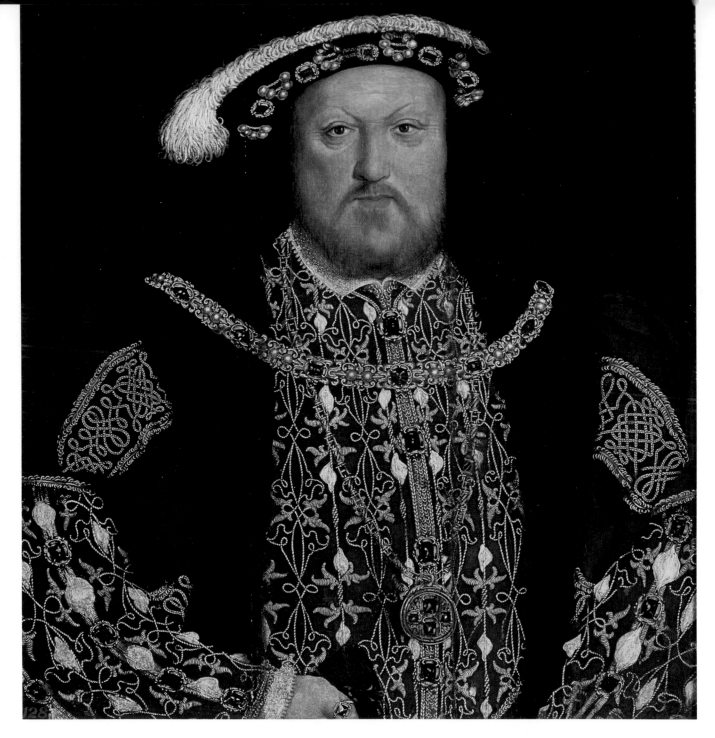

Henry VIII after Hans Holbein, in the 'O' Room at Blickling Hall, Norfolk.

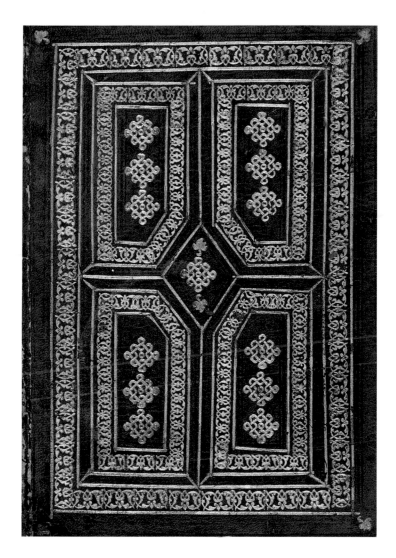

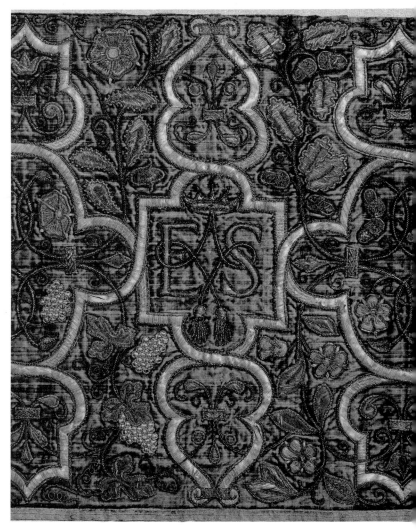

Tooled and gilded leather binding of *The Prince*, by Niccolò Machiavelli, which was first published in 1532. This book was written to provide practical advice on governance to both hereditary rulers and ambitious men who wanted to seize or consolidate power. As such, it was one of the most influential books ever written on politics, and banned in Elizabethan England. Charlecote Park, Warwickshire.

Late 16th-century embroidered cushion cover of crimson velvet with applied floral stems. The initials 'ES' stand for Elizabeth, Countess of Shrewsbury, otherwise known as 'Bess' of Hardwick. Hardwick Hall, Derbyshire.

GRANDEUR

'A taste for the grandiose, like a taste for morphia, is, once it has been fully acquired, difficult to keep within limits.'

OSBERT LANCASTER, *HOMES SWEET HOMES*, 1939

In the grandest historical buildings, pattern has always been used in luxurious schemes to create sophisticated settings. These interiors, carefully created as a unified whole, speak volumes about the aesthetic tastes of the client, but they are also signify his or her social status, whether already achieved or just within reach. Opulent materials and consummate craftsmanship, careful allusions to distinction and connoisseurship, all indicate social ambition carried on through the means of interior design.

Grand Patterns

The grandest patterns combine intricacy of design and intense attention to detail. They would be applied to 'statement' pieces, which were designed to be placed where they would best be seen and most appreciated, such as guest bedrooms, formal dining rooms and entrance halls. Vibrant colour combinations attracted the eye and impressed the visitor.

Grand materials and techniques

There are those materials that are innately impressive, such as tapestry, which has been used in opulent settings since the Middle Ages. It was chiefly desirable for its durability, warmth and decorative potential, and much in demand for bed and wall-hangings, screens and cushion covers. Until the 19th century, all tapestry was hand-woven on looms with bobbins. As many as 300 different colours might be used in any single tapestry. The designs and patterns were intricately created, often featuring complex scenes from the Bible or mythology. Costly and time-consuming to make, sets of tapestries were rightly valued as heirlooms and status symbols.

Inlaid stone and woodwork was also greatly admired in the grander households; pietra dura, scagliola, marquetry and parquetry all provided opportunities to ornament furniture and flooring to great decorative effect.

But perhaps no other material or texture is so evocative of 'the grand manner' as the colour gold. In the form of gilding, brass inlay, gold leaf or lacquer, the colour gold has a rich sumptuousness, which lends itself to intricate pattern-making.

Grand Apparel

Lavish settings provided a sumptuous background for the inhabitants, who similarly needed sartorial splendour to indicate their social standing. 'Broderers' (embroiderers) and court dressmakers of former ages combined technical expertise with impressive design creativity.

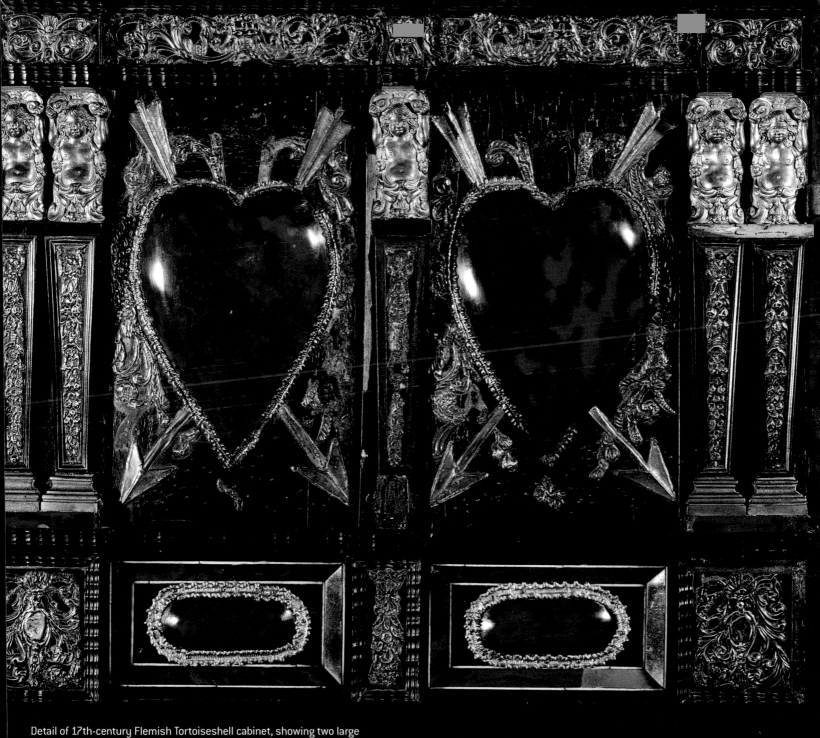

Detail of 17th-century Flemish Tortoiseshell cabinet, showing two large
hearts with crossed arrows, Charlecote Park, Warwickshire.

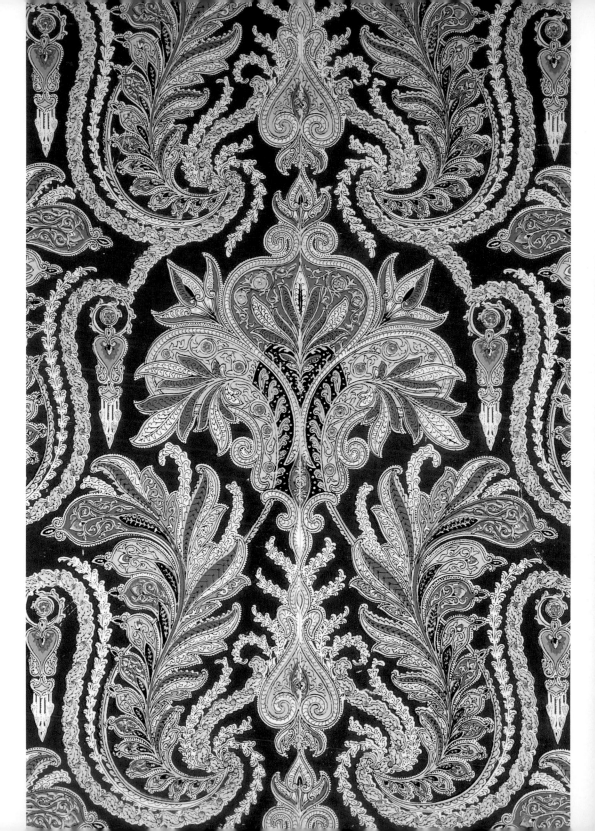

Patterned wallpaper in the Red
Room at Mottisfont Abbey,
Hampshire.

Detail of the cover on a William and Mary walnut chair in a contemporary foliage and floral pattern. The quality and texture of the hand embroidery makes this a very luxurious item. Clandon Park, Surrey.

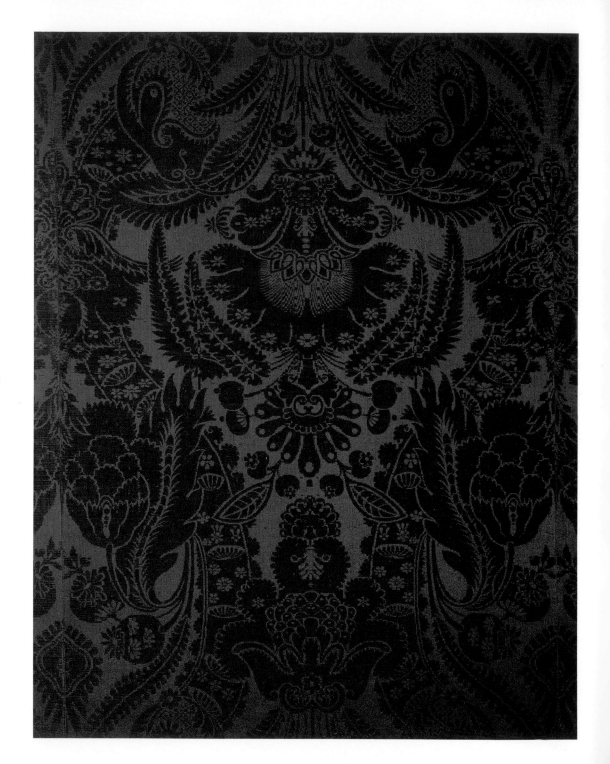

Detail of crimson silk damask wall covering added to the drawing room by Admiral Lukin in 1824. Felbrigg Hall, Norfolk.

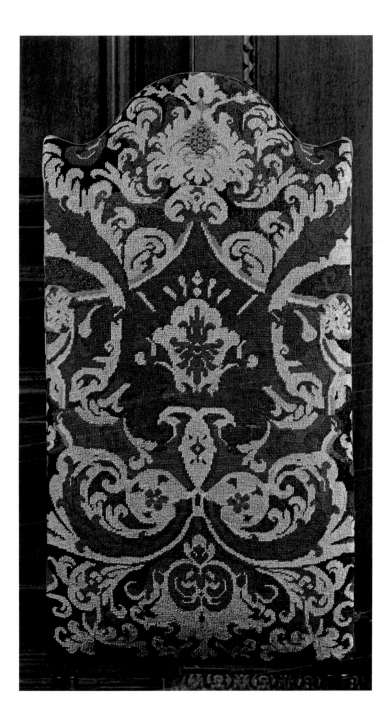

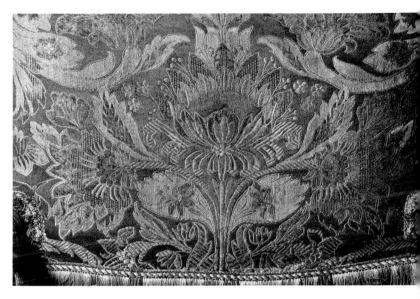

Detail of the fabric from one of the silk damask-covered chairs in the Long Gallery. Ham House, Middlesex.

Detail of the embroidered upholstery of a walnut chair, one of the set of late 17th-century walnut chairs and settees in the Entrance Hall. The bold pattern of vivid cream, red and blue has only survived because the chairs have been protected from UV light by loose covers. Dudmaston, Shropshire.

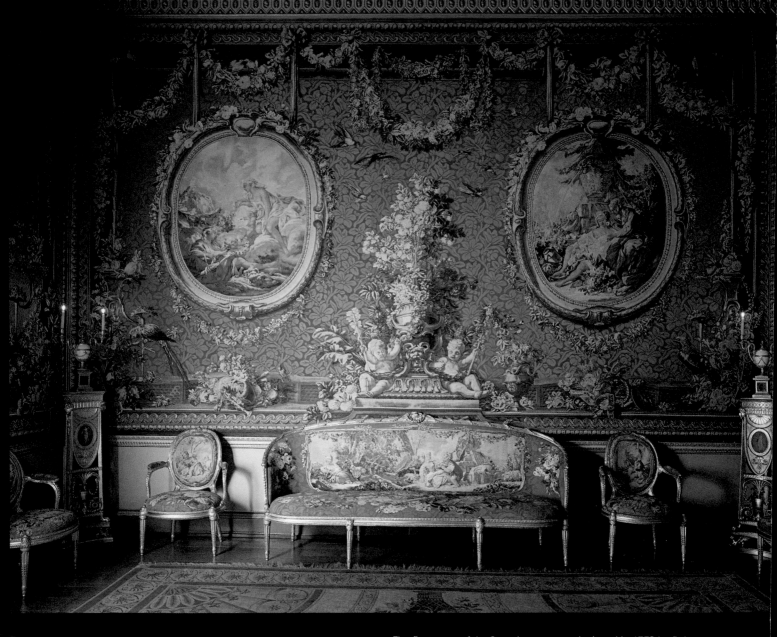

The first room of the State Apartments, designed in 1772 by Robert Adam for Robert Child. A set of Boucher medallion tapestries was ordered from the Gobelins factory in France. The armchairs and the sofa are upholstered in a similar tapestry, originally created for Madame de Pompadour in 1751–53. Osterley Park, Middlesex.

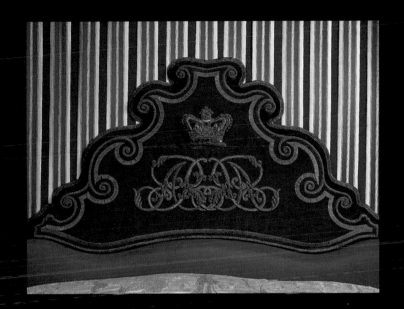

Detail of crimson velvet headboard decorated with Queen Adelaide's monogram in silver embroidery. The Queen's Bedroom was decorated in 1841 and the crimson and ivory striped silk of the bed hangings has been re-woven to match the original moiré striped silk. Belton House, Lincolnshire.

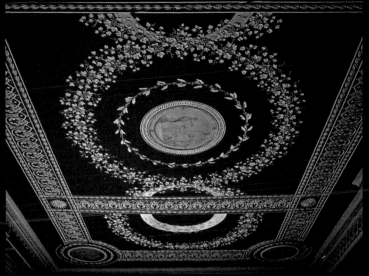

Detail of the plasterwork ceiling in the Dining Room designed by George Steuart in the 1780s with wreaths and vine leaves in gold and Pompeian red. Attingham Park, Shropshire.

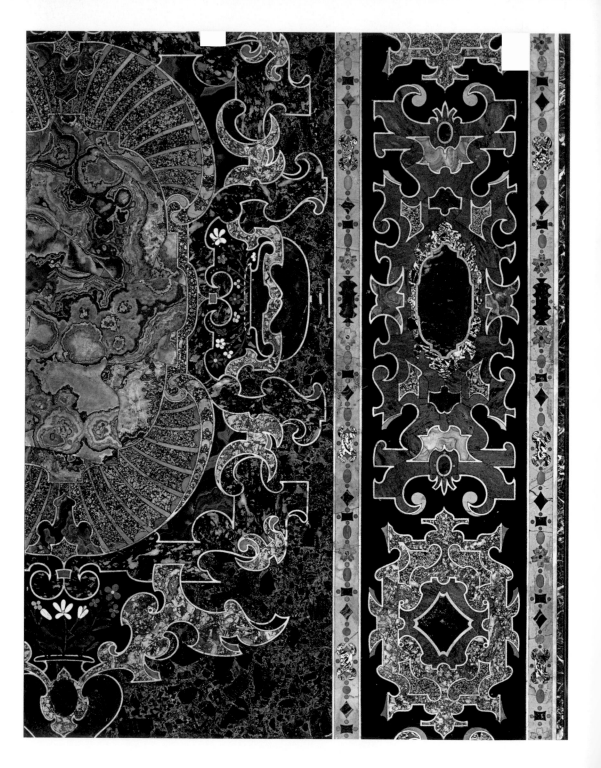

Detail of the Lucy table with 16th-century Italian pietra dura top, purchased in 1823 from Thomas Emmerson by George Hammond Lucy. Charlecote Park, Warwickshire.

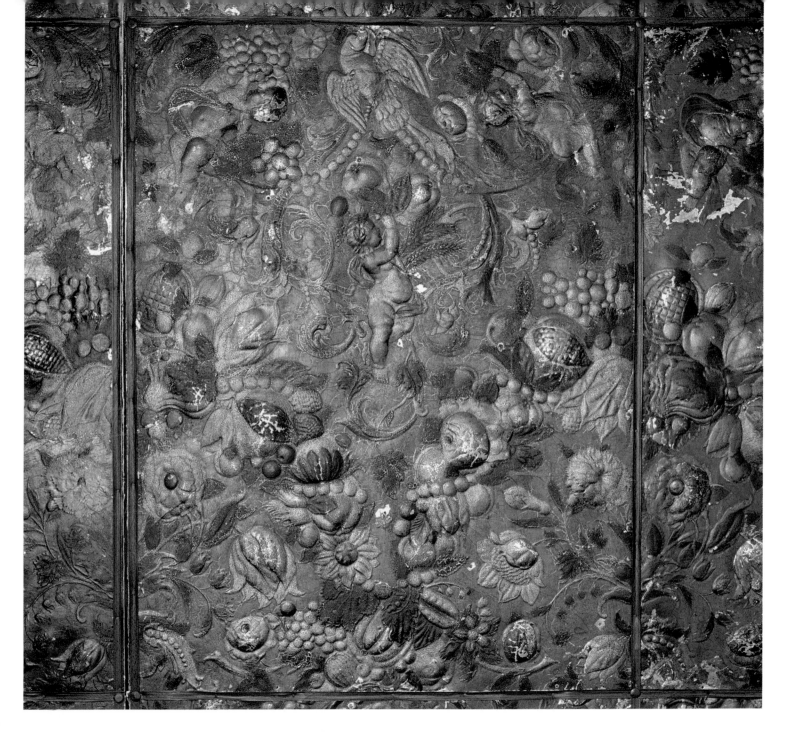

Embossed leather panelling, bought in The Hague, and installed in
1702. Dyrham Park, Gloucestershire.

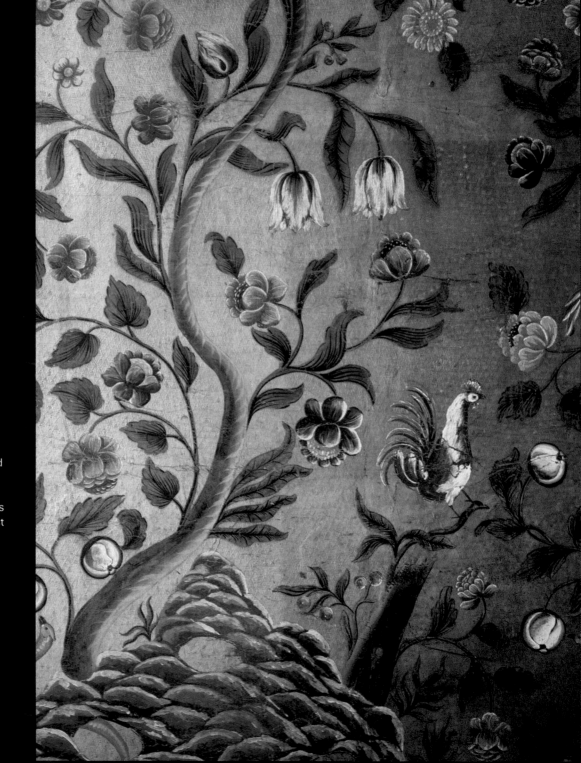

Detail of early 18th-century English 'Cordoba' leather wall hanging in the Dining Room. Calf leather sections are covered with silver foil, which is then varnished to simulate gold. The design is later hand painted in oil. A letter from Rudyard Kipling describes its purchase in 1902. Bateman's, East Sussex.

Embossed and gilded leather wall covering, bought from the Palazzo Contarini in 1849. Kingston Lacy, Dorset.

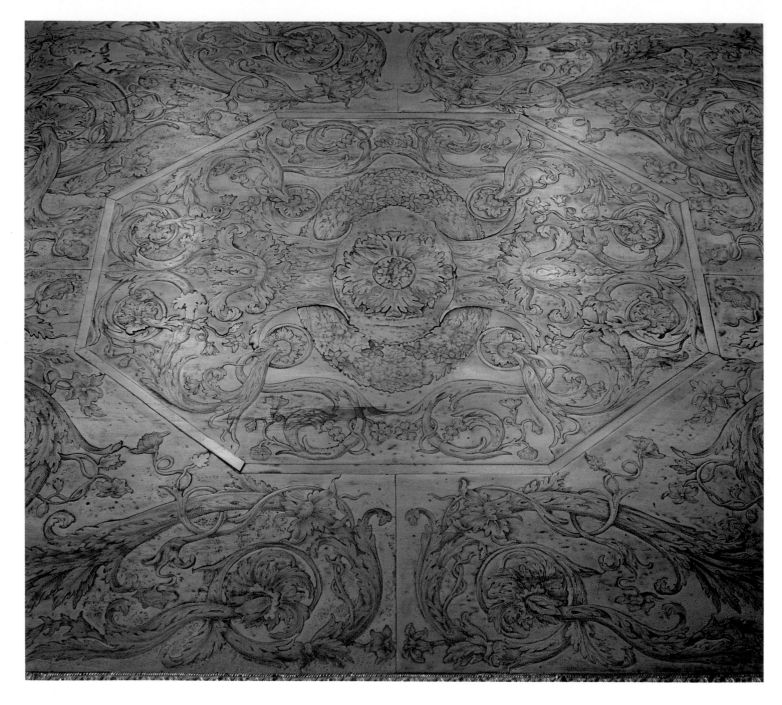

A detail of the gilt table in the Cartoon Gallery, thought to have been given to the 6th Earl of Dorset by Louis XIV in 1670–71. Knole, Kent.

The Holy Bible with the Book of Common Prayer, John Baskett 1712–13.
Cover in red morocco with gilt panels. Anglesey Abbey, Cambridgeshire.

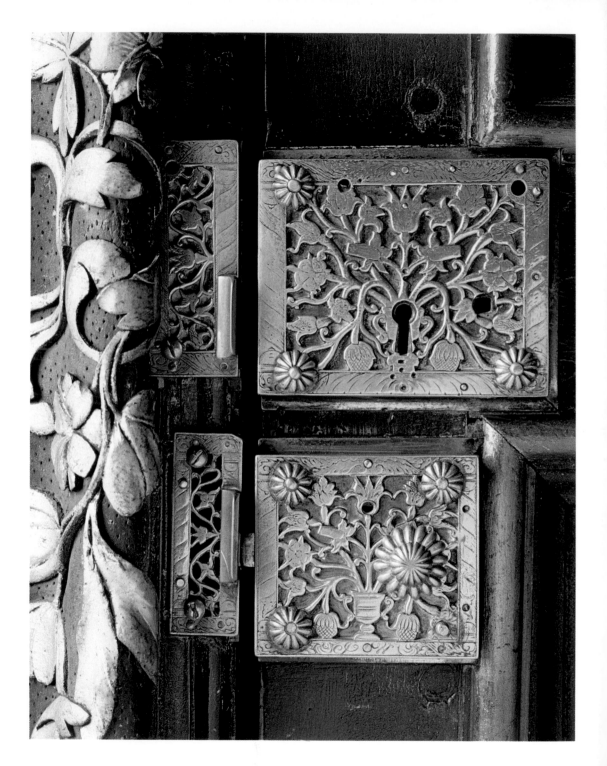

Brass door locks, pierced and engraved with scrolling and tulips, daffodils, roses and strawberries, probably made by John Wilkes of Birmingham, c. 1690.
Dyrham Park, Gloucestershire.

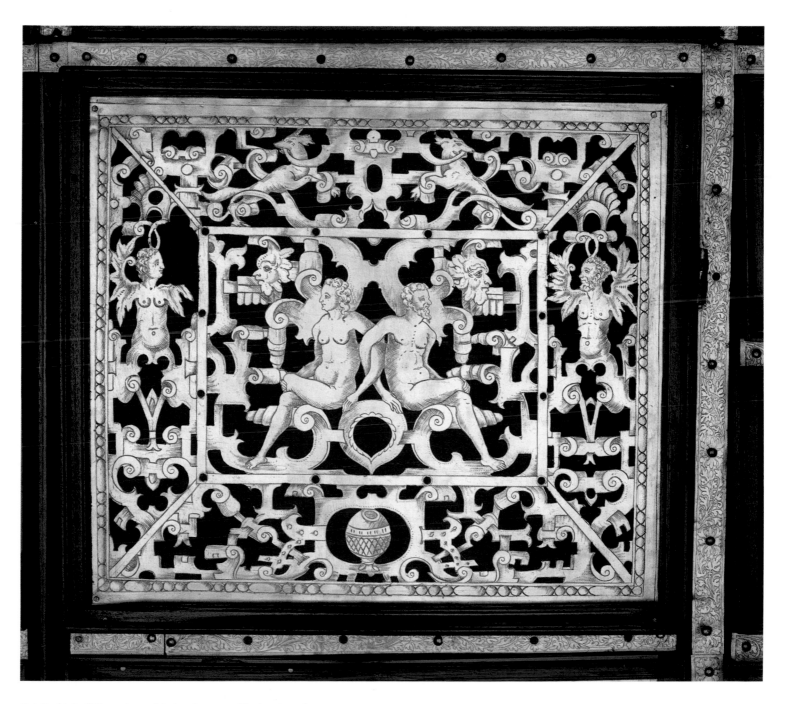

Detail of late 16th-century gilded and engraved fretwork on the
Franco-Flemish cabinet in the Picture Corridor. Polesden Lacey, Surrey.

From its Italian origins, the exuberance of Baroque style subsequently swept across Europe throughout the latter half of the 17th century and the early part of the 18th century. British artists and craftspeople were quick to adopt the new ideas, inspired by patterns and motifs newly available through the medium of printed books. Political and religious upheavals in the Low Countries and France led to a diaspora of Protestant refugees, many of them highly skilled craftspeople, who settled in the British Isles and brought their aesthetic ideas along with their households.

Domestic interiors became more physically comfortable, even opulent, as the flourishing merchant classes grew in prosperity under the Stuarts and the House of Orange. After the trauma and upheaval of the Civil War and the eventual Restoration of Charles II, there was a general mood of relief at the return of internal peace, and the rapid growth of trade with the outside world.

The Baroque style, as found in Britain, is largely divorced from the religious overtones of its Italian roots. In fact, it is both secular in theme and worldly in appearance. It is typified by a sense of drama, a celebration of the ornate and brightly coloured. Patterns are frequently symmetrical in layout with large-scale repeats, and rely for effect on abstract arabesques and curlicues.

Baroque settings revel in luxurious fabrics, such as brocades and velvets, damasks and silks. Upholstery became popular, armchairs being a status symbol, covered in leather, embroidery or tapestry. Gilt-wood and impressive marquetry furniture are evidence of a new sense of self-confidence and a desire to impress. The motifs and themes used owe something to classicism, and imply a degree of intellectual knowledge and sophistication. There were also the beginnings of an interest in the 'unknown' world, sparked by trade and early contacts with other cultures beyond that of Western Europe, such as China and India.

Rococo

The Rococo style was a lighter counterpoint to the disciplined severity of neo-classicism, and the more opulent and dignified style of baroque; it was fashionable in Britain from about 1730 to 1770. The name is derived from the French word 'rocaille', meaning the rock or shell motifs that often featured in its designs. Rococo spread from Europe, particularly France, but in Britain it was occasionally coupled with 'Gothick' style, a romanticised revival of elements of gothic style, ogee arches and quatrefoils.

Rococo featured decorative motifs and influences in an exotic, even frivolous style. It first appeared in Britain in informal buildings such as tea pavilions and garden grottoes, though it was was used primarily in interior decoration, and on furniture, silver and ceramics, rather than architecture, perhaps in recognition of its somewhat ephemeral associations.

The Rococo style relied for its effect on highly imaginative interpretations of chinoiserie, Turkish and Indian figures, coupled with flowers and foliage, and light scrollwork. Occasionally classical or even mythological themes might be introduced, but always with a sense of vibrant movement and sinuousness. In its more extreme forms, there was also an element of asymmetry in design, which emphasised the 'natural' or organic origins of the style.

Delicate swags and garlands, often moulded in plaster or carved in wood, were a key feature of Rococo design. Curlicues and arabesques reached their most extreme, etiolated and ornate forms.

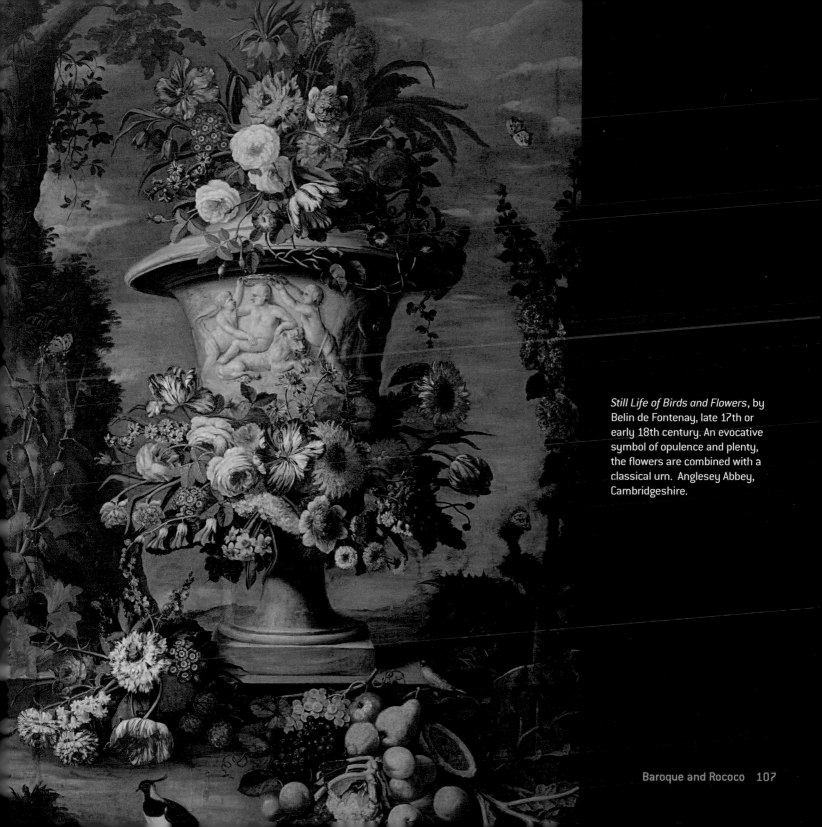

Still Life of Birds and Flowers, by Belin de Fontenay, late 17th or early 18th century. An evocative symbol of opulence and plenty, the flowers are combined with a classical urn. Anglesey Abbey, Cambridgeshire.

Top of Boulle bureau in the Louis
XIV style, dated 1690. Felbrigg
Hall, Norfolk.

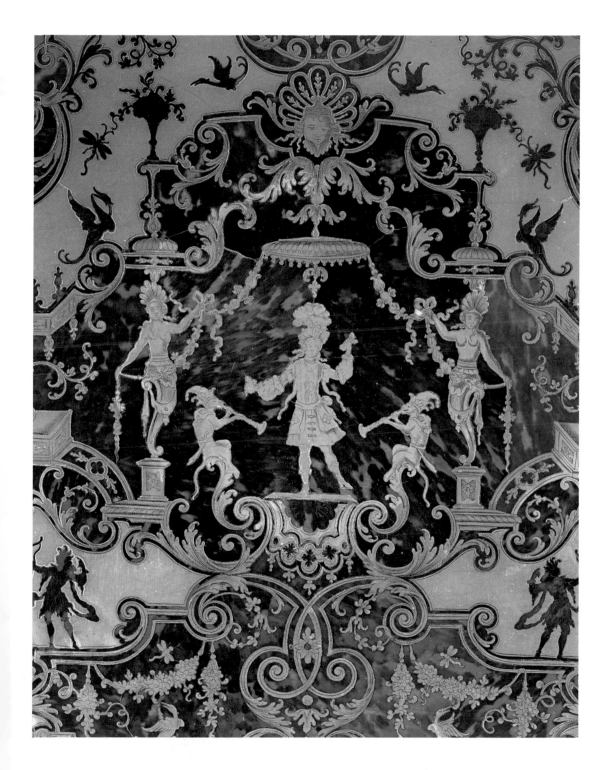

Close detail of the top of the Louis XIV Boulle writing table, with tortoiseshell and brass inlay, known as a bureau Mazarin. Belton House, Lincolnshire.

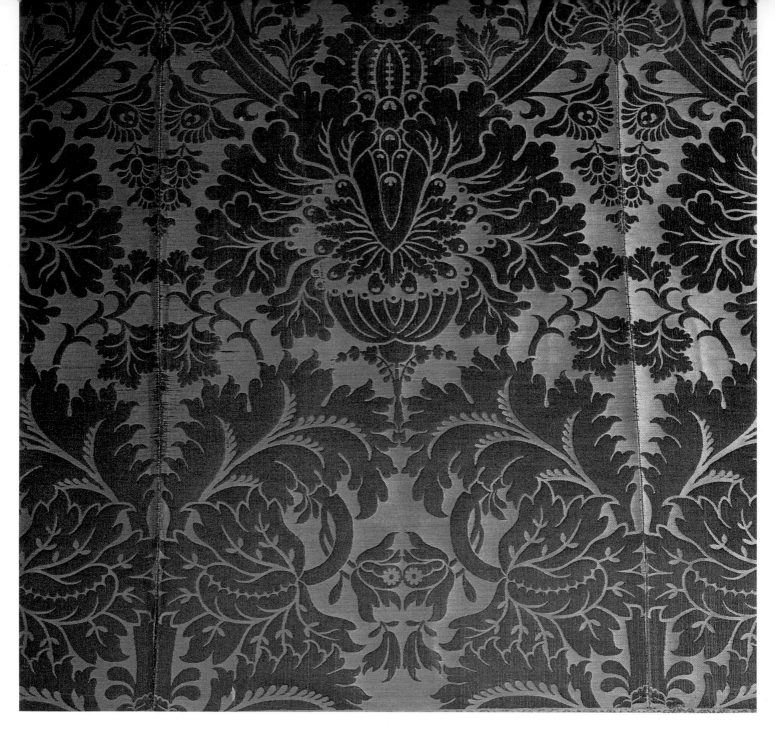

A rare survival of luxurious silk and linen brocade wall hanging, c. 1730. The Vyne, Hampshire.

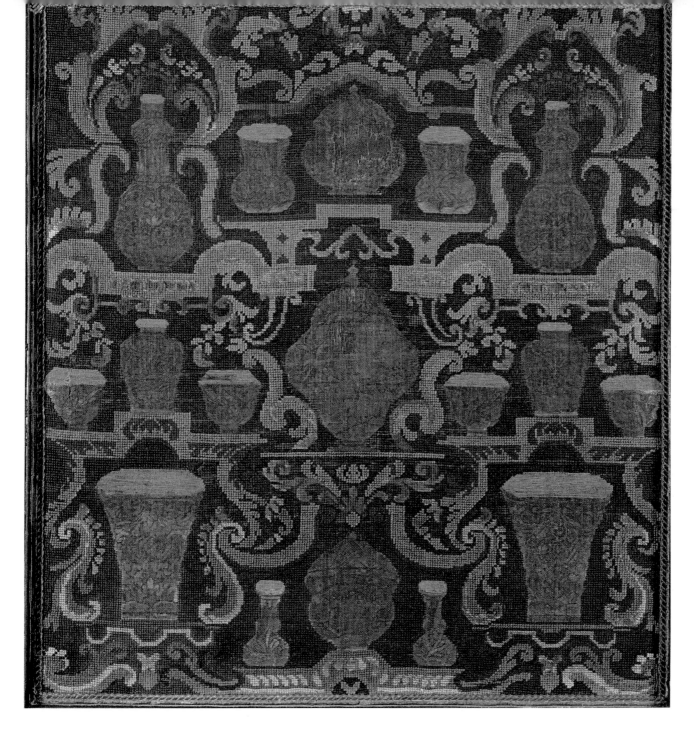

A late 17th-century firescreen in tapestry, depicting an elaborate symmetrical pattern of exotically shaped ceramics. Treasurer's House, York.

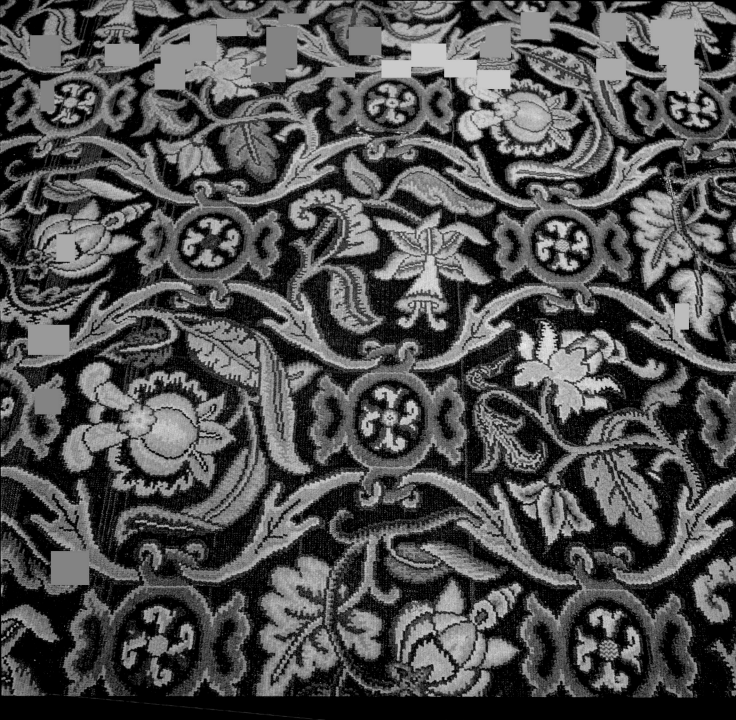

Part of an early 17th-century carpet, a rare example of English turkey-work, in imitation of the motifs and materials of the Middle East. Knole, Kent.

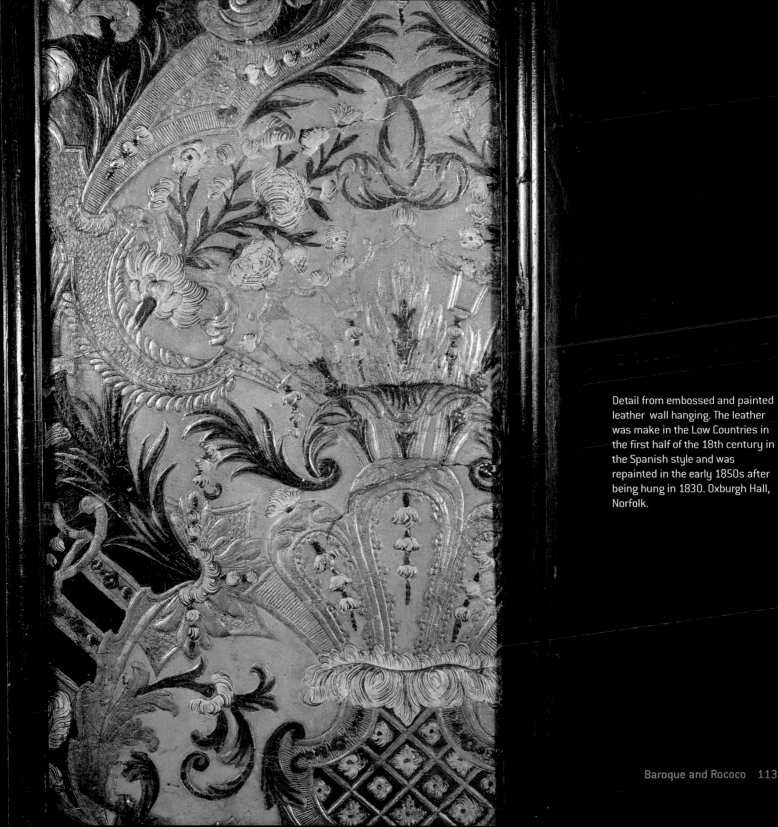

Detail from embossed and painted leather wall hanging. The leather was make in the Low Countries in the first half of the 18th century in the Spanish style and was repainted in the early 1850s after being hung in 1830. Oxburgh Hall, Norfolk.

Detail of *Les Deux Pigeons* wallpaper made c. 1780 by Reveillon, the leading French wallpaper manufacturer of his day. Clandon Park, Surrey.

A detail of a gilded cherub face and surrounding Rococo decoration and gilt wood from an early 18th century scheme in an Italian palazzo. Polesden Lacey, Surrey.

Detail of a section of plaster scrollwork in the Staircase Hall. The pattern was probably taken from Swan's *Pattern Book* of 1757. Castle Ward, Co. Down.

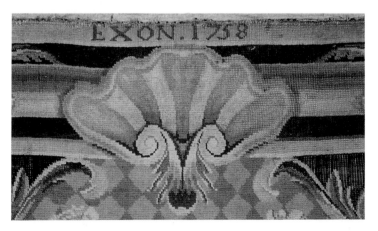

Detail of the Exeter carpet, 'Exon 1758', on the Grand Staircase at Petworth House, Sussex.

Chinese goods were widely available throughout Europe by the 17th century, brought by enterprising Western merchants trading with their Chinese counterparts in Canton. Silks, embroideries, wallpapers, lacquer and ceramics from the period are frequently found in the interiors of country houses across Europe. The trading success of the Honorable East India Company brought to Britain shiploads of Chinese commodities, and inspired a taste for the Oriental that is still evident today.

The majority of the earlier imports were highly decorative. They were desirable because of their perceived novelty value, but also in appreciation of their fabulous workmanship and 'exotic' patterns. Initially, the purchasers were happy to use them merely for decorative effect, in conjunction with more familiar artefacts.

The distinctive patterns and motifs of Chinese imports became wildly popular throughout fashionable Europe. China had a great tradition of decorative painting, whether on textiles or on large paper panels for hanging scrolls or for mounting on screens, but no indigenous history of wallpaper as it is known in the West. The centre of manufacture was Canton, and the earliest examples consisted of single rolls decorated with vertical panels, usually of plants and birds. As they had a uniform background colour, one roll could be applied next to another to give an overall effect, and trimmed at the top or bottom to fit individual rooms. The earliest examples reached Europe in the 1690s, and in 1775 a single ship of the East India Company brought 2,236 pieces of paper hangings to London.

More complex patterns developed, with complete schemes for covering entire rooms. Each roll would be numbered so that the pattern appeared to be continuous. Panoramic pastoral scenes of figures in a landscape or garden were popular for handpainted wallpapers, and in demand for decorating bedrooms and boudoirs. Human figures set against architectural features such as pagodas and bridges followed the Chinese artistic tradition of defying the laws of perspective, which enhanced their suitability for pattern-making over a large area.

The visual vocabulary of Chinese export art offered a new source of inspiration to Western patternmakers, but usually they were unaware of the symbolic significance of popular iconography. Some are self-evident – blossom obviously signifies the coming of spring, but prunus blossom depicted with a 'cracked ice' background symbolises the finding of love in later life. The crane symbolises patience and fortitude; a pair of mallards stand for marital fidelity and devotion, and gnarled trees represent wisdom acquired through experience. By contrast, butterflies are associated with ephemerality and frivolity, while the lotus flower, growing out of mud, is a Buddhist-derived symbol of gradual enlightenment.

Western makers began to see Chinese arts and artefacts as valuable 'raw material' for their own products. The fashion for 'chinoiserie' (derived from *chinois,* the French word for Chinese), imitations and adaptations inspired by art and design from China, Japan and other Asian countries led many British designers and craftsmen to imitate Asian designs and to create their own fanciful versions. The style was at its height from 1750 to 1765, but continued as a recurring theme well into the 1920s.

Furniture-makers would include genuine Chinese components in their cabinets, or commission 'japanned' panels from Oriental lacquer-workers. Abstract Oriental patterns and typical colour schemes were much appreciated in 18th-century drawing rooms.

In the field of interior design, entire room schemes were devised to reflect the fascination with the Celestial Empire. Chinese-inspired ornament provided an exotic and even witty alternative to the prevailing rococo and neo-classical styles.

Chinoiserie patterns influenced more ephemeral forms of the decorative arts; the asymmetric disposition of design, stylised landscapes and mysterious robed figures were reinterpreted by some of the makers of the most luxurious goods available in Europe.

Detail from the 18th-century Chinese wallpaper in the Chinese bedroom. The wallpaper was not put up until around 1840 and is decorated with a continuous scene of a garden party running along the bottom part with birds and butterflies in the trees futher up (see page 122 for whole wall). Belton House, Lincolnshire.

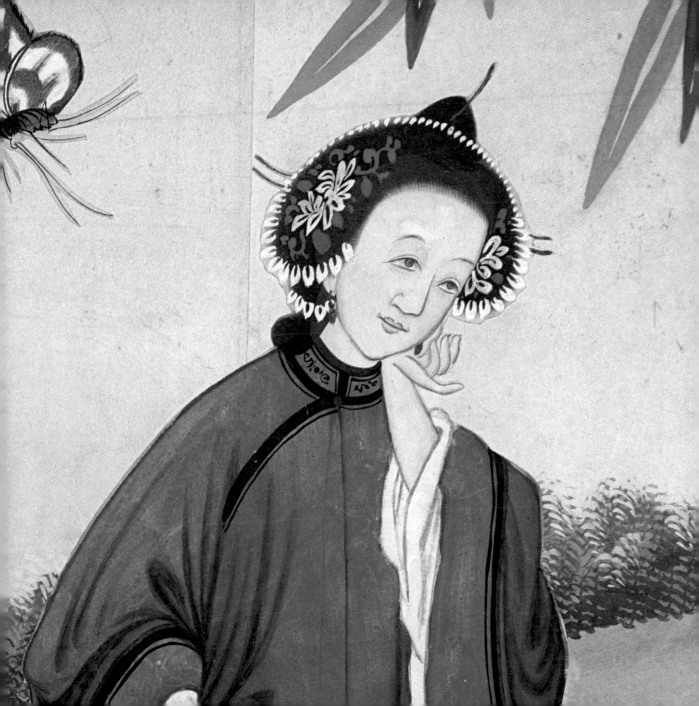

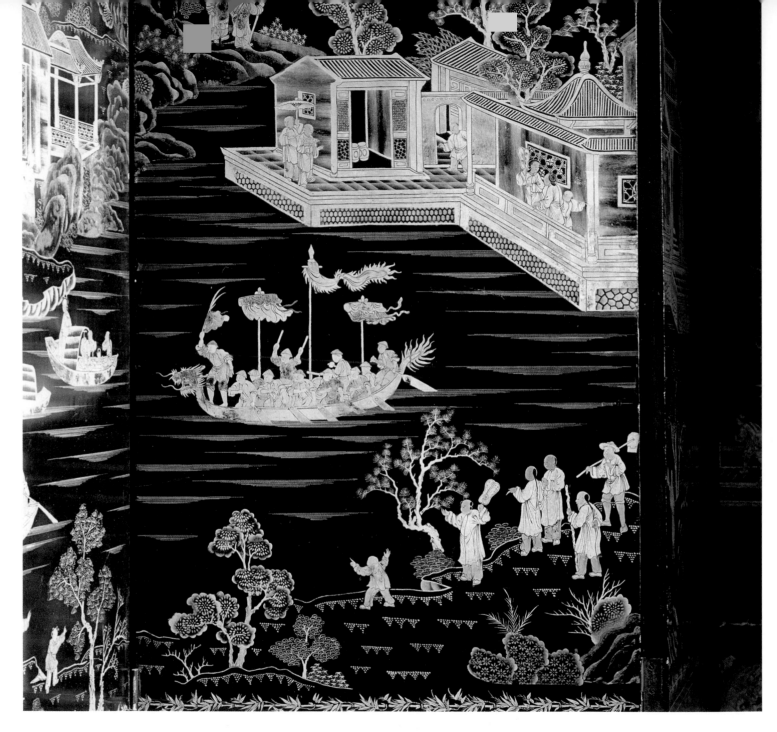

Black-and-gold lacquered, 18th-century Chinese screen in the
Entrance Passage. Sudbury Hall, Derbyshire.

The top of a 19th-century Japanese worktable in black and gold
lacquer. Castle Ward, Co. Down.

Detail of a coromandel (carved lacquer) screen, early 18th century. Felbrigg Hall, Norfolk.

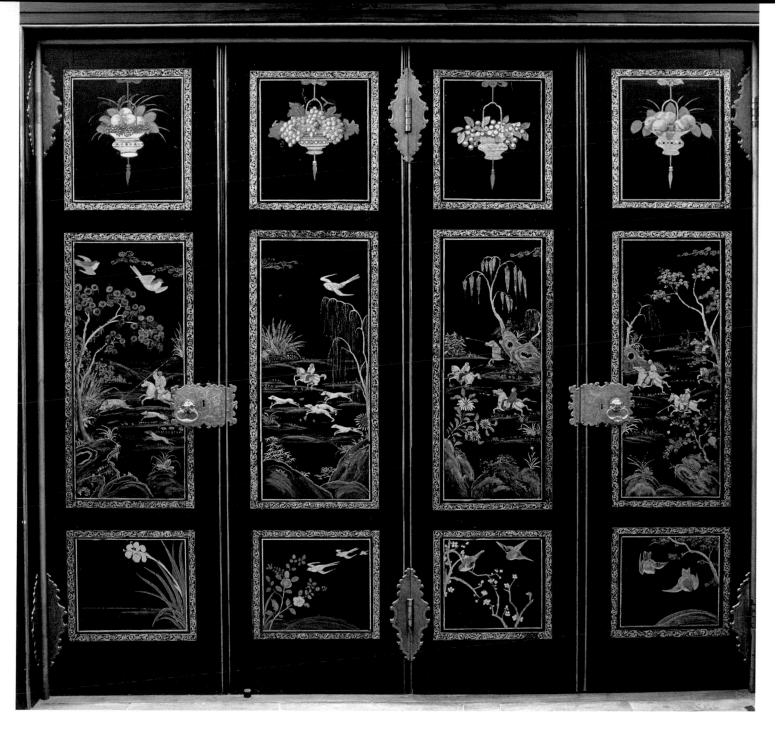

Chinese lacquer screen in the Staircase Hall. The screen disguises the asymmetry of the door to
the Music Room, which is not in the centre of the wall. Mount Stewart, Co. Down.

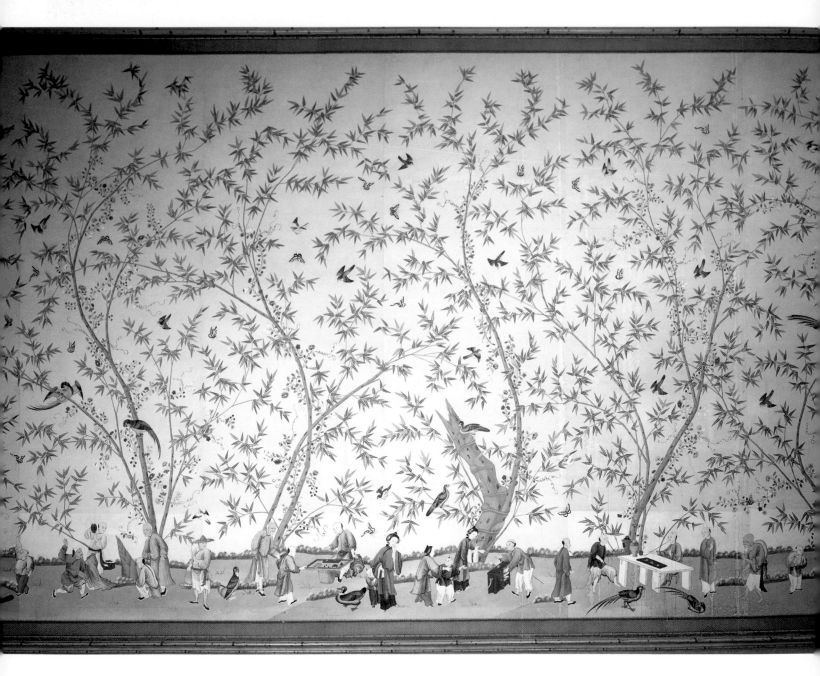

Hand-painted 18th century Chinese wallpaper with a continuous scene of a garden party. The cornice, dado and other joinery have been painted to imitate bamboo, adding to the Oriental effect. Belton House, Lincolnshire.

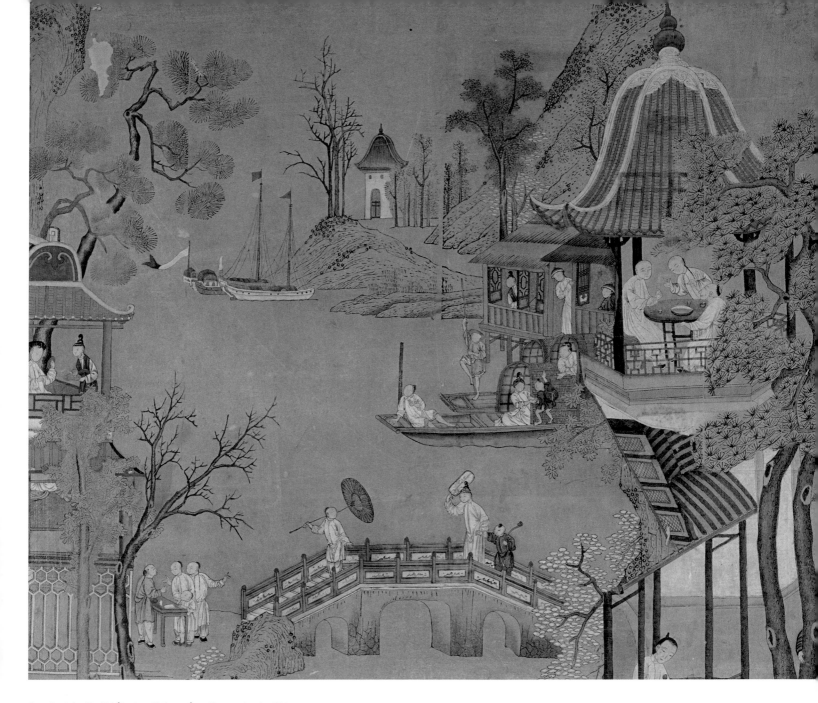

Detail of the 'India' (in fact Chinese) wallpaper in the Chinese
bedroom, hung when the room was remodelled in 1760.
Blickling Hall, Norfolk.

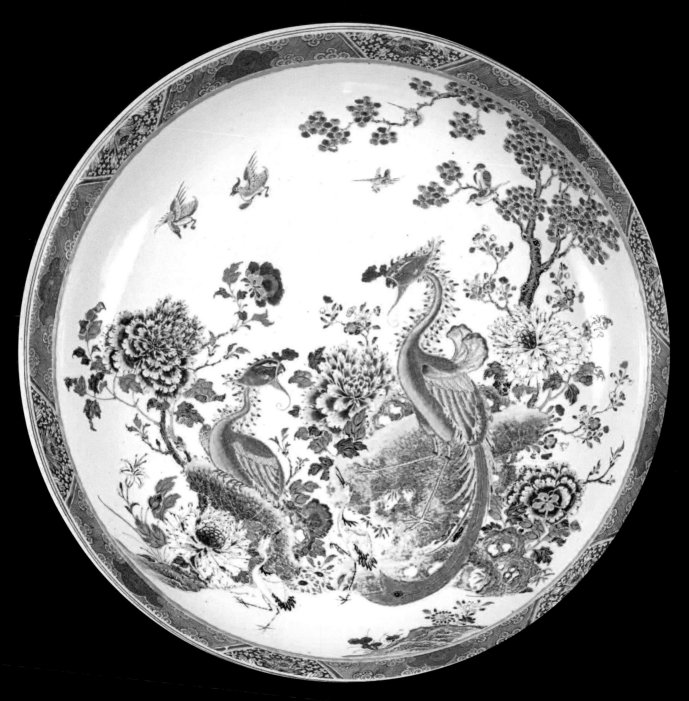

Famille rose porcelain dish from China; part of the cargo of a ship captured by the British off Manila in 1762. Melford Hall, Suffolk.

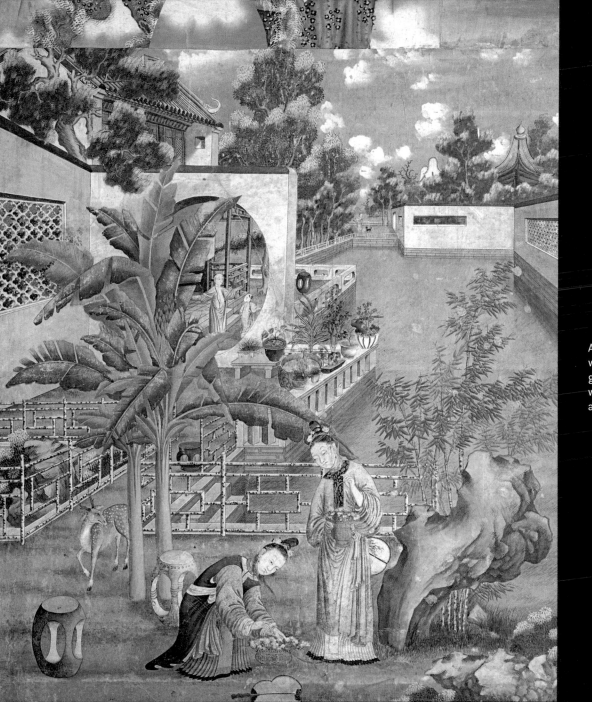

An 18th-century Chinese wallpaper depicting an idyllic garden with balustraded walkways and two ladies arranging flowers. Saltram, Devon.

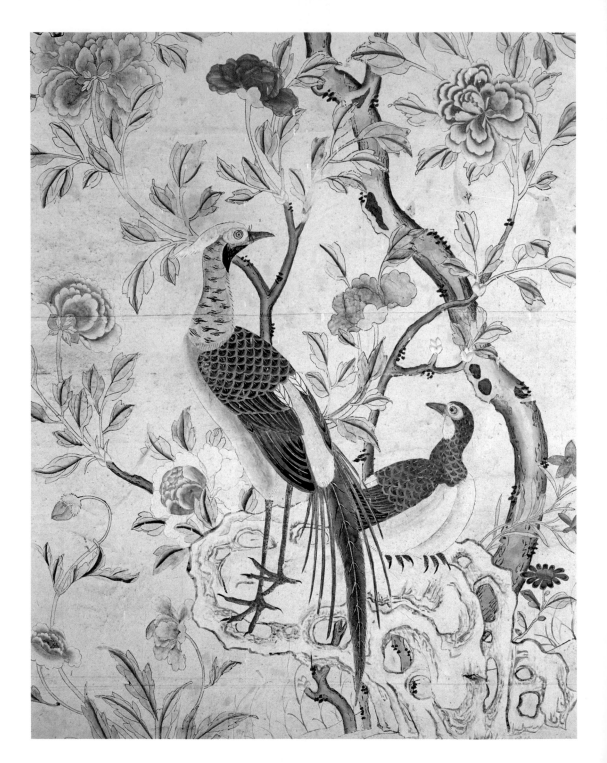

Detail of a mid-18th-century hand-painted Chinese wallpaper, depicting a pair of pheasants. Felbrigg Hall, Norfolk.

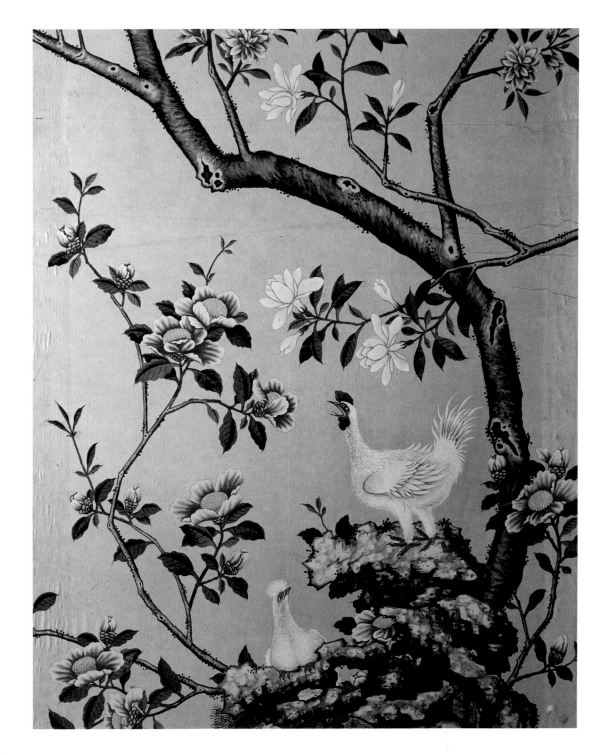

A 19th-century Chinese wallpaper, depicting a hen and a crowing cockerel in a flowering tree. Powis Castle, Powys.

A complex design of 'fine India paper' (although in fact Chinese) depicting birds, trees and flowers. Supplied in April 1771 by Thomas Chippendale for three rooms of the State Apartment that were being redecorated to a design by Robert Adam. Nostell Priory, West Yorkshire.

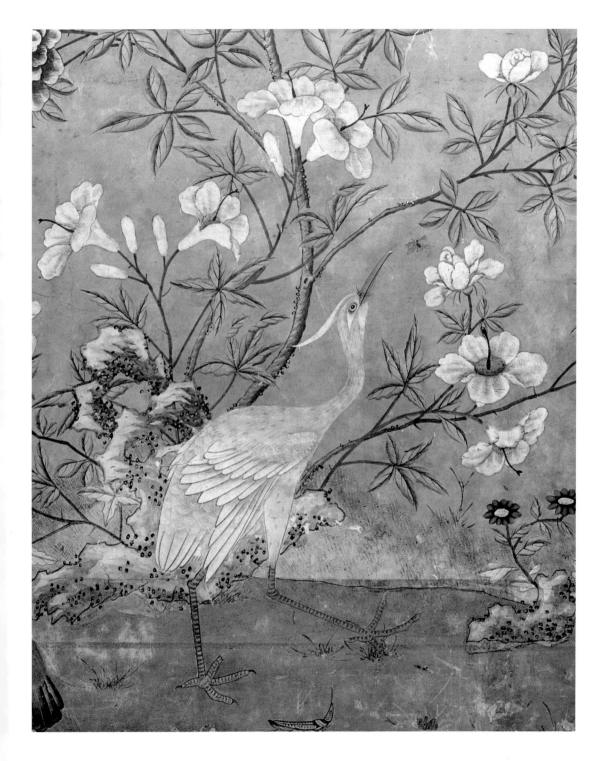

Detail of Chinese hand-painted wallpaper in the State Bedroom, depicting a crane and blossom. Hung when the room was redecorated in 1770, it being no longer fashionable to have bedrooms on the ground floor. The wallpaper was extensively damaged during the 1960s by water leaking through the ceiling and was carefully removed, conserved and rehung in the 1970s when the National Trust took over the house. Erddig, Wrexham.

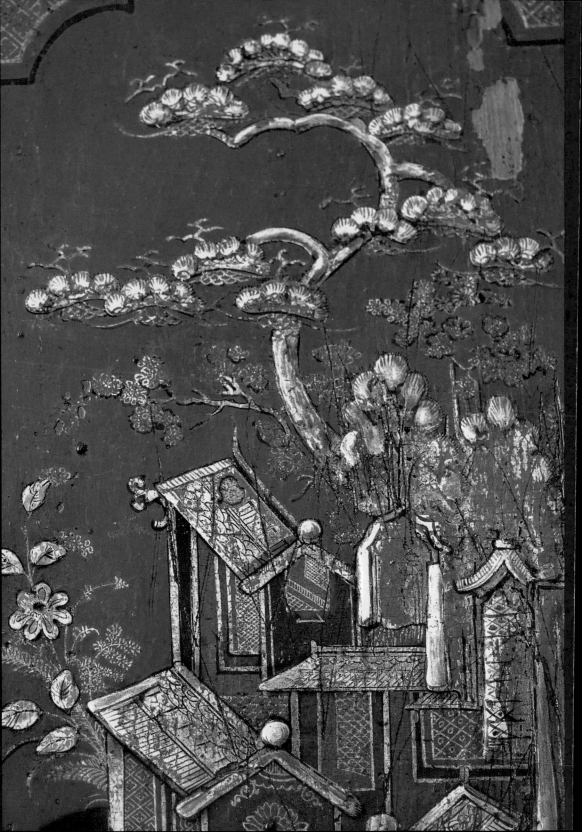

Details from the panels on an 18th-century French red lacquer cabinet. Snowshill Manor, Gloucestershire.

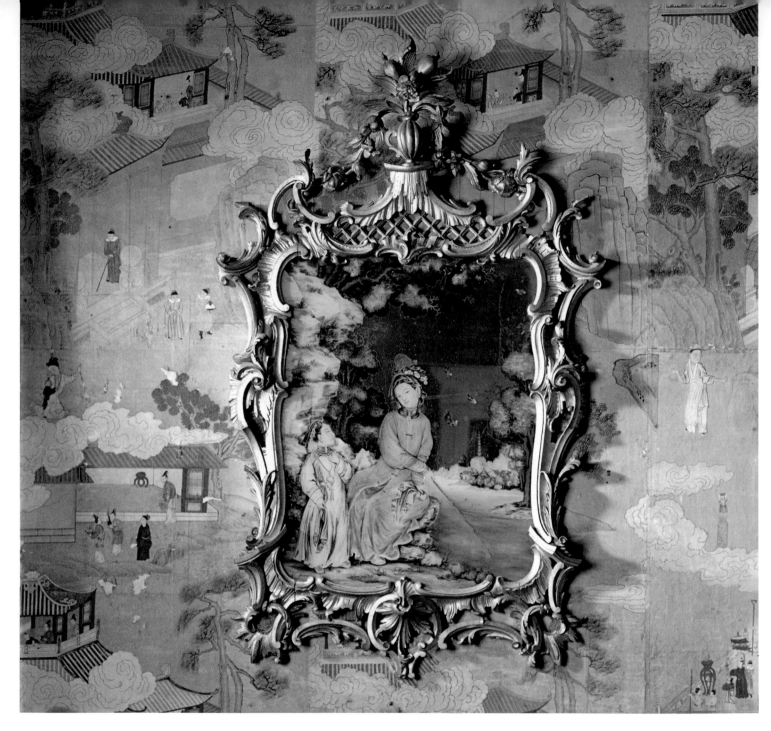

Mid-18th-century Chinese mirror painting hanging in a English rococo giltwood frame
against hand-painted Chinese wallpaper of approximately the same date. Saltram, Devon.

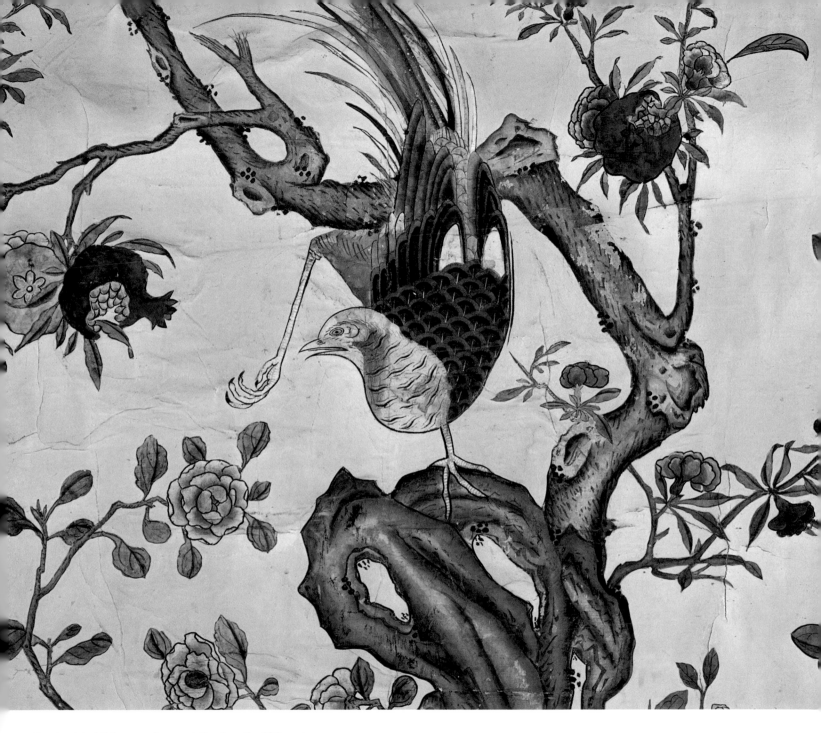

Hand-painted Chinese wallpaper dating from the 18th century,
but put up c. 1800. Ightham Mote. Kent.

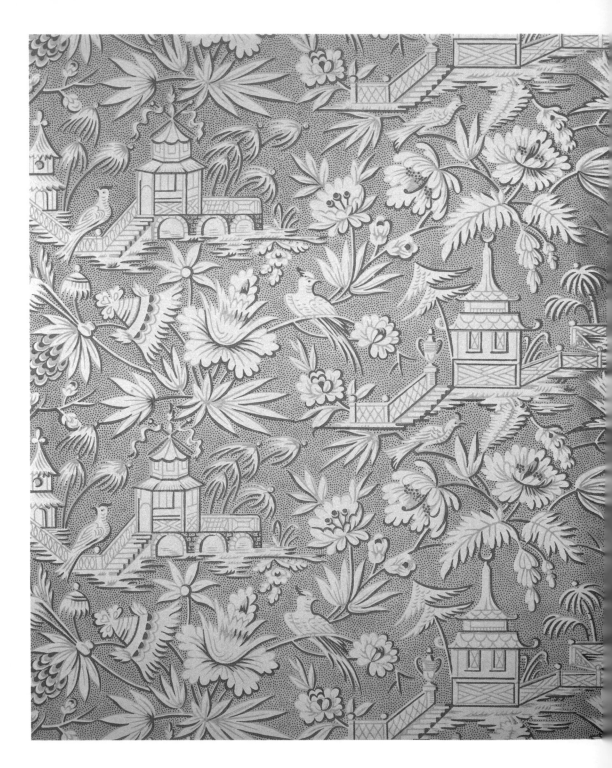

Detail of the wallpaper in the Bow Room. Copied from the 1807 original found intact behind the pier glasses, using old techniques of hand-printing with blocks. Castle Coole, Co. Fermanagh.

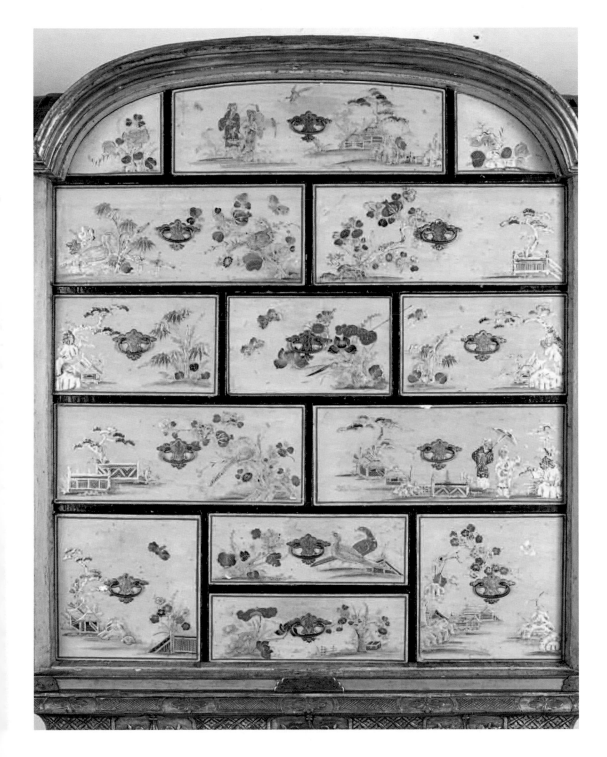

Interior of early 18th-century
japanned cabinet, decorated with
chinoiserie landscapes.
Upton House, Warwickshire.

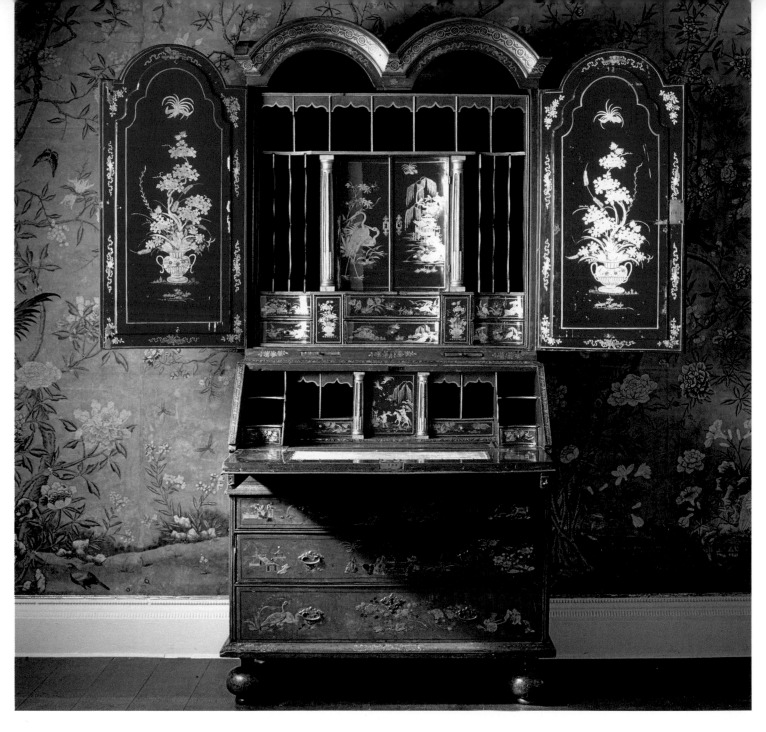

Red japanned bureau-cabinet, made in England c. 1720s. Chinese-inspired decoration adorns the insides of the doors and drawers. On the wall behind is the Chinese-patterned wallpaper described in more detail on page 129. Erddig, Wrexham.

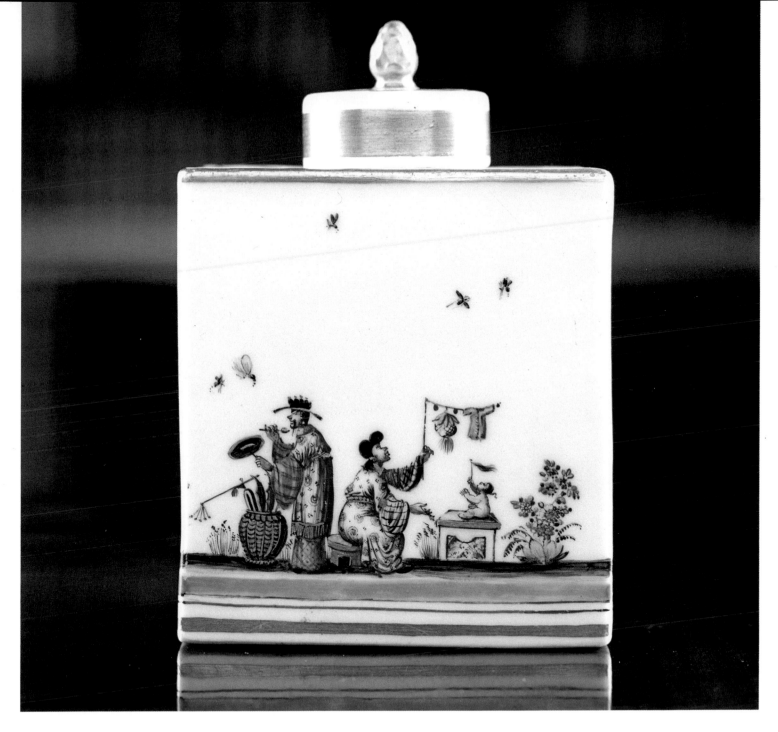

A tea caddy from the Furstenberg porcelain service c. 1770.
Polesden Lacey, Surrey.

The exotic East has long appealed to westerners, a romantic source of myth and mystery exemplified in the 'stately pleasure domes' of Coleridge's poem. But the 19th-century vision of the Orient was also a by-product of mercantile aspirations, the need to exploit the vast potential of Asian markets. As the nations of China and Japan were forced into trade with the West, new understandings of the aesthetics of the East spread.

The British fascination with the arts and artefacts of other cultures was a direct result of the nation's pre-eminence in world trade, and the products of other cultures poured in. Collectors' and connoisseurs' tastes reflected the concerns of Empire and trade. Architects and designers reflected the exuberance of exoticism. Landmark schemes, such as the Royal Pavilion in Brighton, with its three-dimensional fantasies blending Chinese and Indian motifs, made free use of the patterns, forms and colour schemes of those cultures, and the Prince Regent's seal of approval was given to eclecticism.

Egypt

In 1798, Napoleon's army landed in Egypt, in a surprise attempt to establish a power base in the Eastern Mediterranean and to disrupt British trade. From a military point of view, the campaign was a disaster, but illustrated accounts of all aspects of the country were subsequently published in 22 volumes as *Description de l'Egypte*. The result was the birth of Egyptology, as Europeans were astounded by the previously unknown splendours of the Ancient Kingdom. Connoisseurs and collectors vied for artefacts from Egypt, and designers were quick to respond to the new craze.

Middle East

The arts of the Islamic world became increasingly influential throughout Europe from the 1840s, but trade between Northern Europe and the Middle East dates back to Roman times. The complex religious and historical factors influencing the appearance of objects from Iran, Turkey, north Africa and southern Spain were seldom understood, but such works were genuinely admired for their technical and aesthetic brilliance. Colours, patterns and motifs from a variety of sources were used to create a composite 'Islamic' style.

Islamic decoration tends to consists of three main elements, which are often combined in the decorative scheme on a single object; calligraphy in various forms of Arabic script; arabesques, scrollwork and other floral or plant-like designs, and purely geometric forms in infinitely repeating patterns.

India

By the Victorian era, India was seen as the 'Jewel in the Crown' of the British Empire, both as an important market for home-produced goods, and as a source of products for the British market. The magnificent displays of Indian art and design shown at the Great Exhibition of 1851 and at subsequent exhibitions had a profound effect on a number of British designers and commentators in the second half of the 19th century.

Designs influenced by Indian art and architecture were extremely popular in the early 19th century. The renewed interest in the East was stimulated by objects imported from Asia and by newly published books on India and China. The scenes illustrated in these volumes provided fresh sources of inspiration.

Japan

The arts of Japan had a profound influence on British culture in the second half of the 19th century. For two centuries, only a small number of Dutch and Chinese merchants had been allowed to trade with Japan, but in the 1850s the country opened her ports to other foreign powers, including Britain. Large numbers of Japanese objects were subsequently imported to meet the demand for 'all things Japanese'. A single consignment of Japanese decorative arts which arrived too late for inclusion in the 1862 Exhibition was purchased by a young draper, Arthur Lazenby Liberty, and was the foundation of his famous department store.

Japanese art and design was very different from anything previously seen in this country. Not only was it admired for its decorative properties, but in its assymetrical layout, its deliberate use of blocks of void space, and the overall 'flat-pattern' effect, it provided a major source of inspiration for many artists and designers in the period from 1850–1900.

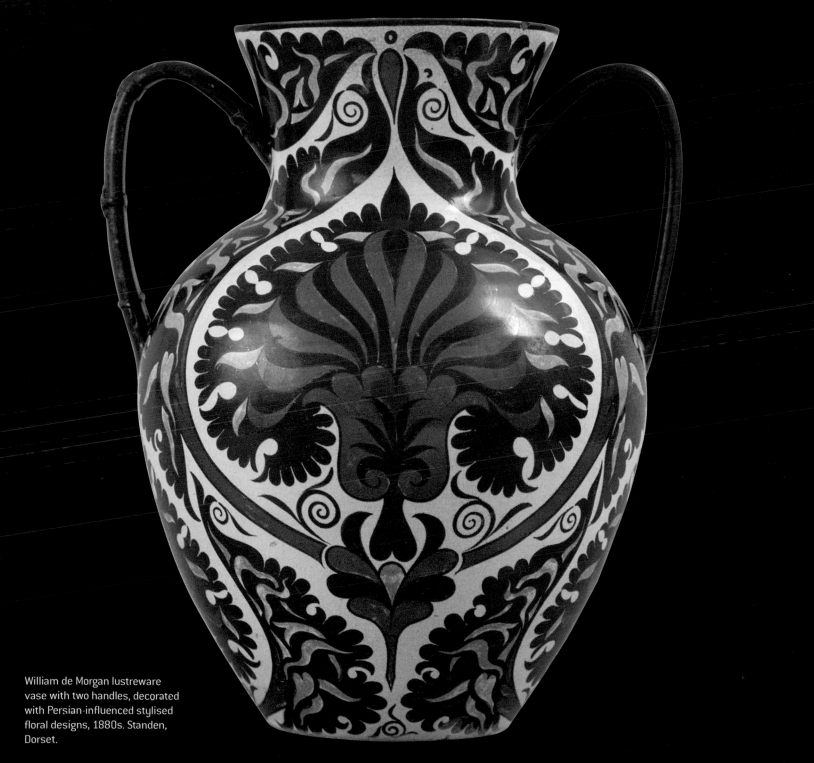

William de Morgan lustreware vase with two handles, decorated with Persian-influenced stylised floral designs, 1880s. Standen, Dorset.

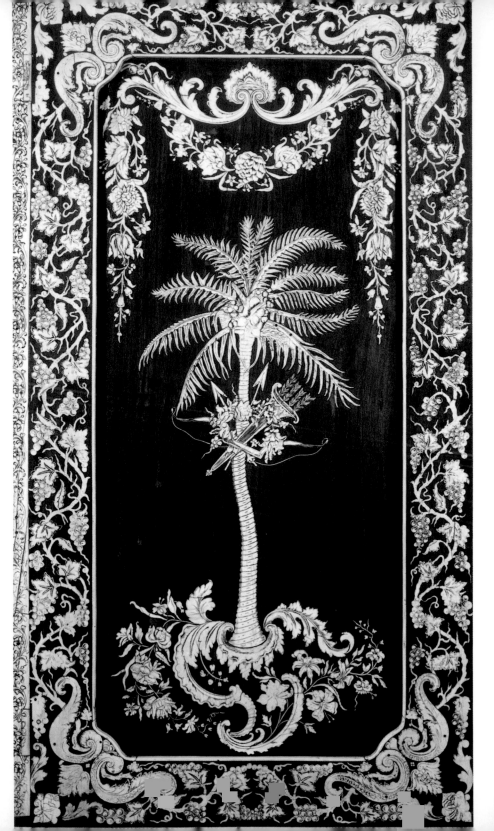

Padouk wood Anglo-Indian cabinet, inlaid with ivory, depicting a palm tree. Kingston Lacy, Dorset.

An elaborately decorated Indian red lacquer bridal chest in
Rudyard Kipling's study. Bateman's, East Sussex.

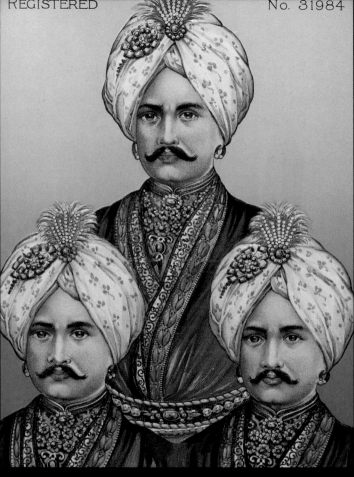

Late 19th-century English textile label, depicting three Indian men wearing turbans. These distinctive graphics made export goods easily identifiable at their destination. Quarry Bank Mill, Cheshire.

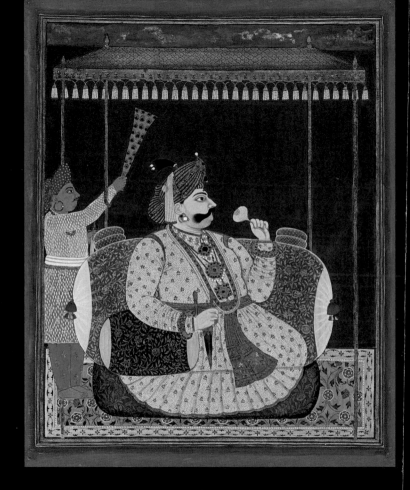

A late 18th-century portrait of Maharaja Pratap Singh of Tanjore, depicted in gouache, gold and beetle wing. The Clive Museum, Powis Castle, Powys.

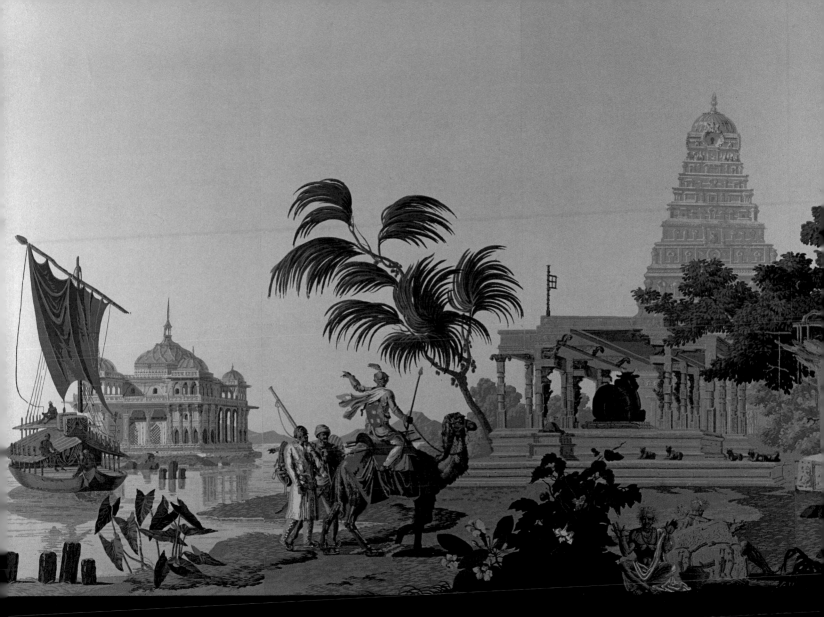

'L'Hindoustan' wallpaper produced by Zuber and designed in 1807
by Pierre Mongin, Basildon Park, Berkshire

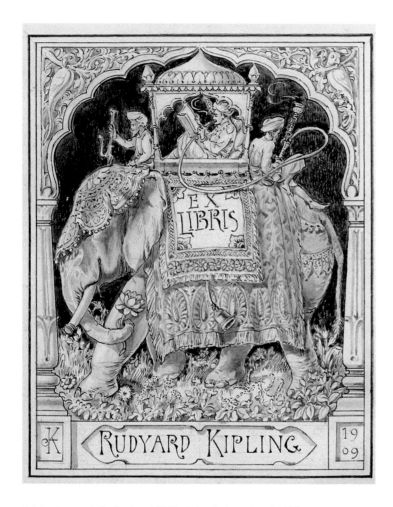

Original artwork for Rudyard Kipling's bookplate, dated 1909. Bateman's, East Sussex.

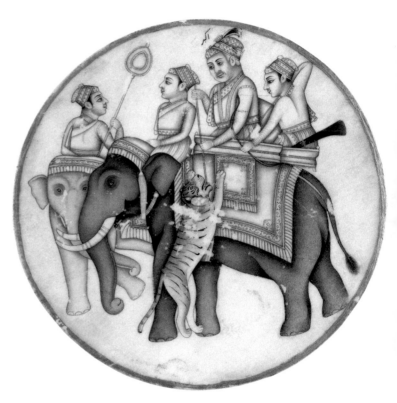

A Ganjifa playing card, dated 1759–60, depicting two elephants carrying four men in on a tiger hunt. Powis Castle, Powys.

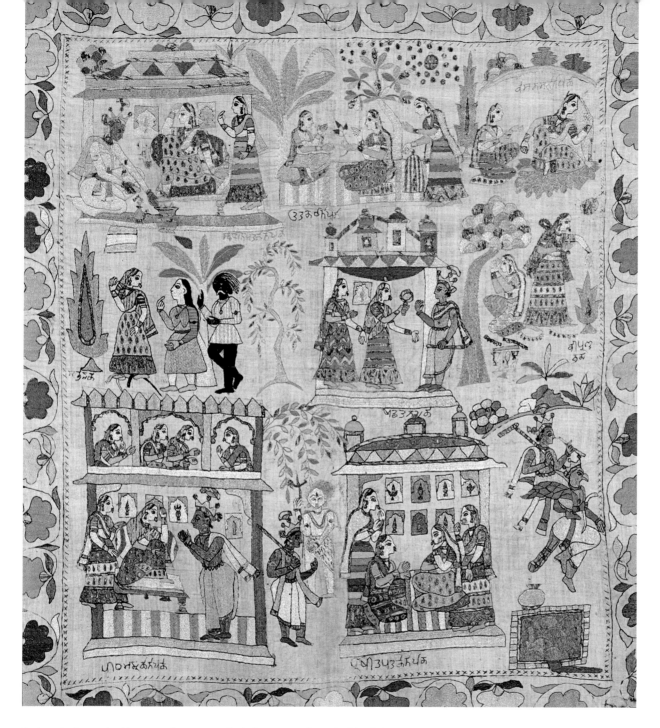

Antique Indian embroidery on a fire screen, depicting scenes from the life of the Hindu god Krishna. Embroideries of this kind are used as a ceremonial covering for trays of gifts at Hindu weddings. Bateman's, East Sussex.

A 19th-century Japanese picnic box in black and gold lacquer. Snowshill Manor, Gloucestershire.

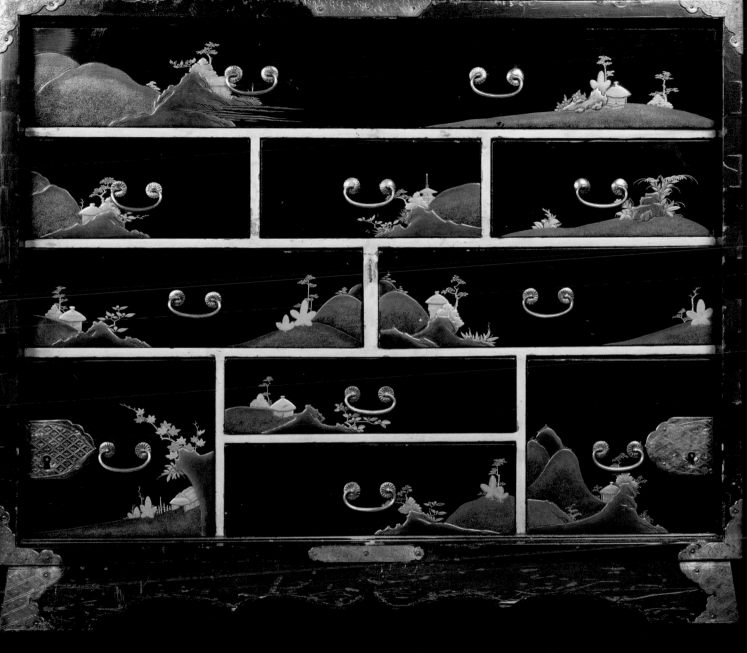

The drawers inside a late 17th-century Japanese black lacquer cabinet. Penrhyn Castle, Gwynedd.

A 1930s D'Oyly Carte programme cover for the Savoy Theatre. Coleton Fishacre, Devon.

RUPERT D'OYLY CARTE'S
SEASON OF
GILBERT AND SULLIVAN OPERAS

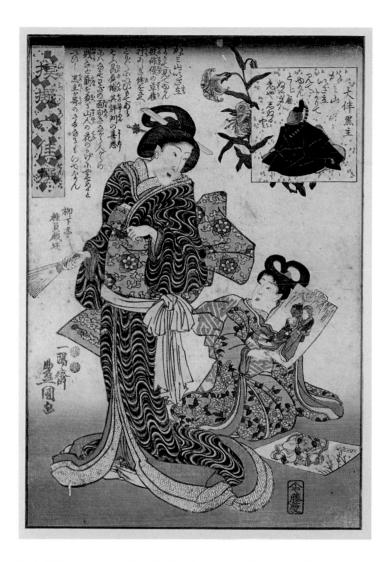

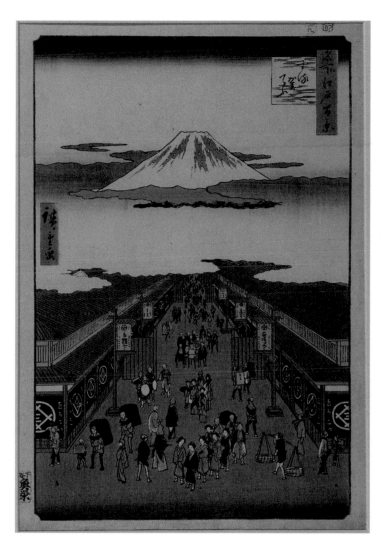

Early 19th-century woodblock print of a Japanese beauty and her maid in kimono, by Utagawa Toyokuni. Standen, West Sussex.

The Road to Mount Fuji, a 19th-century Japanese woodblock print by Utagawa Hiroshige. Cragside, Northumberland.

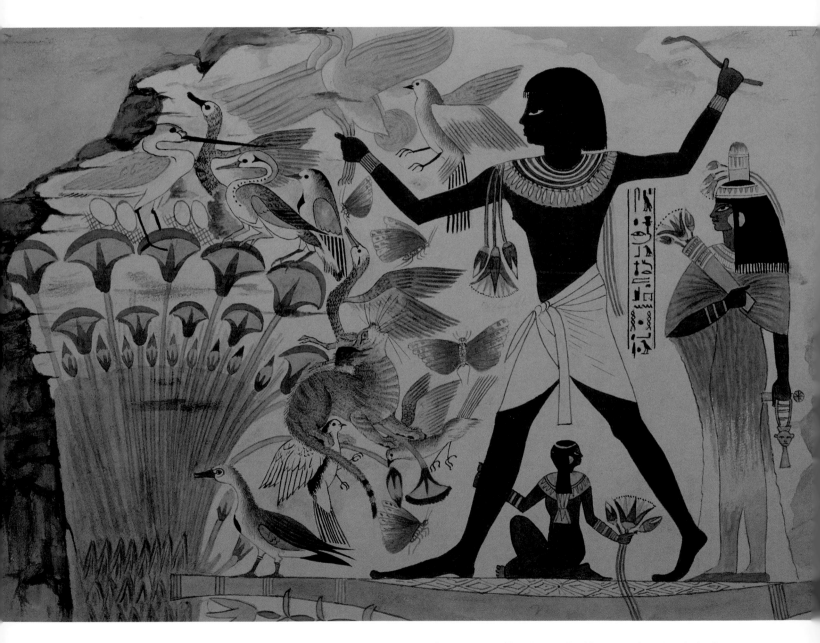

'Fowling scene from Theban Tomb', a copy of a wall painting by
Linant de Bellefonds for William Bankes. Kingston Lacy, Dorset.

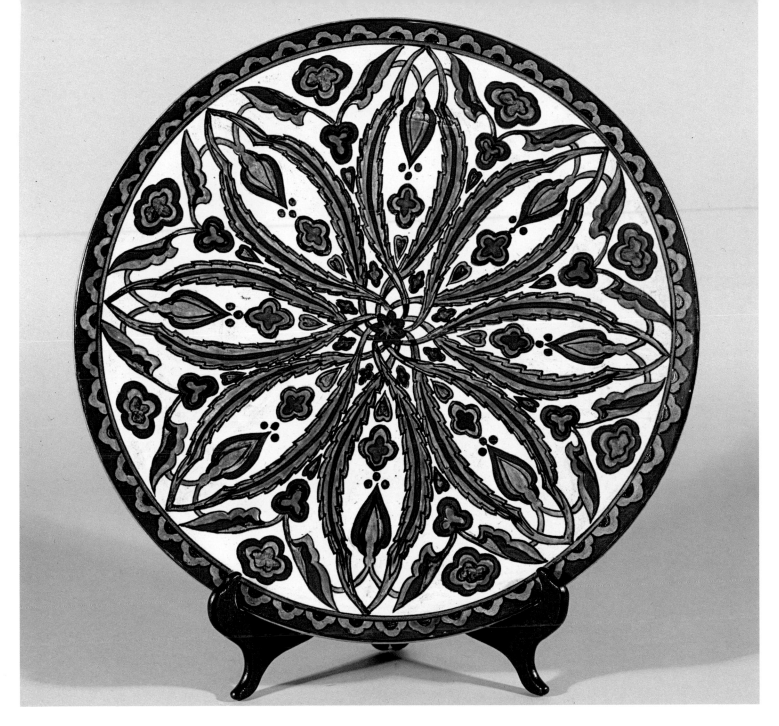

Large, late 19th-century Doulton charger in Iznik style, with stylised floral pattern. Standen, West Sussex.

THE NATURAL WORLD

Realistic and stylised portrayals of natural fauna have been a great source of inspiration for pattern-makers over the centuries. The decorative possibilities are endless, and as informed knowledge and personal observation of living specimens grew, craftspeople and designers were quick to adopt natural motifs when designing decorative details, textiles, wallpaper and stained glass.

Birds have been variously portrayed as harbingers of doom, bringers of peace, and sources of aesthetic delight for millennia. Individual species are associated with symbolic attributes; the eagle signifies power and authority and the peacock is a by-word for personal vanity, while ducks are thought to represent marital fidelity.

Butterflies and insects

'A short life, but a happy one': ephemeral by nature, but gloriously decorative, butterflies and insects were ardently collected by amateur and professional naturalists. Their aesthetic appeal is evidenced by the passion felt by collectors for mounting and displaying them in serried ranks in glass cases. Designers and artists represented their brilliant colours and exquisite patterns in all media.

The British mania for collecting specimens from the natural world encompassed seashells and all aspects of marine life. Consequently, artists and designers have used them as both inspiration and (on occasions) as raw material.

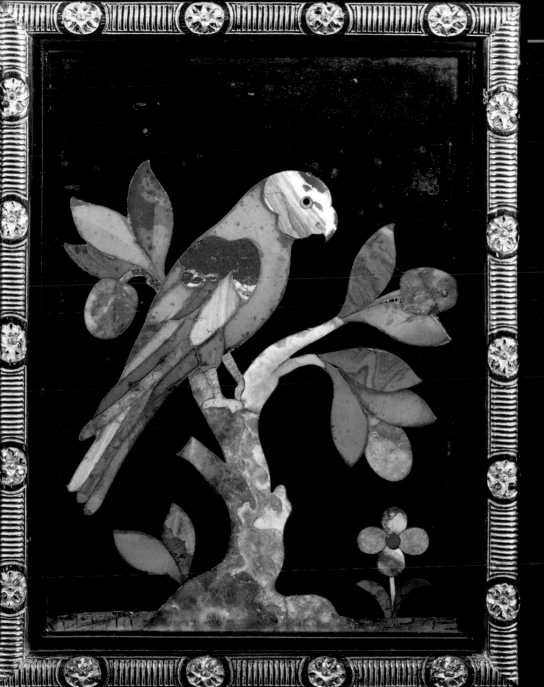

Detail on a pietra dura cabinet, part of the Florentine Cabinet c 1620. Charlecote Park, Warwickshire.

Silk voided *cisele* velvet in a restrained 'bizarre' design, c. 1695–1712. This fabric was used for the curtains, upholstery and pole screens but its origin is unknown. Penrhyn Castle, Gwynedd.

Detail of the late 19th-century, machine-printed wallpaper of peacocks in the lobby of the Red Bedroom. Erddig, Wrexham.

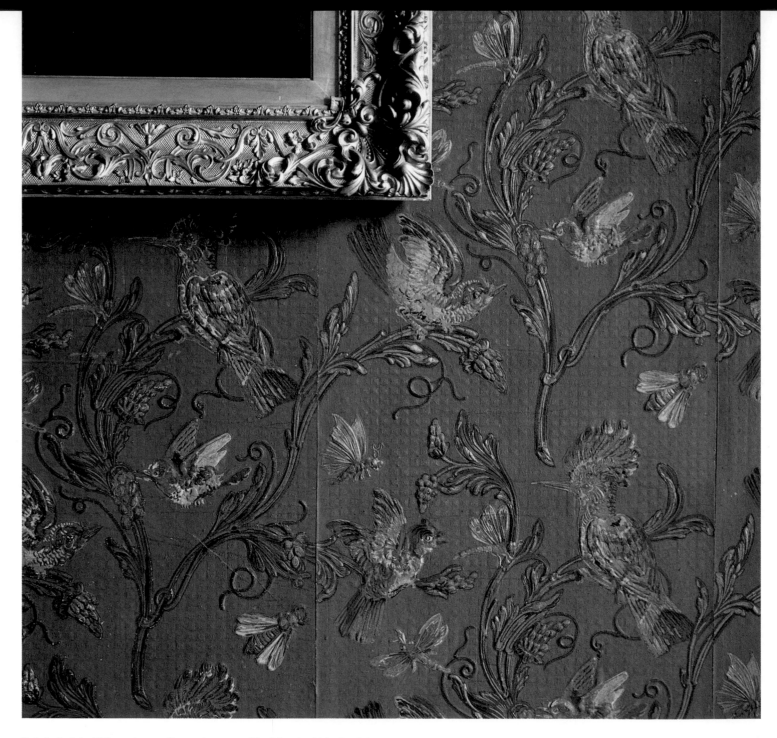

Detail of a late 19th-century wallpaper known as 'Cordelova', which simulates
embossed leather. Dunster Castle, Somerset.

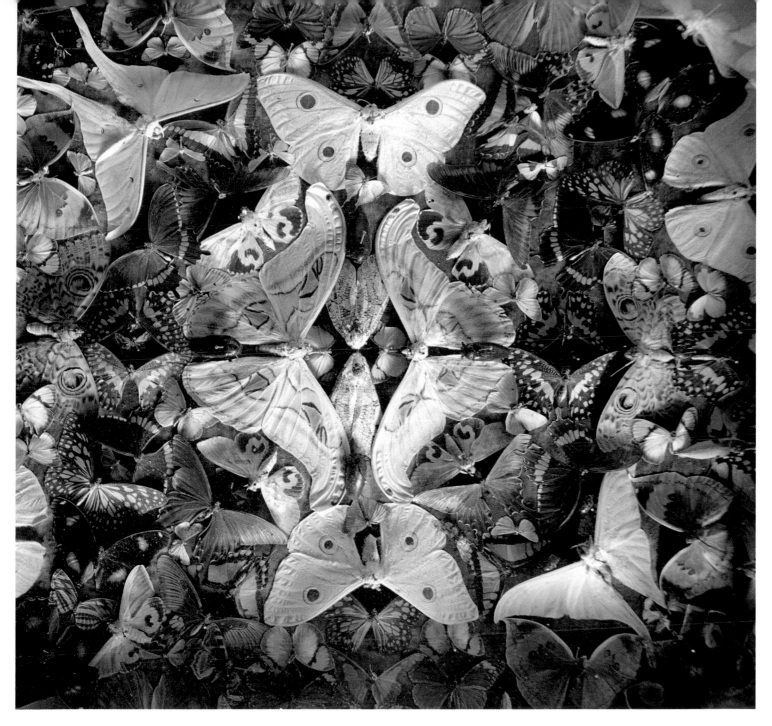

Butterflies, beetles and other insects in a display case, part of the idiosyncratic
collection assembled by Charles Paget Wade. Snowshill Manor, Gloucestershire.

Marbled endpapers from a volume
in the Library collection at
Florence Court, Co. Fermanagh.

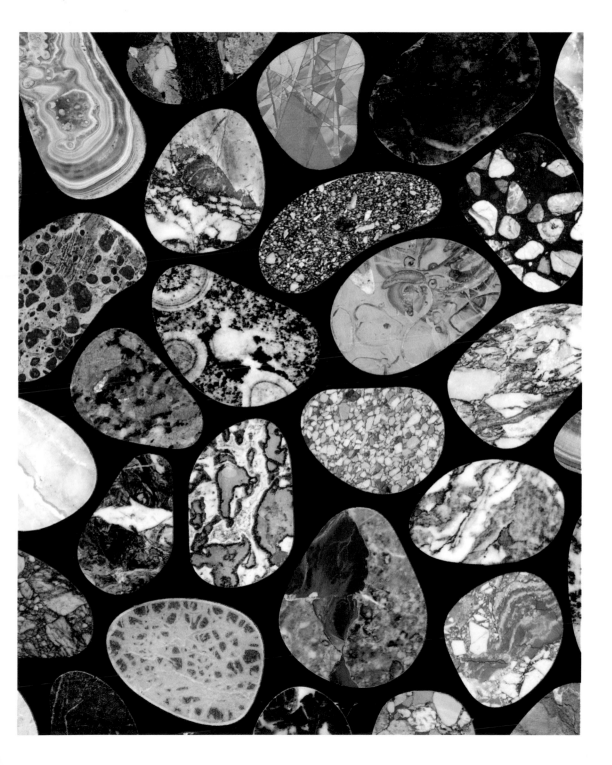

Detail of the polished surface of
an Italian table top (c. 1800),
decorated with different geological
specimens. Croft Castle,
Herefordshire.

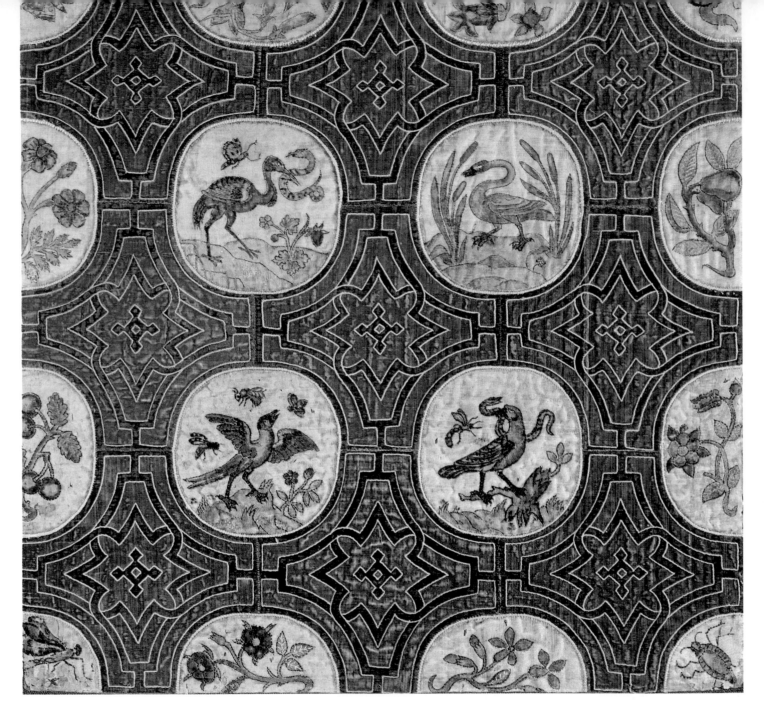

One of a set of nine embroidered panels from the late 16th century with inlaid patchwork and painted birds in roundels. Many of the birds were copied from a single engraving illustrating 'Air' in *The Elements* published by Gerard de Jode, c. 1582. Hardwick Hall, Derbyshire.

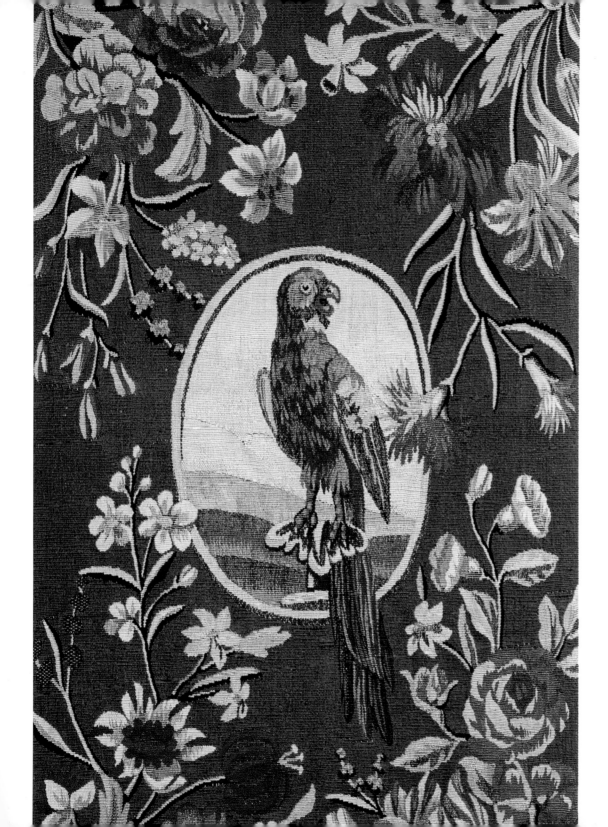

An 18th-century Soho tapestry on an upholstered chair. Antony, Cornwall.

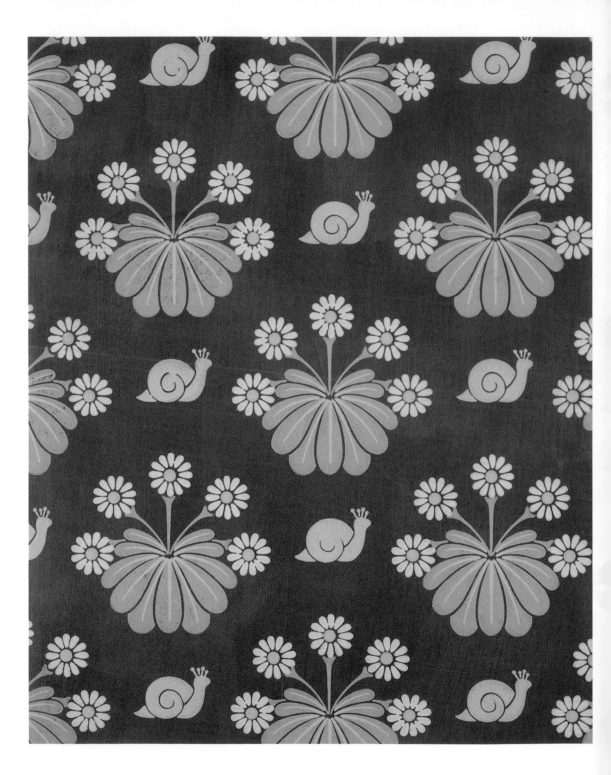

Whimsical wallpaper pattern of featuring snails and daisies. Designed by William Burges c. 1870. Knightshayes Court, Devon.

Detail of a hand-painted wallpaper
designed by William Burges
c. 1870 but not believed to have
been commercially manufactured.
The wallpaper was installed in the
Boudoir in 1991. Knightshayes
Court, Devon.

A Meissen porcelain stand for a bowl (1740–45), painted with insects and modelled flowers. Clandon Park, Surrey.

Detail of an early 18th-century Chinese shrine cabinet in lacquer, with gold dragonflies on a black background. Snowshill Manor, Gloucestershire.

Collection of colourful stag beetles. Overbeck's, Devon.

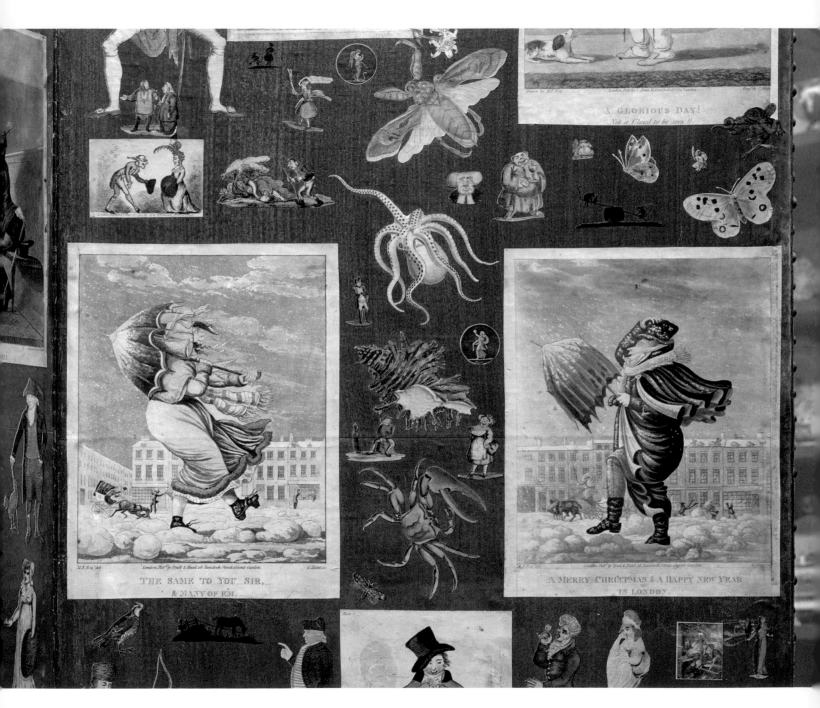

THE SAME TO YOU SIR,
& MANY OF 'EM.

A MERRY CHRISTMAS & A HAPPY NEW YEAR
IN LONDON.

A GLORIOUS DAY!
Not a Cloud to be seen!!

Detail from an early 19th-century scrap screen featuring marine and insect life and caricatures of the period. Arlington Court, Devon.

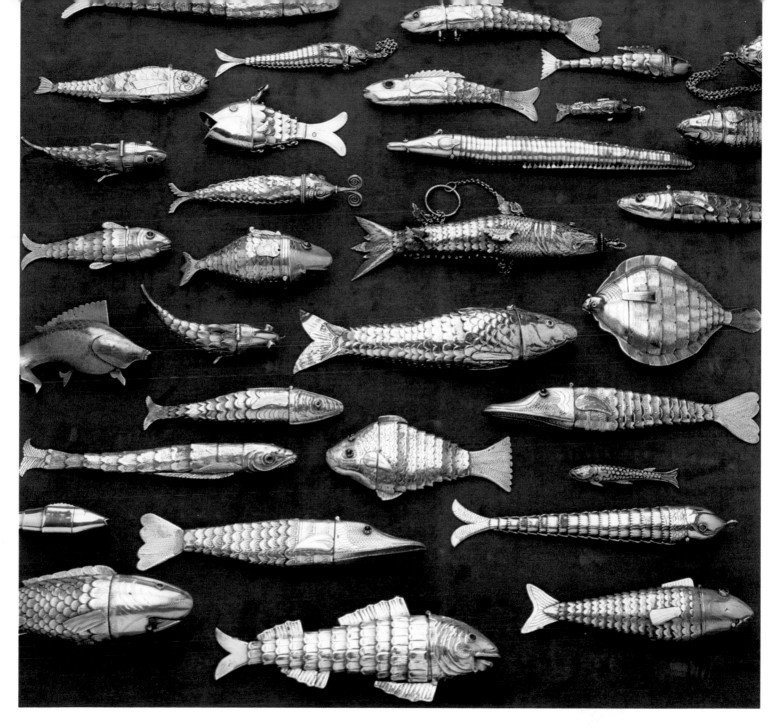

A collection of silver fish used as novelty scent containers, vinaigrettes and as ornaments owned by the 3rd Marchioness of Bristol. Ickworth, Suffolk.

The Glory that was Greece, and the Grandeur that was Rome inspired the Neo-classical style which swept Britain and France in the 1750s. The art and artefacts of the Ancient World were increasingly accessible to the wealthy and fashionable of Northern Europe, through the archaeological discoveries made at Herculaneum and Pompeii. The sons of the British aristocracy and the more adventurous gentry began to undertake the 'Grand Tour', to explore the remains of classical civilisations. They were fuelled by curiosity, inspired by engravings, illustrations and books, funded by their wealthy families and generally kept in check by an accompanying tutor. It was the beginning of cultural tourism, and many an English country house received its share of classical souvenirs, from statuary to mosaics, some of dubious antiquity.

Neo-classicism became the most dominant style in Britain during the first three decades of the 19th century. British architects, artists and makers sought to create an eternally valid 'true style' that could be expressed across all areas of the visual arts. Forms and motifs from ancient Greece and Rome were the basis of the style. To these were added elements taken from nature, from the arts of ancient Egypt, and from French designs of the mid-18th century. The combination of different patterns and colours made Regency Classicism a visually rich style.

The style's initial inspiration came from the architectural remains of the structures of the Ancient World, the surviving pillars, pediments, proportions and patterns of Italy and Greece.

Early British interpretations of neo-classicism owed a great deal to the designs of the 16th-century Italian architect, Andrea Palladio (1508–1580). Palladio was inspired by buildings of ancient Rome. Palladian-style exteriors were plain and based on rules of harmonious proportion; bold, austere, block-coloured. Strong architectural themes dominated, with an emphasis on symmetry and a reliance on columns supporting pediments. Statuary recalled the great figures of the classical world. Bare wooden floorboards, or stone flags, might be with furnished with sisal matting or Oriental or Turkey-work carpets, a pragmatic solution to the chillier climate of Northern Europe compared with the Mediterranean origins of the style.

The natural successor to the rather austere, Roman-derived monumentalism of Palladianism was the neo-classical style, which encompassed the more fluid style of Greek culture. It was more elegant in design and more feminine in appearance – plain floorboards would be covered with pile carpet from the grandest factories in Savonnerie, Aubusson, or Wilton in England. Ceilings were made of smooth painted plaster, with simple cornice mouldings of repeated geometric patterns. Very grand interiors would be decorated with neo-classical motifs on painted and gilded plaster. Intricately patterned surfaces such as textiles or furniture sported overtly neo-classical imagery.

There was an overall sense of finesse and lightness in all ornament, and a highly developed sense of pattern, featuring swags of flowers, ornamental bows, cupids and mythological or pastoral scenes, often set in panels.

Inspiration was taken from direct observations of architecture and ornament, revealed by excavations in Rome, Pompeii and Herculaneum. Illustrated books and engravings were published by influential architects and designers, such as Robert and James Adam, who were thus able to offer the new visual vocabulary to their aspirational and affluent clients.

The Neo-classical style offered magnificent decorative opportunities. From the ordered geometries of the classical world, complex schemes could be devised. Circular devices, medallions and ovals define many of the patterns of this era, and decorative scenes refer to the myths and legends of Greece and Rome.

Rectilinear patterns with abstract motifs appealed to the more purist neo-classical pattern-makers. Schemes of this type were invariably subtly coloured in light tones.

The human form as a motif in pattern-making also received the neo-classical treatment, particularly with the rise in popularity of the Greek style in the first decade of the 19th century. In 1806 Lord Elgin brought sections of the marble frieze from the Parthenon in Athens to London, and the vogue spread for the statuary and aesthetics of ancient Greece. Women's fashions began to imitate the soft folds of the 'chiton' or ancient Greek dress, often worn with a bandeau or circlet suggesting a delicate classical wreath. In the fields of the applied arts, designers exploited the fashion by depicting heroic mortals and Classical Gods, vestal virgins, philosophers and laurel wreaths.

A recurrent motif which runs from the classical world and is much beloved by pattern-makers is the urn, amphora or decorative vase so associated with the ancient world, and much sought-after by Regency connoisseurs and collectors.

One element which further informed neo-classicism is the fascination with the recent archaeological discoveries in Egypt, instigated by Napoleon's military campaigns in North Africa, and popularised by lavishly illustrated publications such as Baron Denon's *Voyages dans la Basses et la Haute Egypte* (1802–3). Ancient Egyptian motifs such as scarabs, palm, papyrus and lotus flowers, and even hieroglyphics, started to appear in fashionable interiors. Colour palettes were influenced by Egypt; 'eau de nil' (literally Nile-water green') would be combined with colour schemes of sand and lapis lazuli blue, with touches of strong ochre. Decorators were particularly taken with the mythical figure of the sphinx, and included these mysterious figures as part of their visual vocabulary.

Illustration of a classical figure in mosaic, which was published in *Peintures Inédites* (Paris, 1836) by Raoul Rochette. Calke Abbey, Derbyshire.

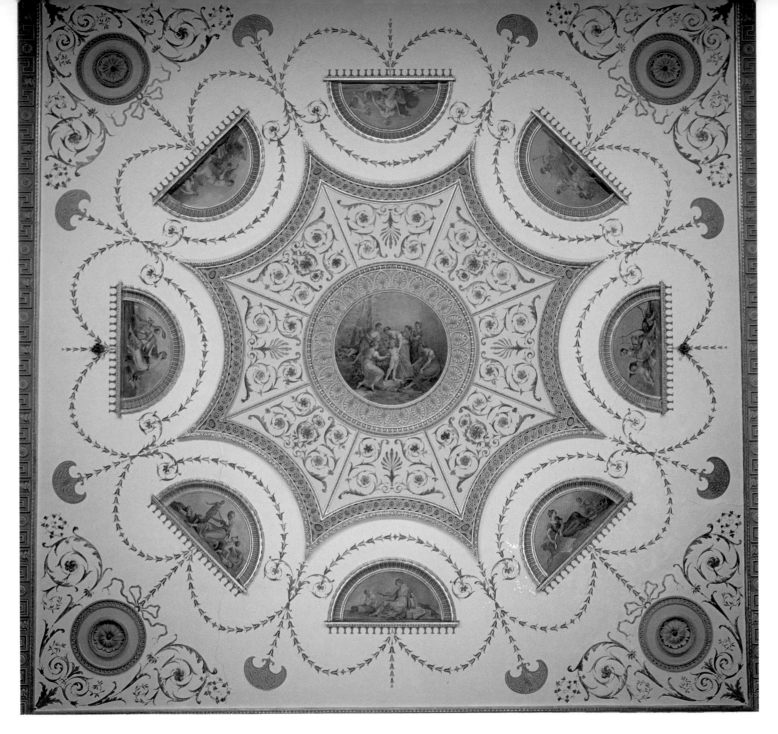

The ceiling in the Tapestry Room, designed by Robert Adam in 1767. The central scene is taken from the legend of Cupid and Psyche and the eight fan-shaped lunettes, linked by ornate garlands, were painted by Antonio Zucchi. Nostell Priory, West Yorkshire.

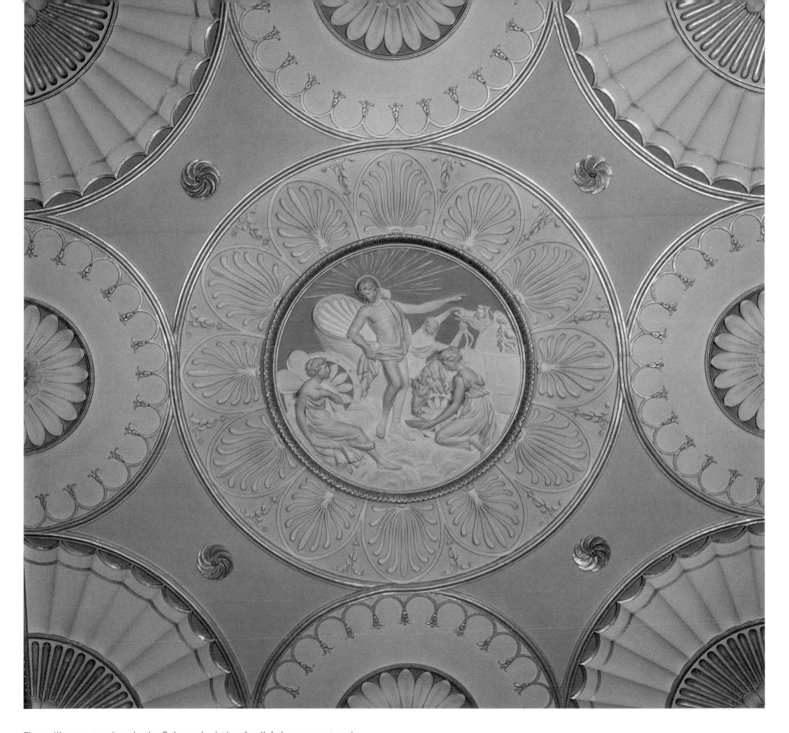

The ceiling centrepiece in the Saloon, depicting Apollo's horses watered by the Hours, by Antonio Zucchi. Nostell Priory, West Yorkshire.

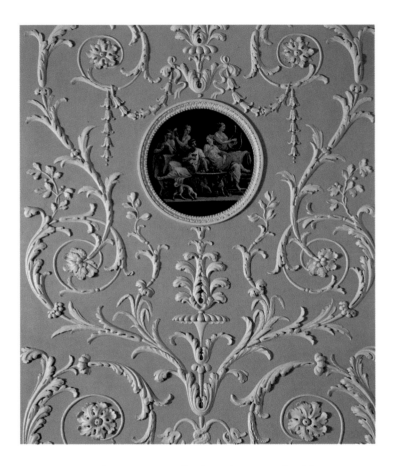

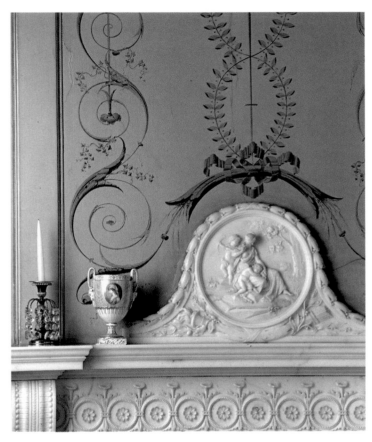

A painted roundel depicting a wedding feast, by Antonio Zucchi, 1767. The ornate stucco panel is part of the decoration on the walls of the Eating Room. Osterley Park, Middlesex.

The Boudoir, with a decorative wall scheme based on the designs of Angelica Kauffmann, 1775 . The figure of Venus guards the sleeping Cupid in the marble roundel above the mantelpiece. Attingham Park, Shropshire.

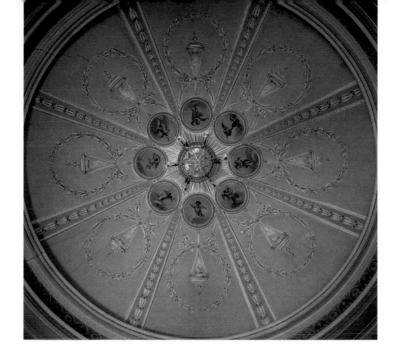

The painted ceiling in the Boudoir. Decorative wreaths complement roundels containing putti, c. 1785. Attingham Park, Shropshire.

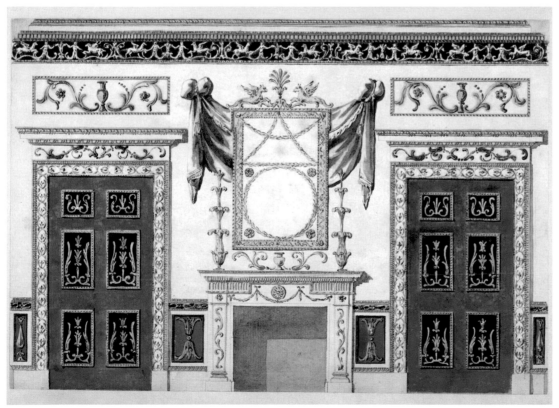

'Design for the painted breakfast room in the family pavilion', one of three designs in pen, ink and watercolour, by Robert Adam, 1760. Kedleston Hall, Derbyshire.

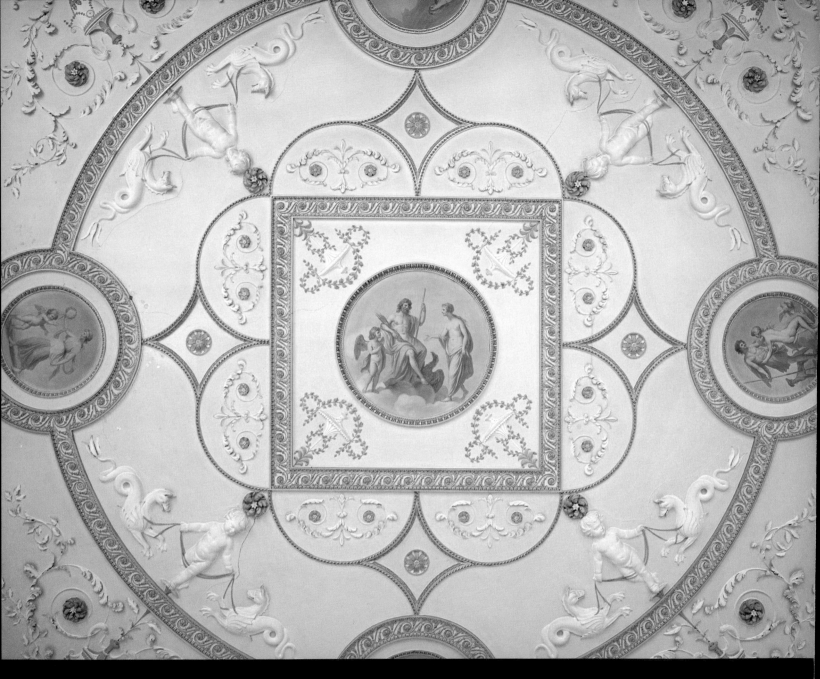

The Drawing Room ceiling, designed by Henry Holland in 1778. The central medallion of Jupiter, Cupid and Venus is painted in the style of Biagio Rebecca. Berrington Hall, Herefordshire.

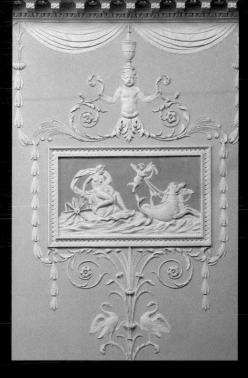

Detail of the plasterwork on the south wall of the staircase, late 1760s. Claydon House, Buckinghamshire.

One of the outer bays of the 18th-century rococo carved ceiling in the North Hall by Luke Lightfoot, featuring sunburst-like trophies of militaria. Claydon House, Buckinghamshire.

A Neoclassical nymph, painted by Antonio Zucchi in the 1760s and repainted by Thomas Ward in 1819–20, on one of the doors of the Little Dining Room. Nostell Priory, West Yorkshire.

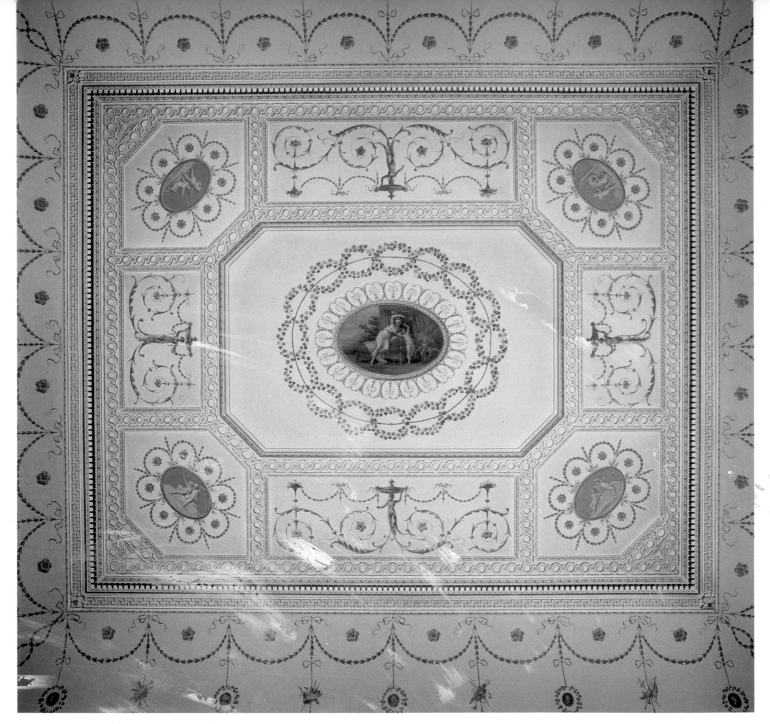

Detail of the ceiling in the Little Dining Room. The ceiling was designed by Robert Adam, executed by Antonio Zucchi and displays elements of the Pompeian style of frescoes, which were first excavated in the mid-18th century. Nostell Priory, West Yorkshire.

Detail of ceiling designed by Robert Adam in the Top Hall. Repainted in 1982 to a neutral colour scheme, which approximated Adam's intentions while allowing for later changes. Nostell Priory, West Yorkshire.

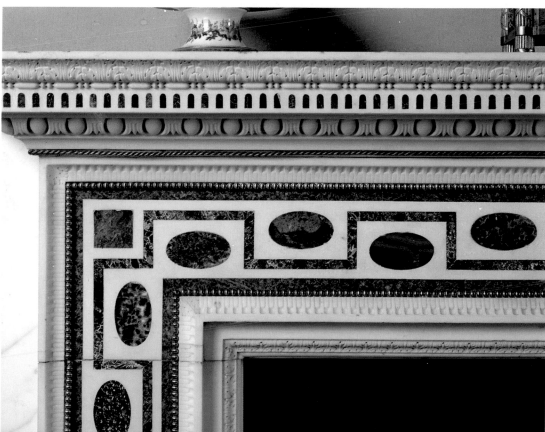

Corner of the Italian chimneypiece, with oval inserts of coloured marble, in the Drawing Room, 1829. Ickworth, Suffolk.

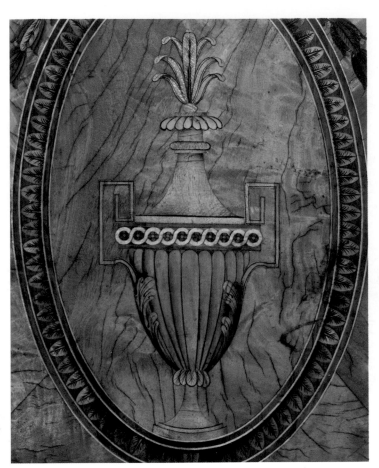

Exquisite marquetry in a variety of woods on an 18th-century commode. Nostell Priory, West Yorkshire.

As above. Nostell Priory, West Yorkshire.

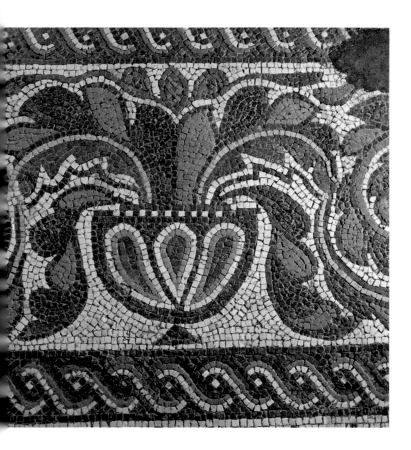

Part of a mosaic panel in the floor of the Dining Room, featuring an urn bordered by rope motifs. Chedworth Roman Villa, Gloucestershire.

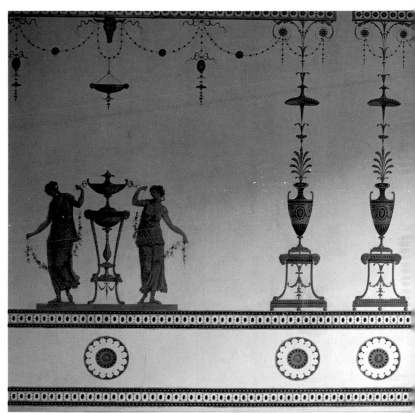

Detail of one of the painted panels covering the walls of the Etruscan Dressing Room. Although designed by Robert Adam, they were papered and painted by decorative artist Pietro Mario Borgnis. Osterley Park, Middlesex.

MONOCHROME

The stark combination of black with white has enormous graphic impact. The absence of other colours allows pattern-makers to achieve high-contrast results, often coupled with a sense of elegant austerity. As a colour combination, black and white was particularly favoured in the Middle Ages, throughout the Tudor era, and up to the 17th century. It was to achieve a new popularity in the early decades of the 20th century, when it became associated with the clean lines and sharp edges of Modernism.

The colour combination had interesting connotations when it came to costume and personal adornment; to the Puritans, it signified sobriety, cleanliness and therefore Godliness. For the Victorians, the 'cult of mourning' personified by Queen Victoria stipulated careful sartorial rules for the recently bereaved. Black was the staple of a widow's wardrobe, alleviated in the fullness of time by tiny touches of white. Even today, dress codes apply for attendance at formal occasions such as funerals, court-dress and professional musical performances. Black and white is formal, grave and measured.

The absence of colour denotes seriousness of purpose when used in architectural settings, and black and white in combination add gravitas and a sense of order to decorative schemes.

A silhouette is a form of portraiture in which the subject is depicted, usually in cut black paper, and nearly always in profile, against a white ground. This apparently simple technique required great skill on the part of the silhouettistes, or paper-cutters, but it also allowed them to show their dexterity in rendering patterns and details. The use of stark black and white to depict the human form adds considerable drama to the subject.

Naturally, it is in the medium of print that black and white excels in its graphic impact. On paper and in textiles, crisp black designs on a white ground have an immediate appeal.

Self-colour patterns rely for their effect on subtlety of technique and a reliance on the difference in texture achieved by the addition of the design. Such patterns tend to be small-scale and intricate, more suited to personal effects and costume than grand schemes.

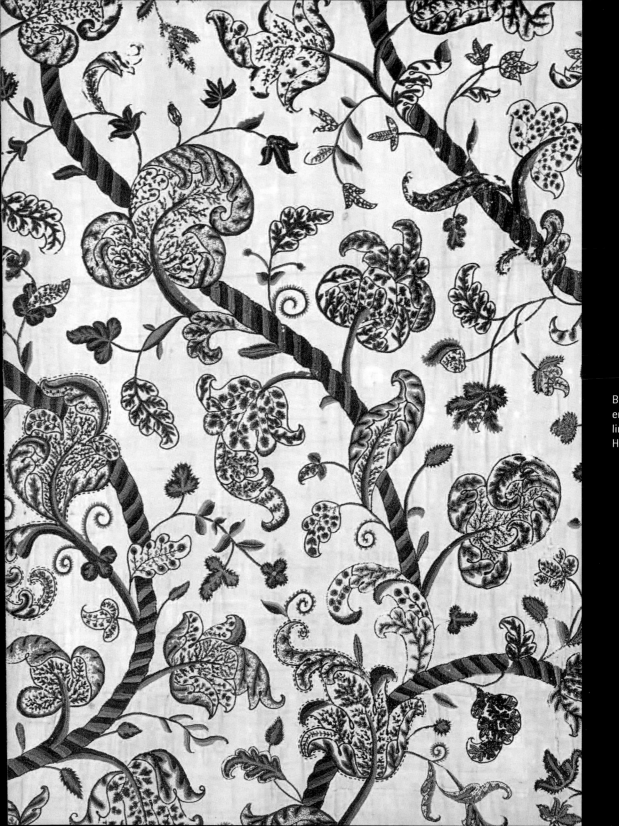

Black and white crewelwork embroidery on a 17th-century linen bed hanging, at Chastleton House, Oxfordshire.

A single hand-stencilled fleur-de-lis (see also below). Bradley Manor, Devon.

In the Middle Ages, plastered and limewashed interior walls were occasionally decorated with stencilled patterns, though their survival to the present day is rare. Bradley Manor, Devon.

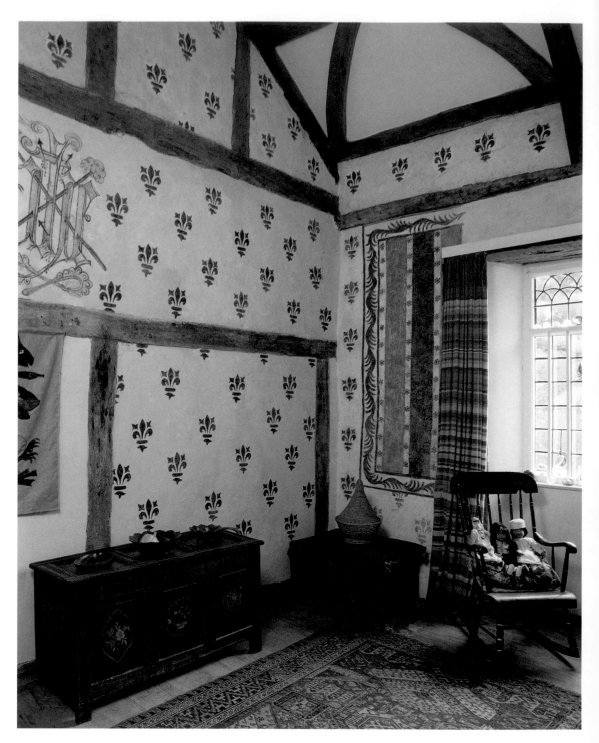

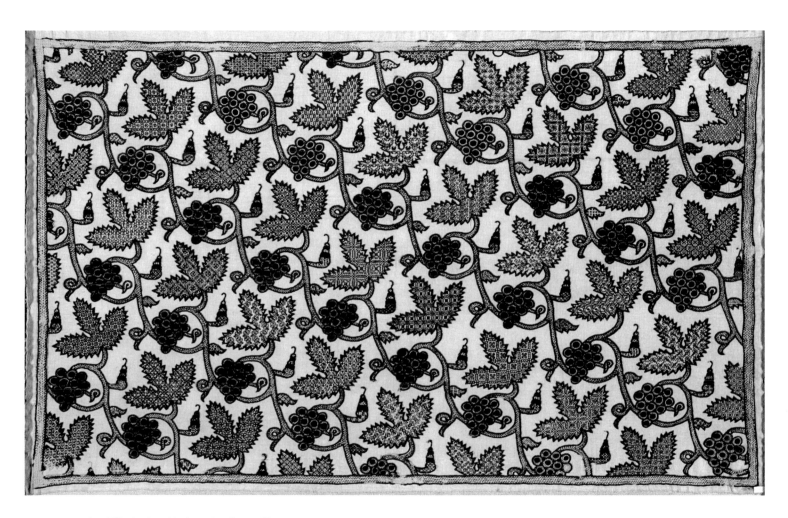

A rare example of Elizabethan black work, a linen pillow-case
embroidered in silk thread in a continuous pattern of trailing vines.
Antony, Cornwall.

Rococo transfer-printed Liverpool fireplace tiles, c. 1765 in the Library Ante-Room. Croft Castle, Herefordshire.

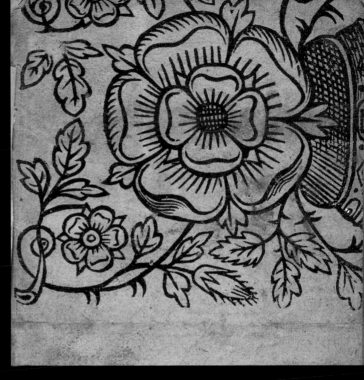

Detail of the cast-iron balustrade on the Staircase with a pattern of scrolls and leaves and John Ferguson's handrail of mahogany inlaid with ebony. Mount Stewart, Co. Down.

A piece of early block-printed wallpaper, found inside a book published in 1609. Lanhydrock, Cornwall.

Detail of a folding screen door, separating the Living Room from the Dining Room. Peter Thompson decorated it with stalks of sweetcorn, highlighted in gold leaf on a black background, on one side and paintings of bamboo on the other side. The Homewood, Surrey.

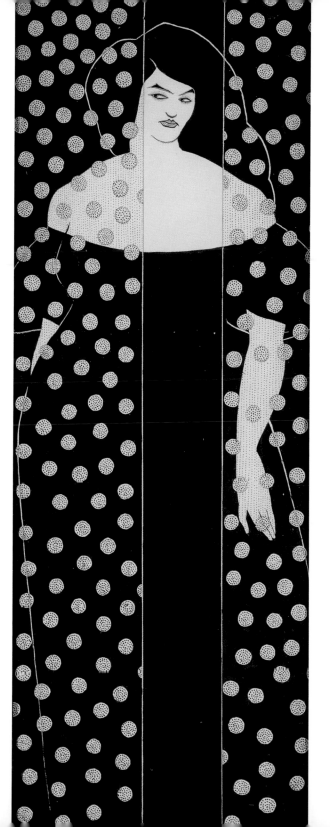

Original artwork for the poster to
publicise George Bernard Shaw's
Arms and the Man. Designed by
Aubrey Beardsley in 1894.
Shaw's Corner, Hertfordshire.

Detail of the 1920s curtain
fabric, designed by Raoul
Dufy, in Lady Dorothy's
Bedroom. Coleton Fishacre,
Devon.

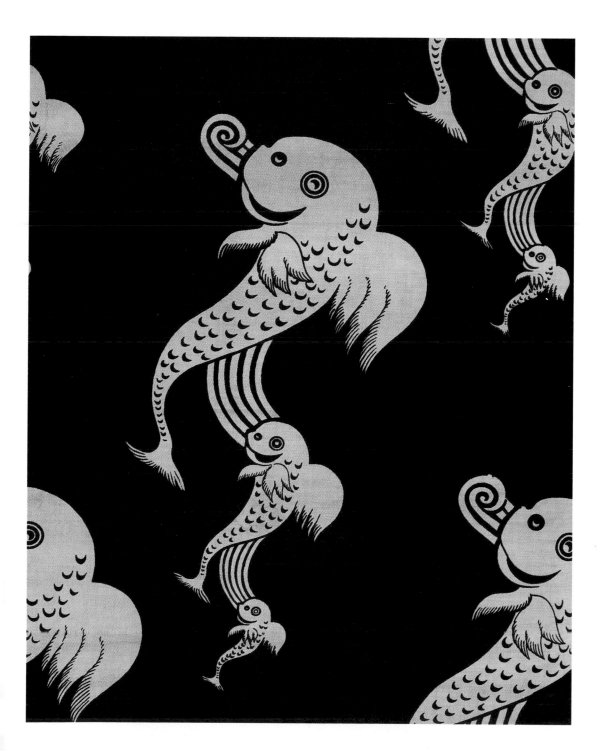

Detail of the dolphin-patterned bathroom curtain fabric from the early 20th century. Anglesey Abbey, Cambridgeshire.

style for religious architecture and art throughout large parts of Northern Europe until the 16th century, when it was supplanted by the new vogue for Italian Classicism which informed the Renaissance.

In Britain the massive solidity of Norman architecture, with its thick walls and limited windows, was gradually replaced by an emphasis on the pointed arch, supported by pillars, topped by intricate stone tracery, and supported externally by flying buttresses. Interior decoration featured stylised, elongated human figures set against flat backgrounds; patterns were of stylised foliage and intricately entwined plant forms.

The symbolism of the pointed arch, and soaring vaulted ceilings, was to provide a foretaste of the Christian view of heaven on earth. It is therefore slightly ironic that a style which later came to be seen to be so quintessentially English was introduced by craftsmen, masons and designers from France and Germany. Even more ironically, the pointed arch itself and the sophisticated geometry underpinning the decorative carved stone screens and window openings fitted with delicate filigree carved stonework owes its arrival in France to the Norman conquest of Islamic Sicily in 1090, the Crusades, which began in 1096, and trading contacts with the Islamic population in Spain.

In the middle of the 18th century, a sense of romantic nostalgia began to develop, a reappraisal of Britain's unique cultural past. Norman, Gothic and Jacobean styles were re-examined, and there was an appreciation for the skill, the expertise and the visual vocabularies of the master-builders and artists of the Middle Ages in some quarters. John Chute, who inherited The Vyne in 1754, with its magnificent medieval Gothic chapel, was a close friend of Horace Walpole. He helped design the influential 'Gothick' interiors of Walpole's villa at Strawberry Hill in Twickenham.

By the end of the century, Medieval Revivalism, and specifically the Gothick style, offered a robust and rather patriotic stylistic alternative to neo-classicism. Patterns, forms and motifs in this style tended to be based on architectural details, modified where necessary to suit two-dimensional surfaces.

was the Gothic Revival. For architects, designers, manuacturers and their clients and customers, the Gothic Revival provided a vigorous counter-culture to the steam-powered consumerism of the Industrial Revolution. Designs for every aspect of everyday life, from chapels to hearth tiles, light fittings to town halls, were influenced by the forms and patterns of the Middle Ages.

In *The Stones of Venice* (1851–3) John Ruskin had called for recognition of Gothic art as the high point of civilisation. Serious research from primary sources was undertaken by visionaries such as Augustus Welby Northmore Pugin, William Burges and William Morris, and adapted for modern use.

Pugin felt that to create an illusion of depth on a 2-D surface was in some way 'dishonest'. A flat surface should be decorated with a flat pattern, usually with geometric repeats. He favoured motifs derived from gothic, medieval and pre-Renaissance sources, and from heraldry. Pugin introduced crisp, richly coloured decoration, textiles, wallpapers, tiles. Burges designed exuberantly coloured, richly ornamental interiors, with every surface covered in pattern. Morris, through his association with the painters of the Pre-Raphaelite Brotherhood, was taken with the idealism of a former 'Golden Age', but his later designs adapted to the aspirations, commercial concerns and practical needs of the aesthetically aware Victorian.

The designs of the Gothic Revivalists appealled to certain sections of the newly rich, who had become wealthy through manufacturing and trading. Pugin, Burges and Morris offered a fanciful vision of Medieval chivalry and romance. On a subtle level, 'going Gothic' offered well-off households with no great land-owning antecedents an instant heredity, a sense of their own ancestors and cultural heritage. The Gothic Revival style flourished from 1830–1900, and informed many aspects of the Arts and Crafts Movement.

A highly ornate memorial cross in the Victorian Gothic style dedicated to Matilda Blanche Gibbs (d.1887), made by Barkentin and Krall, in gilt bronze, worked with enamels with gold thread, rock crystal and semi-precious stones. Tyntesfield, Somerset.

Gothick patterned wallpaper, copied from the 1830s original scheme, with a repeat design of flying buttresses and arched windows. Hanbury Hall, Worcestershire.

Ceiling of wooden ribs and Tudor rosettes, believed to have been installed in the 1840s by John Norris, an enthusiast of the Gothic style. Hughenden Manor, Buckinghamshire.

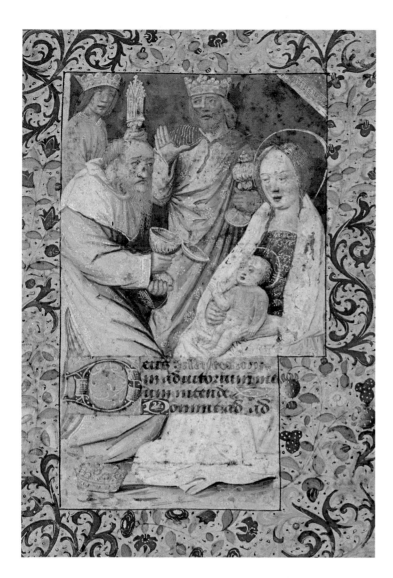

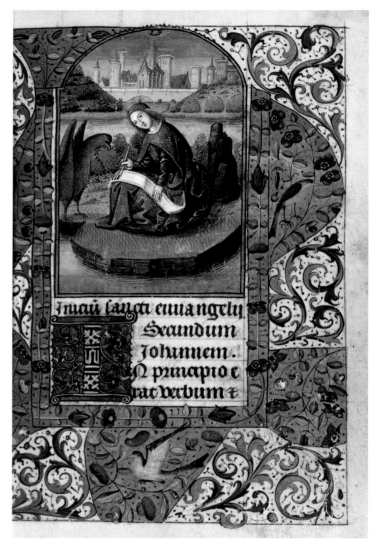

'The Adoration of the Magi'. Miniature page from a Book of Hours by the School of Jean Bourdichon. Aberconwy House, Conwy.

Illumination from a Book of Hours (Paris, 1480–1490) showing a saint writing, observed by an eagle. Charlecote Park, Warwickshire.

One of four brass rubbings taken
by T.E. Lawrence (Lawrence of
Arabia) between 1906 and 1909,
with a hand-written inscription.
Clouds Hill, Dorset.

*Ralph Lord Stafford from the Canopy of the Brass
of Sir Hugh Hastings, 1347, at Elsing, Norfolk.
Rubbed and Mounted by T. E. Lawrence between 1906 and 1909.*

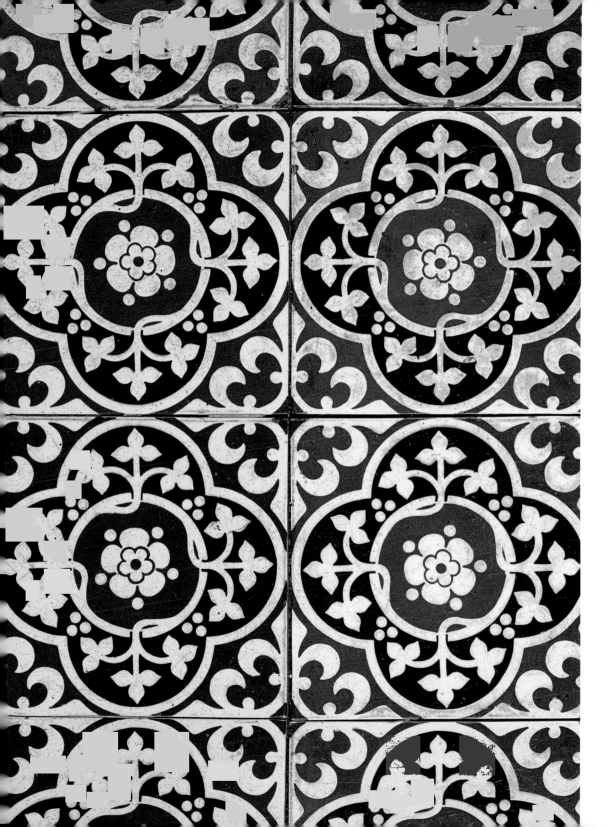

Mid-19th-century encaustic tiles in the Gothic Revival style, made by Minton. Dunster Castle, Somerset.

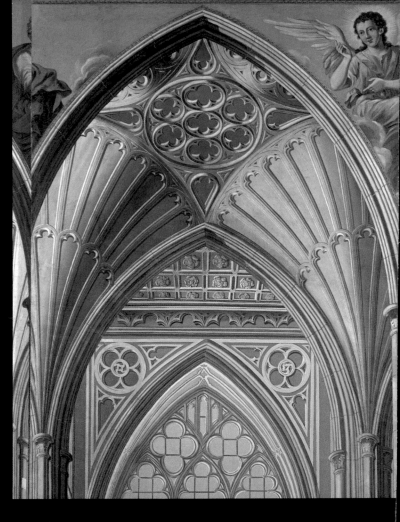

A stained-glass chapel window designed by Woolridge in the style of Walter Crane and executed by Powell's. The private chapel was designed by Arthur William Blomfield in 1873–75. Tyntesfield, Somerset.

Detail of *trompe l'oeil* painting of Gothic arches and fan vaulting. Painted by Spiridione Roma, 1769–71. The Vyne, Hampshire.

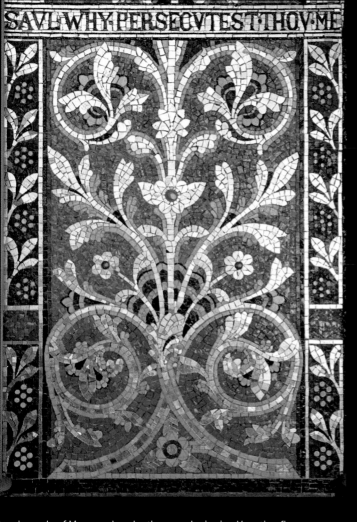

Mosaic made of Murano glass by the award-winning Venetian firm Salviati & Co. in the 1870s. It is a detail from part of a triptych behind the chapel altar. Tyntesfield, Somerset.

The Library ceiling designed by J. D. Crace who adapted William Burges's original uncompleted scheme in c. 1870. Crace's designs for the ceiling decoration were reinstated by the National Trust in 1984. Knightshayes Court, Devon.

The central section of the South
stained-glass window in the
chapel. The glass, by Clayton and
Bell is inscribed, 'It is an holy and
good thought to pray for the dead',
and dates from 1883.
Clevedon Court, Somerset.

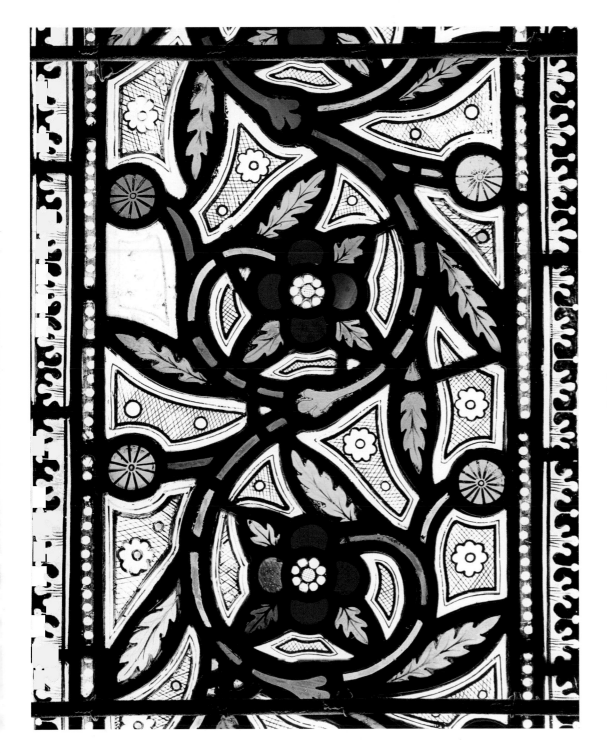

A stained-glass chapel window designed by Woolridge and executed by Powell's in the 1870s. Tyntesfield, Somerset.

ARTS AND CRAFTS

'We all gave dinner parties and furnished our homes with Morris papers, old chests and cabinets and blue pots…Most of us were very anxious to be up-to-date, and in the fashion, whether in aesthetics, house-keeping or education.'

MRS HUMPHREY WARD, NOVELIST.

The Arts and Crafts style grew out of a reaction against the growing industrialisation of Victorian Britain. Designers and artists associated with this movement believed passionately in the equal status of all the decorative arts, and the availability of 'art for all'. They were committed to the 'honesty' of skilled work, preferably undertaken by hand, using traditional methods and techniques. By the beginning of the 20th century their ideals, images and methods had profoundly affected every aspect of the decorative arts in Britain, and generated similar movements in Europe and America.

William Morris (1834–1896) was a design Colossus, energetic, passionate and visionary. His visions, however, were often a sophisticated reinterpretation of the patterns, motifs and methods of production of former eras. Morris was undoubtedly a product of Victorian society, but he railed against much of its material culture. He was a youthful visitor to the 1851 Great Exhibition, which was an exuberant celebration of the country's international pre-eminence in industry and manufacturing. The Crystal Palace acted as a vast showcase for British manufacturers, enabling them to advertise their industrial virtuosity. Morris dismissed the majority of the mass-produced exhibits as 'tons upon tons of unutterable junk'. However, he was intrigued by the Medieval Court, which showed Gothic Revival furniture by Augustus Welby Northmore Pugin and William Burges, and he was frankly enthusiastic about the hand-made ceramics and textiles from other pre-industrial cultures, such as Persia. The visual vocabulary of the Middle Ages, and later the designs, processes and colourways of the Middle and Far East, were to inform Morris's pattern-making. His most important design legacy was to create structured patterns from natural forms, combining a sense of organic growth controlled by a subtle geometry.

Medievalism

Morris was not a lone voice in believing that a return to the aesthetic principles and production values of the Middle Ages was the only appropriate response to eclecticism and mass-manufacture. Gothic-inspired architect-designers such as Pugin and Burges had shown the way, but they were dependent upon commissions from sympathetic clients. In Morris's case, he was wealthy enough to be his own client, and he engaged his friend, the architect Philip Webb, to create Red House, his first home, according to his own ideals.

Red House was a revolution; a three-dimensional exercise in designing, building and decorating a house and all its contents, one congruent with 'medieval' principles. The exterior of the house was based upon English 'vernacular' architecture; that is, the type of organic building which had grown from probably humble origins over centuries, and particular in its use of materials and forms to its locale. Morris and Webb enrolled the help of their friends, such as Dante Gabriel Rossetti and Edward Burne-Jones, to help design and decorate aspects of domestic life.

For Morris, the process was a revelation. He started to research and design the patterns and processes of former eras; frustrated by the quality of what he was able to buy for his new house from contemporary sources, he taught himself to make what he required. Fired with enthusiasm, he set up Morris, Marshall, Faulkner & Co., which later became Morris & Co., to transform the Victorian interior. 'The Firm' was to outlive Morris by more than four decades, finally closing in 1940.

Morris revelled in the value of skilled labour, and chose imagery derived from Britain's pre-industrial past. He favoured softer, more 'natural' colours as a reaction against the harshness of industrial dyes, and was to experiment with vegetable and mineral dyes. The company's designs featured stylised plant and animal forms. Like the tapestry-weavers and embroiderers of centuries before, he favoured native species, and rendered them in loving and lavish detail.

The human figure

Nowhere was the Arts and Crafts fascination with the Middle Ages more apparent than in their depiction of the human figure. Scenes from the Bible, from myths, legends or allegories, received the 'Gothic' treatment. Groups of figures would be massed tightly, in a field lacking depth, in the manner of *quattrocento* paintings. Great attention was paid to authentic details of dress, drapery and ornament, yet the subjects consciously lack movement, and are reminiscent of Gothic friezes.

It was in depictions of allegorical subject matter that the Arts and Crafts designers were able to combine their passion for medievalism with that for exuberant pattern. The commercial firm of Morris & Co. produced large-scale tapestries combining stylised arabesques, symbolic fruits and flowers and a carefully balanced colour distribution. And, like the guild workers of old, Morris and his contemporaries each specialised in designing different aspects of the same piece of work, in order to produce a collaborative end result. Morris's great strength lay in the design of stylised plant forms and rhythmic and sophisticated pattern-making; his friend Burne-Jones was more concerned with depicting the human form.

Arts and Crafts flat pattern

One aspect common to both the Gothic Revival and its successor, the Arts and Crafts Movement, was its commitment to 'truth to materials'. To committed medievalists, when designing a repeat pattern for a flat surface, it was crucial to produce a pattern that didn't dissemble – the pattern should not imply depth, by using perspective or shadowing to suggest three dimensions, as it was intended to decorate a flat surface. Morris and his contemporaries were eventually to move to more complex and subtle patterns, but the reliance on natural motifs, even relatively humble everyday ones, remained strong throughout.

But this approach left the designer with a technical problem – how to give a repeating pattern a more sophisticated graphic structure and a coherent sense of progression? Morris was an excellent draughtsman and was able to create patterns that married his ideology of flat pattern with a lively and increasingly complex sense of rhythm.

Middle Eastern patterns and forms

The Arts and Crafts designers and pattern-makers were not immune to subtle influences from foreign cultures. Contact with the art and artefacts of pre-industrial societies informed their visual vocabulary, disseminated through the media of exhibitions, publications and personal observations in museums and galleries.

There was a strong influence from the decorative arts of the Middle East which particularly impressed William de Morgan, a friend and colleague of Morris and a consummate ceramicist. He made many designs in imitation of 15th- and 16th- century Iznik wares, and his most famous commission was a set of 'Islamic' tiles for the Arab Hall in Lord Leighton's house in Holland Park Road. His patterns featured flowers, birds, fish, sailing ships and heraldic beasts, and his trademark was the brilliant colouration and attractive red lustre on many of his ceramics.

De Morgan's ceramics were associated with the Aesthetic Movement of the 1870s, an approach to life based on the philosophy of 'art for art's sake'. It emphasised the importance of art above all other values, and the pleasure to be found in beautiful things. Aestheticism was a complex mixture of a number of styles; classical and Japanese art were particular inspirations. It was fashionable from 1870–1900. Designers such as E.W. Godwin replicated the circular and geometric motifs typically found on Japanese armour and metalwork. Aesthetic Movement designers imitated Japanese artistic devices, such as the assymetric disposition of pattern and the use of sinuous and stylised plant forms.

Art Nouveau

Art Nouveau, as it appeared in continental Europe, was an exuberant and highly sensual form of decoration which influenced all areas of the decorative arts. In Britain, however, it was largely derided for its perceived decadence; *The Studio* magazine dismissed it as 'The Squirm'. In their use of organic forms in sinuous shapes, some designs by Arts and Crafts practitioners anticipated the later concerns of Art Nouveau pattern-makers. The use of exuberant arabesques and curves was nevertheless disciplined by a sophisticated disposition of pattern and colour to achieve an overall evenness of effect.

'Moresque' ceramic plate hung against Morris & Co.'s 'Seaweed' wallpaper, designed by J.H. Dearle in 1896–1901. The tessellated dado rail and oak panelling recall medieval and Tudor interiors and were a popular feature in Arts and Crafts schemes. Lanhydrock, Cornwall.

Imaginations calm and fair,
The memory like a cloudless air,
The conscience as a sea at rest.

The wallpaper 'Acanthus' was designed by William Morris for
Morris & Co. in 1875. The quotation is from 'In Memoriam' by Lord
Alfred Tennyson (1849). Arts and Crafts interiors often featured
an improving line from literature, in imitation of painted
decorations in medieval manor houses. The assorted Chinese and
Japanese ceramics are interspersed with Parian-ware figures'
Wightwick Manor, West Midlands.

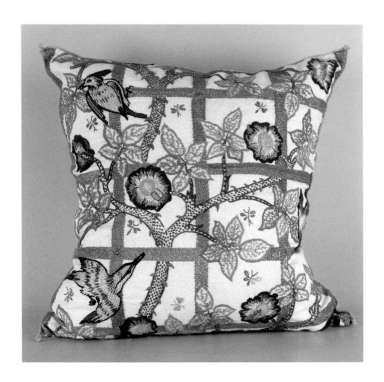

Cushion after William Morris and Philip Webb's 'Trellis' design (1862). Worked in cross stitch in 1986–7 by Elizabeth Morley, the great-grandaughter of the Beale family, who commissioned Standen from Philip Webb and filled it with Arts and Crafts designs. Standen, West Sussex.

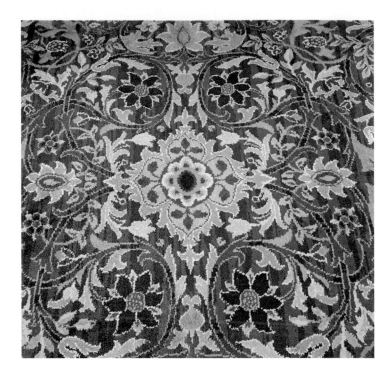

Hand-knotted carpet in a Morris & Co. design, possibly by his Head Designer, J.H. Dearle c. 1890. Wightwick Manor, West Midlands.

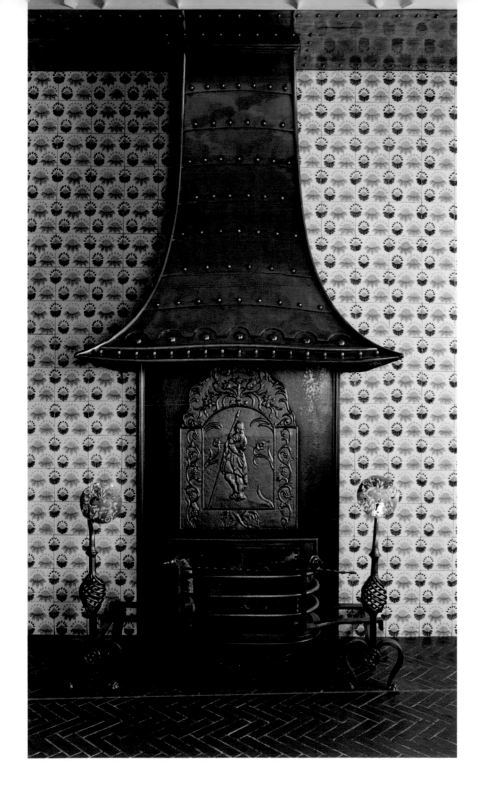

The 'Old English' inglenook or recessed fireplace was a popular feature of Arts and Crafts interiors. The architect Edward Ould was influenced by traditional interiors in England and the Low Countries, and installed an inglenook in the Billiard Room. Wightwick Manor, West Midlands.

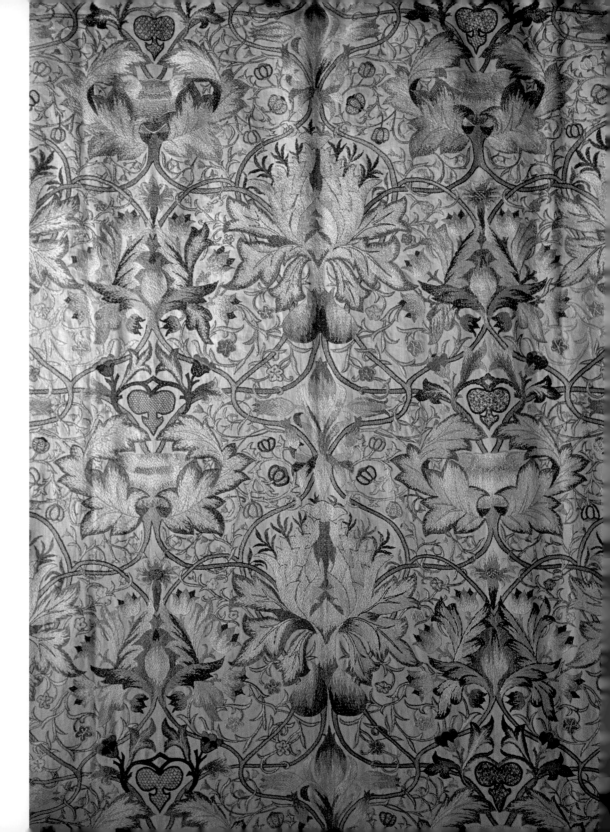

Morris & Co. wallhanging in the 'Artichoke' design (1877) by J.H. Dearle. To be embroidered in silk on a printed linen background, the kit was marketed by the firm to individuals to finish at home. Margaret Beale and her daughters completed the embroidery c. 1896. Standen, West Sussex.

Arts & Crafts style sideboard by Llewellyn Rathbone with marquetry
panels and medievalist decoration. Standen, West Sussex.

Pomona tapestry design (1884); the figure was by Edward Burne-Jones, and the background by William Morris. Wightwick Manor, West Midlands.

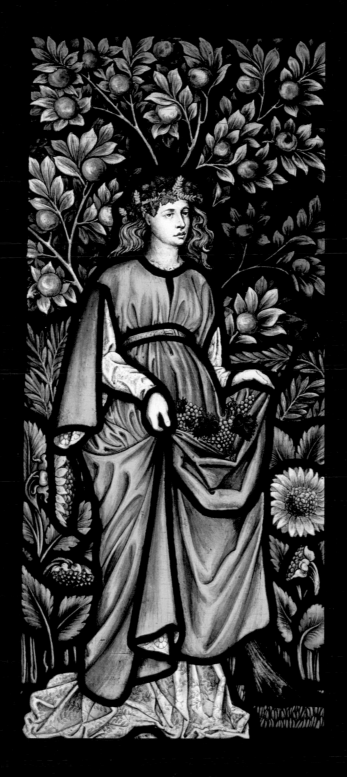

'Autumn', one of a set of stained-glass panels depicting the four seasons, supplied by Morris & Co. in 1873. Cragside, Northumberland.

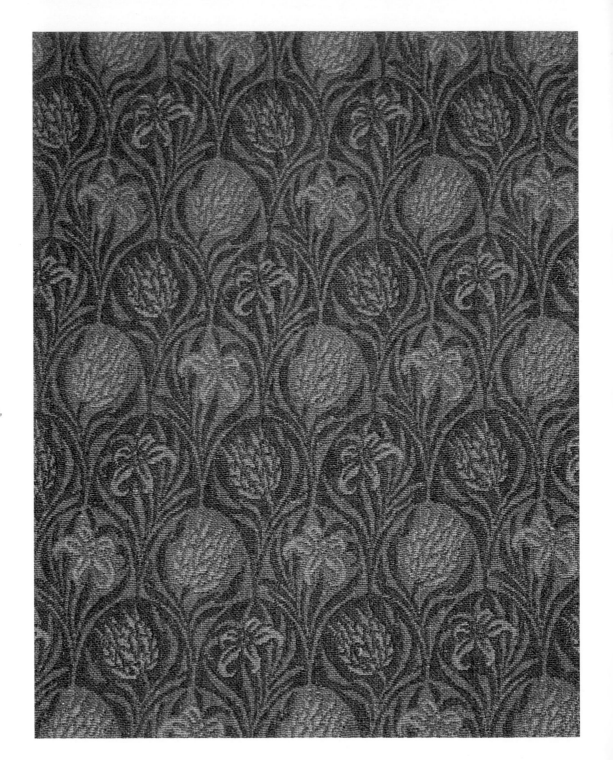

Detail of a Kidderminster carpet woven to William Morris's 'Tulip and Lily' pattern, c. 1875. Standen, West Sussex.

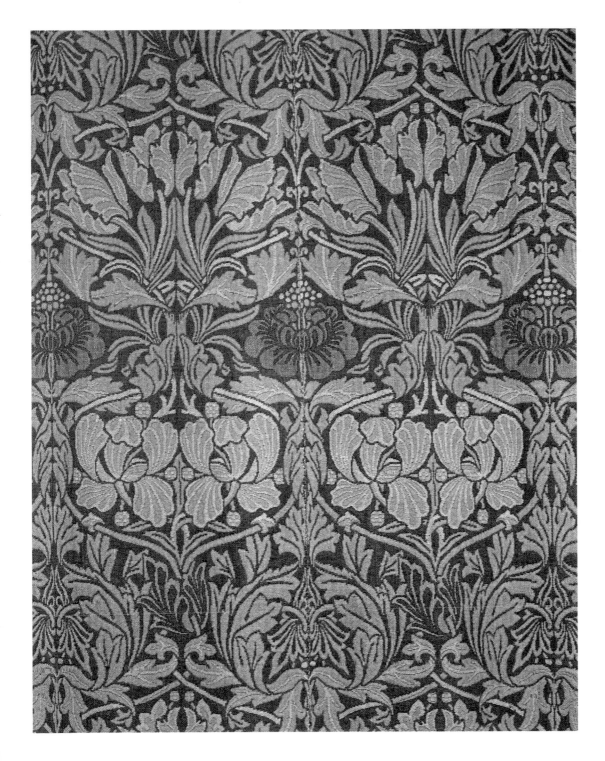

Wool curtains in William Morris's
'Tulip and Rose' design (1876),
and sold through Morris & Co.
Wightwick Manor, West Midlands.

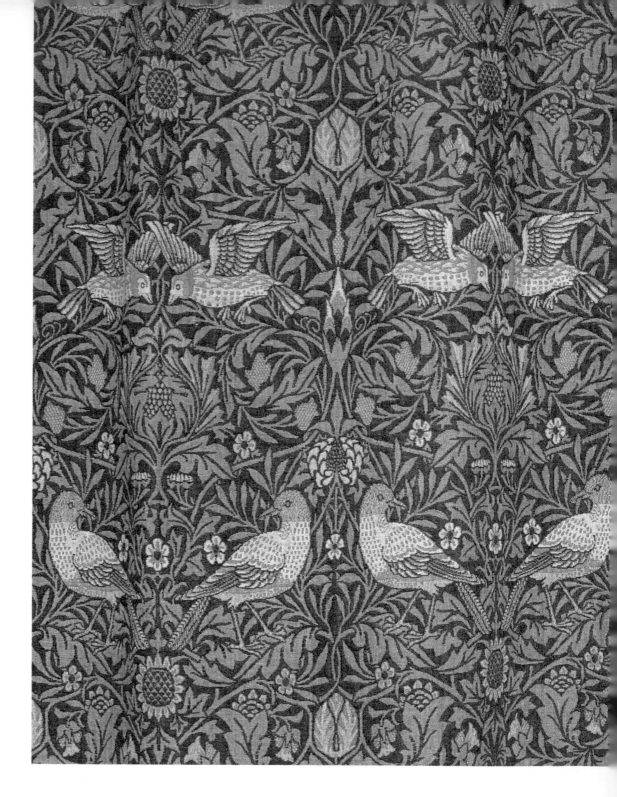

Tapestry produced by Morris &
Co., from the 1878 'Bird' design by
William Morris. Standen, West
Sussex.

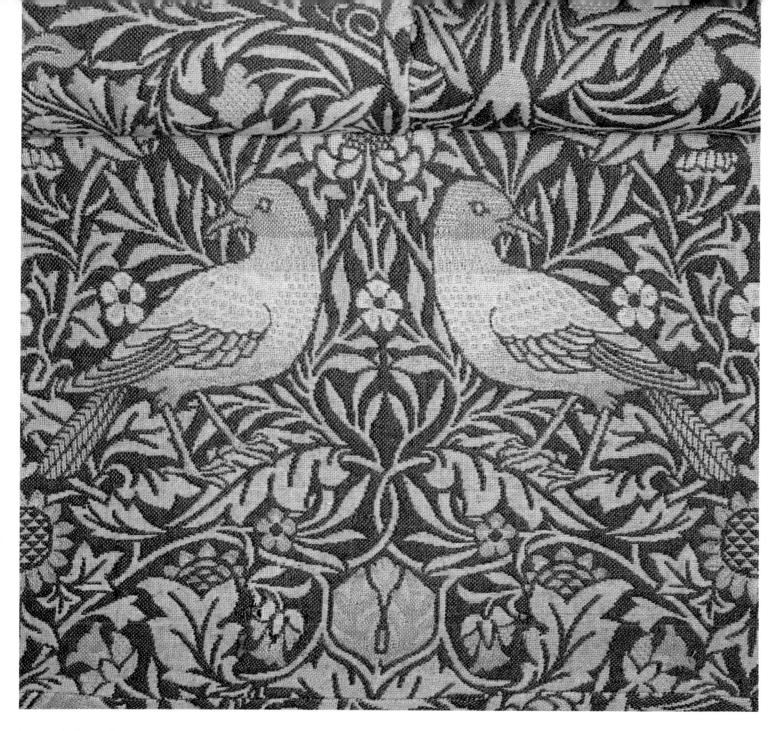

'Bird' design in a different colourway used to cover a sofa at
Wightwick Manor, West Midlands.

'Peacock and Dragon', designed by William Morris in 1878, reveals a Middle Eastern influence. Here it is on a woven woollen fabric used as a window seat cover. Wightwick Manor, West Midlands.

'St Agnes', a tapestry first woven by Morris & Co. in 1887, one of a series of seven taken from designs for stained glass by Edward Burne-Jones. Standen, West Sussex.

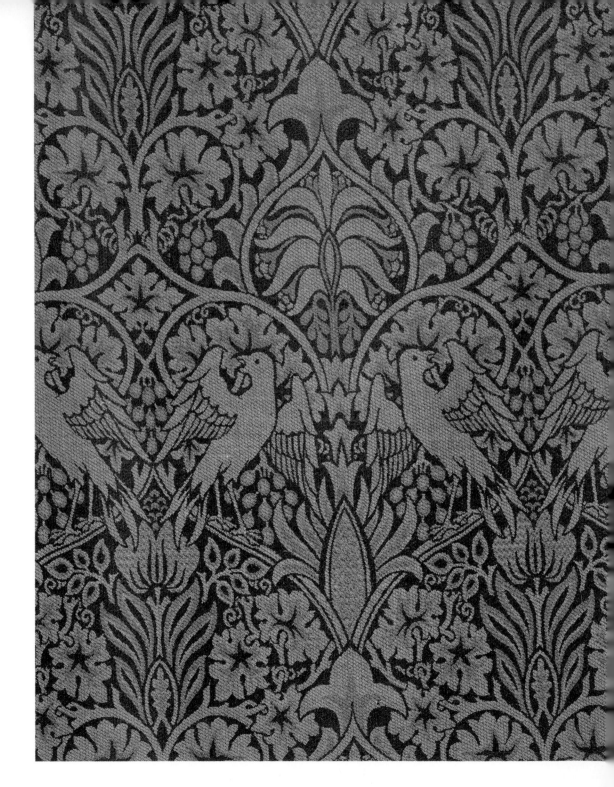

Woollen curtains made to William Morris's 'Bird and Vine' design (1879). Sold by Morris & Co. Wightwick Manor, West Midlands.

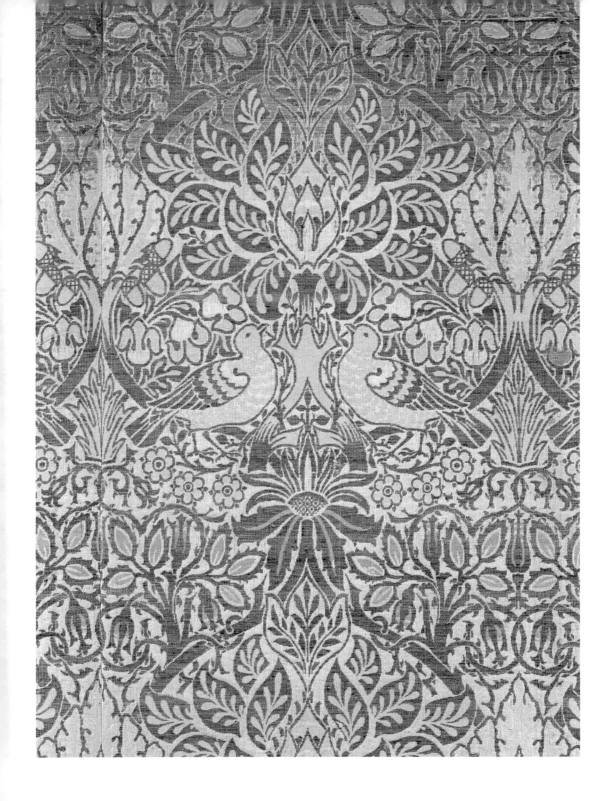

Jacquard woven silk and wool wall-hangings to William Morris's 'Dove and Rose' design (1879). This example dates from c. 1893 but the original colours (pink and indigo) have since faded. Wightwick Manor, West Midlands.

Glazed polychrome tiles in the 'Tulip and Trellis' pattern, designed by William Morris c. 1872–76 and made by the William de Morgan pottery. Wightwick Manor, West Midlands.

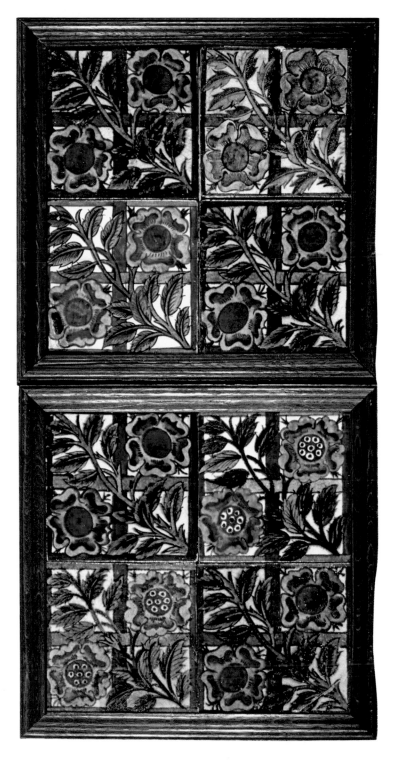

Framed William de Morgan tiles, c. 1872–82. This is an experimental design from his Chelsea period. Standen, West Sussex.

A William de Morgan underglaze-painted tile c. 1872–82. The designer was inspired by the vibrant colour palette and stylised floral forms of 16th-century Iznik ceramics from Turkey. Standen, West Sussex.

A William de Morgan tin-glazed earthenware tile of the mid-1870s. Designs of this type were intended to form composite patterns on walls and fireplace surrounds. Wightwick Manor, West Midlands.

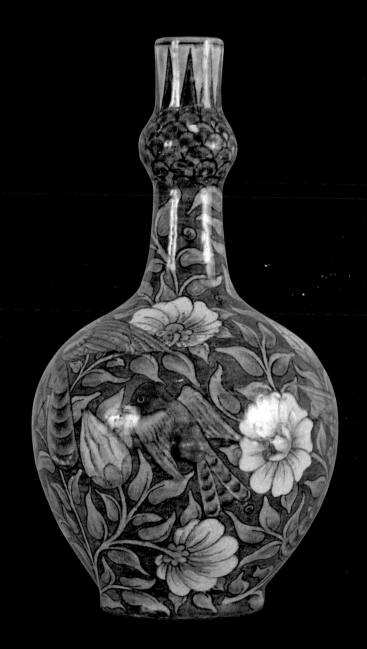

The gourd form of this vase and the choice of colours reveal the influence of the traditional ceramics of Persia. Design by William de Morgan c. 1890. Standen, West Sussex.

Curtains printed on linen and cotton to William Morris's 'Cray' design (1884) for Morris & Co. It was one of his most expensive but enduringly popular patterns. Wightwick Manor, West Midlands.

'Wild Tulip' hand-blocked wallpaper designed in 1884 by William
Morris for Morris & Co. Wightwick Manor, West Midlands.

'Bachelor's Button' wallpaper designed by William Morris in 1892 and produced by Morris & Co. Standen, West Sussex.

Detail of 'Seaweed' wallpaper
designed by John Henry Dearle,
Morris & Co.'s chief designer
during the 1890s. Printed by
Jeffrey & Co. c. 1896–1901.
Lanhydrock, Cornwall.

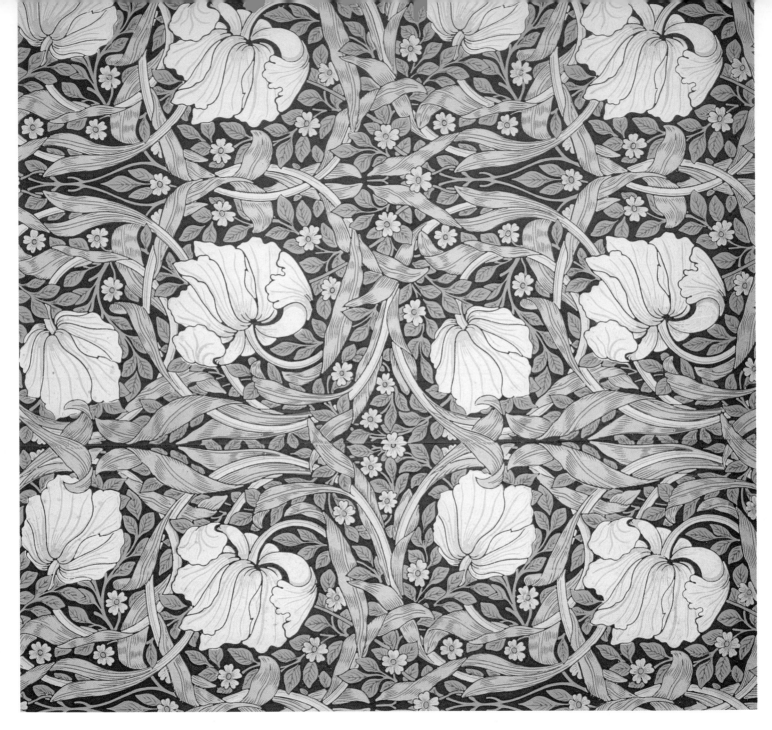

'Pimpernel' wallpaper designed by William Morris in 1876 for Morris & Co. Wightwick Manor, West Midlands.

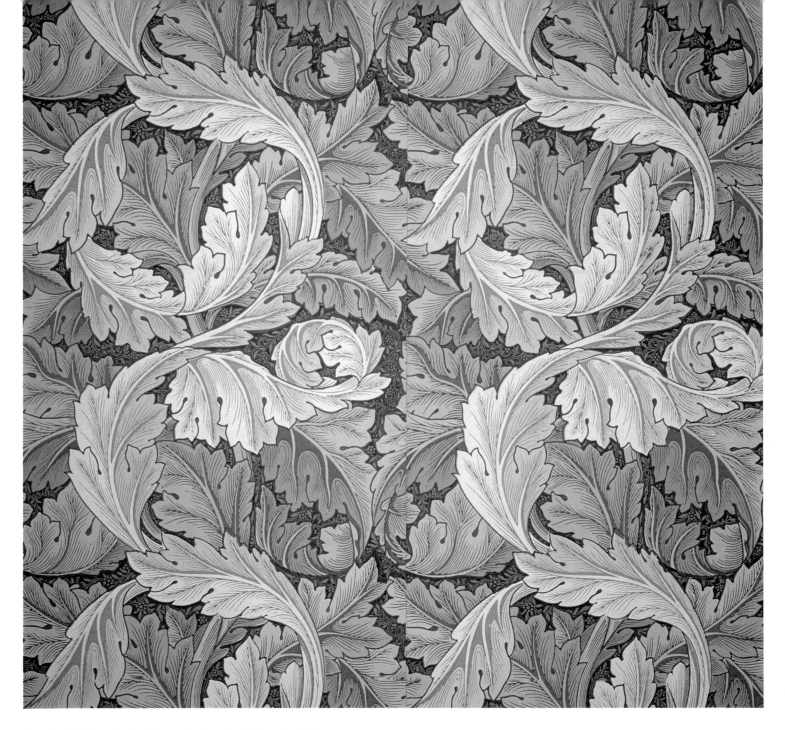

'Acanthus' block-printed wallpaper designed by William Morris in
1875 for Morris & Co. Wightwick Manor, West Midlands.

One of a pair of Doulton drug jars
by Mark V. Marshal, c. 1900.
Standen, West Sussex.

'The Angel and the Trumpet'. Printed curtain fabric designed by
Herbert Horne for the Century Guild, c. 1885. Stoneacre, Kent.

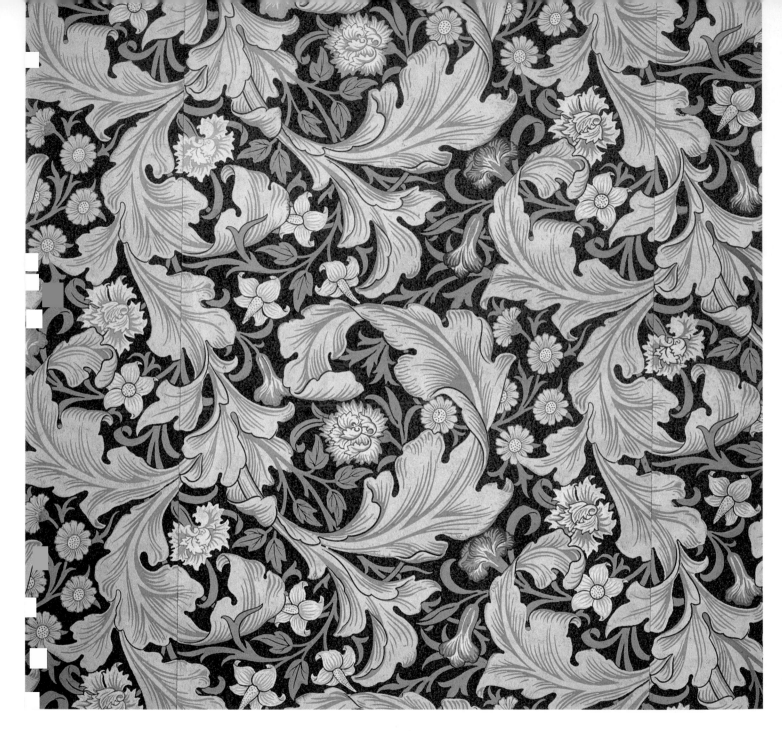

'Leicester' wallpaper, designed by J.H. Dearle for Morris & Co. in 1911. Wightwick Manor, West Midlands.

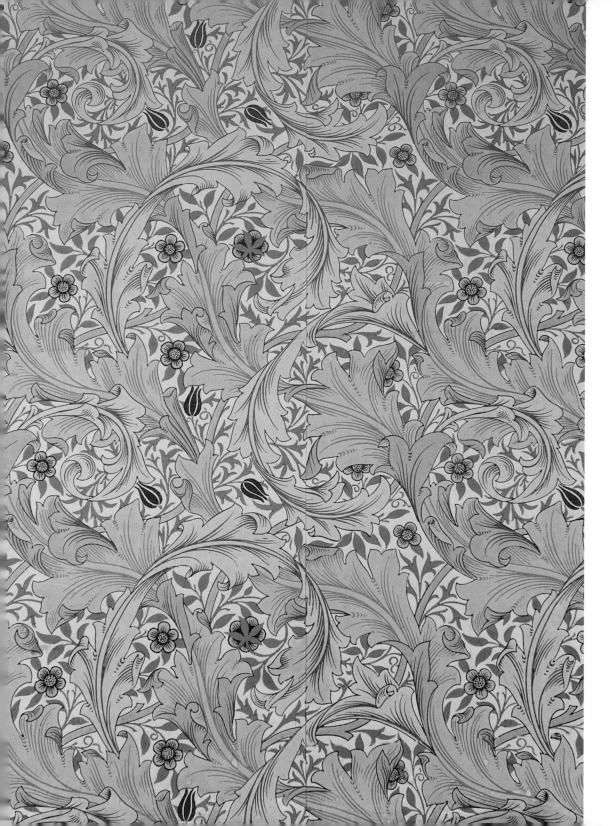

'Granville' wallpaper designed by J. H. Dearle for Morris & Co. in 1895. Wallington, Northumberland.

In many respects, the Victorian and Edwardian eras were a halcyon period for undiscriminating lovers of pattern. A bewildering panoply of styles, techniques and materials pepper these eight decades. Seething, intricate and brightly coloured pattern was much in demand, from Balmoral tartans to toiles de Jouy. Successive revivals of historical styles gave manufacturers and their customers a vast field from which to choose images and motifs, and the newly affluent middle classes were quick to adopt the trappings of historicist styles, in full knowledge of the fact that these were mostly mass-produced using the latest technology.

Until the Design Reform movement of the mid-19th century, pattern design in industrial Britain was not regarded as an integral part of the manufacturing process, but rather as an afterthought, applied at speed by a largely untrained factory worker. Significantly, these workers were known as 'hands', a term previously used for unskilled farm-labourers. Manufacturers either trained their in-house staff to replicate historical patterns, or 'bought in' ready-made designs for inappropriate applications.

The apogee of Victorian pride was the Great Exhibition of the Works of Industry of all Nations, which was held in the Crystal Palace in Hyde Park, London, during the spring and summer of 1851. It was the first international exhibition of manufactured products, and was enormously influential on the development of many aspects of society including art and design education, international trade and relations, and even tourism. But while the exhibition was a massive commercial success, and the illustrated catalogue found its way into many better-off homes, there were those who raised dissenting voices. Henry Cole collected together the very best examples of modern manufacturing and craft, as well as pre-industrial objects from other cultures, and used them as the foundation for what was to become the Victoria and Albert Museum, to inspire and train future designers. William Morris dismissed the exhibition as 'tons upon tons of unutterable junk' and was motivated to embark on his own experiments in art and design.

Morris's call for 'art for all' and his genuine regard for the forms and patterns of the past struck a chord with a certain section of the Victorian populace, those who admired the singularity of vision of the Gothic Revivalists such as Pugin and Burges. Although Morris's and Pugin's patterns were of necessity expensive to purchase, there

was an appreciation of the styles of the past, and a burgeoning sense of national pride in the cultural heritage of Victorian Britain.

There are subtle reasons behind the appetite for the styles and patterns of the past. The new meritocracy of the mercantile classes might have been justifiably proud of their business acumen, but they were less certain about their position in society. Self-made businessmen with social aspirations, if they lacked noble, land-owning ancestors of their own, were determined to 'buy' a history for their family. It was in the middle of the 19th century that the fine art and antiques trade started to expand, to meet the new demand for historical artefacts, and the desire to establish socially acceptable aesthetic credentials is also evident in the fashion for historicist styles. The motifs, colour schemes and distinctive patterns of the Renaissance, the Baroque, the Rococo and Greek were rigorously plundered for inspiration, and manuals of ornament and design became available to the public to help them select appropriate schemes for their homes.

These 'arbiters of taste' were crucial in introducing both the public and the design profession to new visual vocabularies. In 1856, Owen Jones published *The Grammar of Ornament*, a sumptuous full-colour compendium of pattern design, a comprehensive guide to indigenous historic styles and more exotic, foreign sources, such as the art of ancient Egypt or South America. The book remained continuously in print until 1910, and was regarded by many commercial designers and manufacturers as the recognised authority on all aspects of pattern-making. In 1868, Charles Eastlake's *Hints on Household Taste* stimulated wider public interest in interior design, and eventually led to the success of Robert Edis's work, *The Furniture and Decoration of Town Houses*.

Feelings ran high between the various exponents of different styles; Lady Mount Temple was extremely proud of the French style of her London house, with its 'watered papers on the walls, garlands of roses tied with blue bows! Glazed chintzes with bunches of roses' She invited the artist – and collaborator of Morris – Dante Gabriel Rossetti to dinner, and when she asked him if he could suggest any improvements, he replied 'Begin by burning everything you have got.'

Conversely, a writer in the *Journal of Decorative Arts* in 1892 praised the design and colour of Morris papers, but went on to say 'The patterns are palatial in scale, and whilst their colouring is very

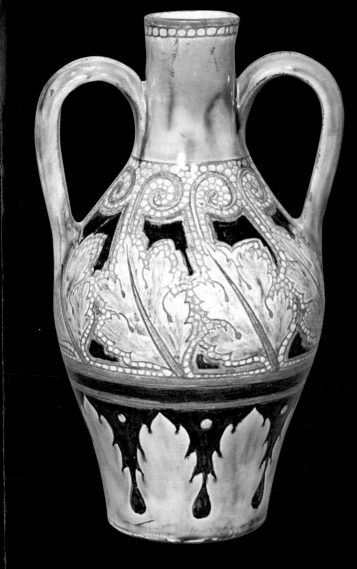

This Della Robbia vase, manufactured between 1894 and 1906, was inspired by the work of the 15th-century Florentine sculptor Luca della Robbia. Standen, West Sussex.

beautiful and soft, the magnitude of the designs exclude them from ordinary work'. There were also those who saw the Arts and Crafts Movement as reactionary and backward-looking; designers such as Godwin embraced the new themes coming from Japan, creating Aesthetic Movement furniture in imitation of Oriental designs. Oscar Wilde actively disliked Morris patterns, preferring to decorate his house in Chelsea with Japanese papers.

While the Arts and Crafts Movement was to have a strong influence over more avant-garde tastes in pattern-making, it is nevertheless true that for the majority of people in the Victorian and Edwardian era, their taste was an affirmation of their social status, and reflects both their sense of themselves and their preoccupations. Consequently the sensuous and slightly risqué style of Continental Art Nouveau was watered down in British interpretations, and a sense of fervent patriotism ran through the Edwardian era like veins through marble.

Revivalism

The French Style represented luxury and glamour and was the most popular commercial style in Britain from about 1835–1880. Medieval, Baroque and Renaissance patterns were used by manufacturers to replicate the styles of the past. A new appreciation for the more decorative forms of Greek art informed the more avant-garde households, and prompted a reinterpretation of classical pattern. Considerable technical ingenuity went into the mass-manufacture of Victorian designs, with new techniques developed to apply flock in imitation of cut velvet, and gilt to mimic Spanish leather.

The Gothic Revival resonates throughout the 19th century. It was seen as a high-minded and principled style, and was in demand both for the new civic buildings springing up in industrial towns such as Manchester, and as a style appropriate for the better-dressed domestic interior.

There was also a somewhat sentimental longing for the perceived simplicity of the more rural, pre-industrial era. Britain was probably the most advanced industrialised nation in the world by the late Victorian era, yet an underlying nostalgia often permeates the domestic setting.

Wallpaper c. 1839 designed by English decorators J.G. Crace in the Morning Room. Arlington Court, Devon.

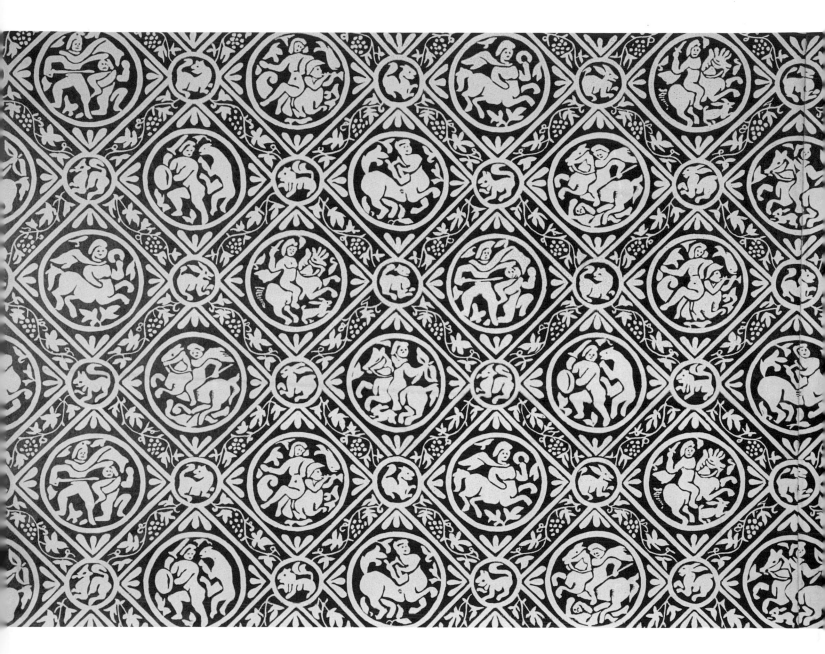

An 1840s wallpaper with a diaper pattern of mythological figures in roundels. Ightham Mote, Kent.

Ornate brown and gold wallpaper,
with an assertive pattern recalling
Elizabethan strapwork, designed
by Thomas Willement in the
1830s. Charlecote Park,
Warwickshire.

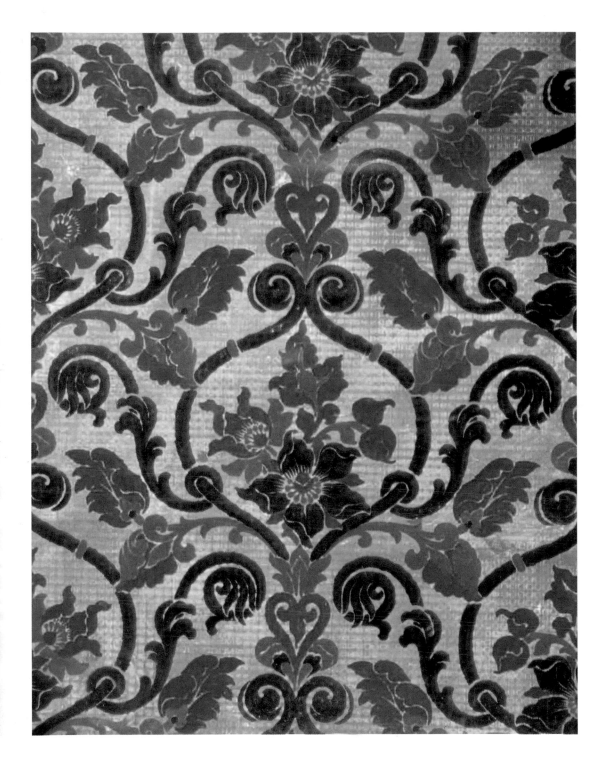

Flock on gilt wallpaper c. 1850 in the Library. Flock paper was often scaled to suit the size of room. Oxburgh Hall, Norfolk.

1830s wallpaper in crimson and blue flock on a gold ground, by Thomas Willement, with oak panelling by J. M. Willcox. Charlecote Park, Warwickshire.

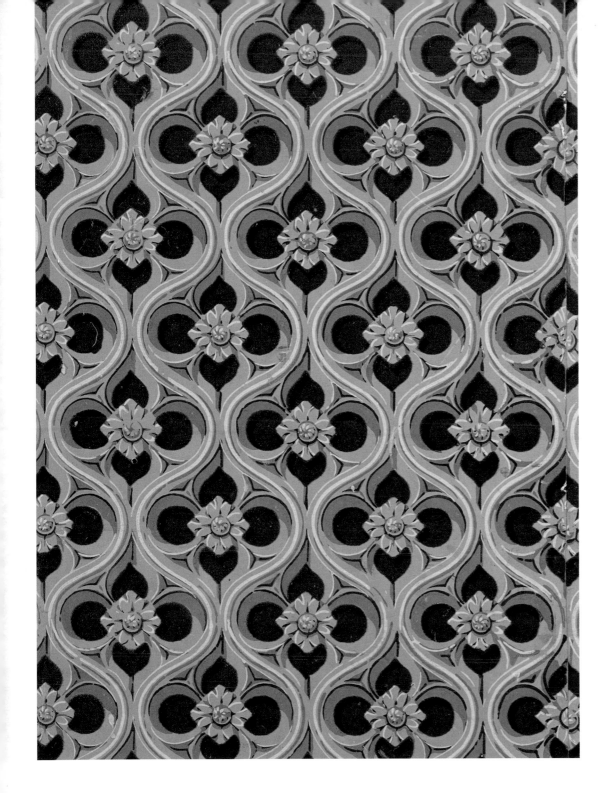

Victorian red-and-white patterned
wallpaper in an intricate pattern
inspired by Gothic architecture.
Oxburgh Hall, Norfolk.

Majolica tiles, manufactured by Maw & Co. c. 1860, with a blend of Moorish and Gothic influences. Cragside, Northumberland.

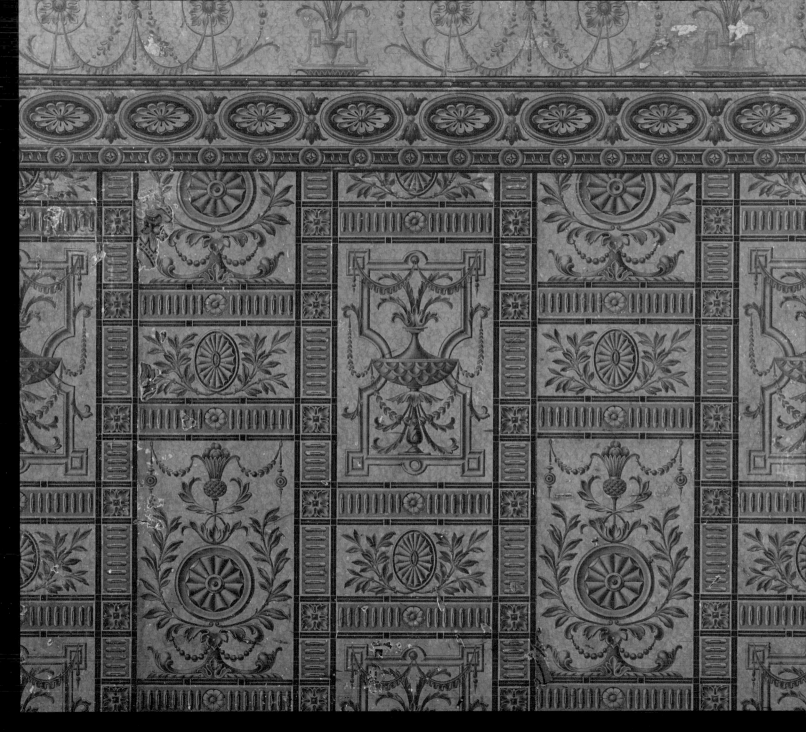

Neo-classical Revival-style Victorian varnished wallpaper.
Sunnycroft, Shropshire.

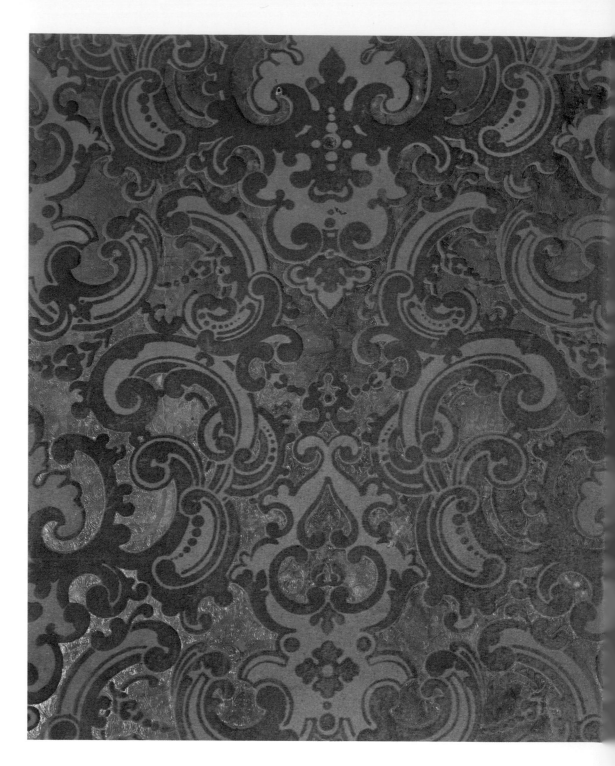

An early Victorian flock and gilt wallpaper. Oxburgh Hall, Norfolk.

Queen Victoria presented this inscribed copy of her *Leaves from the Journal of Our Life in the Highlands* (1868) to Benjamin Disraeli, who she made Earl of Beaconsfield. Maroon leather with gold embossing. Hughenden Manor, Buckinghamshire.

Hand-knotted wool carpet
designed by William Morris's Head
Designer, John Henry Dearle for
Morris & Co. in the 1890s.
Standen, West Sussex.

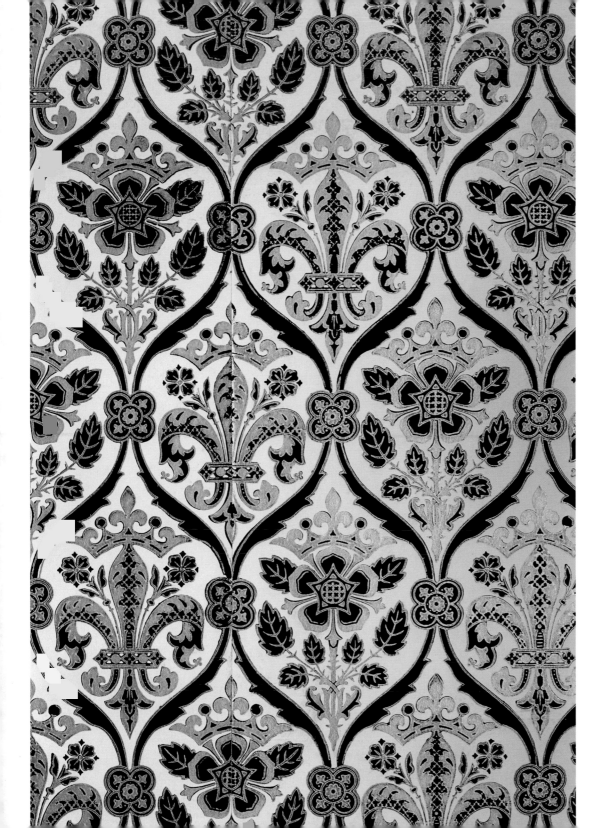

One of more than a hundred wallpapers in the Gothic Revival style, originally designed by A. W. N. Pugin for the Palace of Westminster c. 1850. It was reproduced and reinstalled in Lanhydrock in the 1960s. Lanhydrock, Cornwall.

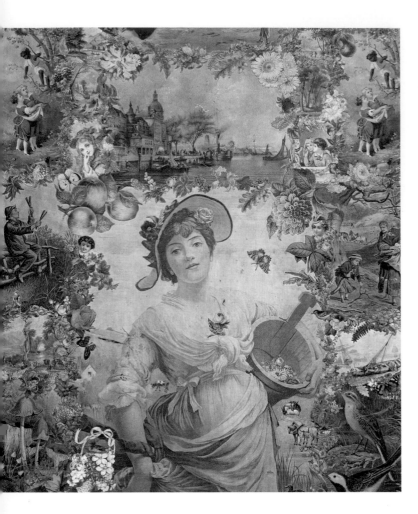

Details from a Victorian découpage screen, decorated with pre-printed scrap-book
illustrations to be applied at home by the hobbyist. Bradley Manor, Devon.

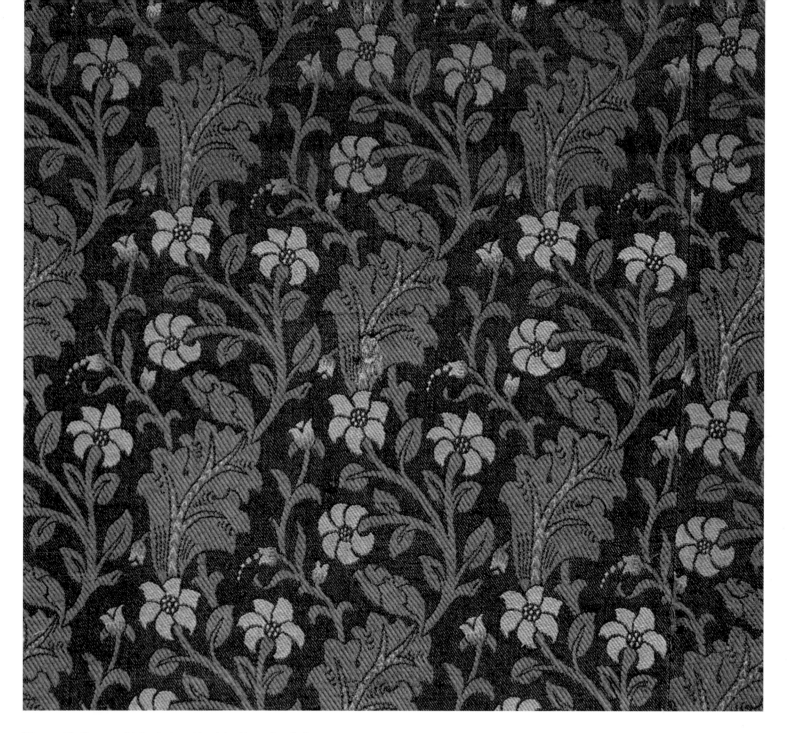

'Diagonal Trail' woven fabric, designed by John Henry Dearle for
Morris & Co. c. 1893. Wightwick Manor, West Midlands.

Undated textile trade label depicting a strongman on a bicycle, holding up two women cyclists. Quarry Bank Mill, Styal, Cheshire.

Undated textile label featuring an elephant walking along a tightrope. Quarry Bank Mill, Styal, Cheshire.

Undated textile trade label featuring a woman in ballet-slippers balancing on a bubble, waving flags. Quarry Bank Mill, Styal, Cheshire.

Undated textile trade label depicting a clown in a circus ring with performing dog, watched by a crowd in Edwardian dress. Quarry Bank Mill, Styal, Cheshire.

'Dutch Boy and Girl with a Cart', a printed nursery frieze c. 1905, published by Lawrence & Jellicoe Lanhydrock, Cornwall.

'Hen and Chickens', a nursery frieze, c. 1905, published by Lawrence and Jellicoe. Lanhydrock, Cornwall.

'Christmas Bird Band Scene', part of a nursery frieze, published by Lawrence & Jellicoe, c. 1905. Lanhydrock, Cornwall.

GLOSSARY

Abstract A non-figurative motif.

Alleyways Unintentional lines formed by empty spaces between motifs.

Arabesque A stylised interpretation of foliage patterns, derived from Mediterranean cultures, originally from the Middle East, brought to the West through trade.

Balanced stripes A symmetrical pattern of stripes, with matching stripes on either side of a central block.

Block printing A form of relief printing with wooden blocks.

Border design A pattern designed to run along the edge of textiles or other two-dimensional designs.

Brocade A woven fabric similar to damask, with figured patterns raised by spooling additional coloured threads through weave.

Brocatelle A form of damask, a woven fabric with a satin or twill design contrasted with a plain or satin-weave ground.

Calico A heavyweight cream-coloured woven cotton fabric, much used for Indian printed fabrics.

Cartouche A decorative plaque, often circular or oval in shape.

Chevron A design of zigzags in a stripe arrangement, also known as herringbone.

Chinoiserie A Western interpretation of an oriental design.

Chintz Originally a term to describe multi-coloured printed Indian textiles, it now refers to rather traditional-looking floral fabrics.

Crewelwork Outline embroidery, with contrasting infill stitches, stitched with a woollen yarn on a heavyweight linen or cotton fabric.

Curlicue A curved motif of abstract design.

Damask A jacquard-woven reversible fabric, usually in one colour. It was originally produced in Syria, hence the name.

Flamestitch A hand-embroidery technique, stitched on canvas, which gives random zigzag effects. It is popular for upholstery.

Figurative A design using realistic elements, such as recognisable plants, animals or humans.

Fleur-de-lys A stylised 3 or 5-petalled lily, popular in the Middle Ages as a symbol of purity.

Geometric Abstract, non-representational patterns based on rectilinear, circular or polygonal forms.

Ground The surface onto which pattern is applied.

Guilloche A decorative pattern of repeating interlacing curves or circles, often used as a border.

Herringbone A design of zigzags laid alternately (see also chevrons).

Mille Fleurs Literally, 'a thousand flowers'. The representation of a border pattern with realistically depicted flowers, as seen in medieval illuminated manuscripts and tapestries.

Monochrome The use of a single colour against a contrasting ground.

Monogram A motif made of interlocking initials.

Mosaic A pattern or design made up from many small fragments in variable colours.

Motif A device or element which, when repeated, makes up the pattern.

Narrative pattern A sequence of scenes, realistically depicted, showing episodes from a story or legend.

Naturalistic A design where the motifs are realistically depicted.

Negative space The gap between motifs in a pattern.

Paisley A stylised motif based on the palm shoot, which originated in Indian textiles and was reproduced by weavers in Paisley, Scotland, hence the name.

Passementerie Tassels, fringing, braids and ribbons, known as passements', developed in Italy to conceal

seams and decorative edges of wall, bed and window hangings.

Patchwork A method of joining together scraps of assorted fabrics, either in random shapes ('crazy' patchwork) or in regular and often intricate geometric patterns.

Plaid A woven fabric consisting of horizontal and vertical bands of stripes, achieved by incorporating contrasting colours into the warp and weft.

Repeat The horizontal or vertical distance between identical motifs, an important consideration when designing patterns to be joined laterally, such as wallpaper or furnishing fabrics.

Scale The relative size of a pattern; large-scale patterns are naturally better suited to cover large areas.

Self-colour The application of one texture against another of the same colour, to achieve a subtle pattern.

Side repeat The horizontal repeat on a patterned surface.

Stylised A design with abstracted elements to emphasise its decorative effect.

Tessellations A repeating pattern of interlocking motifs that can be extended indefinitely.

Toile de Jouy A method of copper-plate printing on fabric or wallpaper which imitates the effect of engraving.

Void An area without motifs or patterns on a decorated surface.

INDEX

PICTURE CREDITS

All images National Trust Photo Library www.ntpl.org.uk. ©NTPL/Peter Aprahamian: 121, 185 left, Bill Batten: 25, 96, 156, 172 left, 179 right, John Bethell: 27, 61, 95 right, 100, 175 centre & left, Michael Caldwell: 207, Stuart Cox: 22 right, 43, 64, 66, 80, 81, 130, 131, 146, 164 left, Andreas von Einsiedel: 16, 18, 20 left, 24, 26, 34, 51, 58 right, 73, 77 bottom left & right, 92, 99, 102, 105, 112, 115 top & centre, 118, 132, 136, 137, 154, 157, 167, 170, 176, 197 right, 198, 203, 204 right, 205, 209, 213, 223, 226, 227, 229, 230, 231, 240, 247, Mark Fiennes: 113, 171, 237, 242, Roy Fox: 79 left & right, 151, Geoffrey Frosh: 63, L & M.Gayton: 206, Jonathan Gibson: 9, 87, 210, 212, 219, 220, 224, 244, Dennis Gilbert: 7, 49, 186, 188, Barry Hamilton: 44, John Hammond: 5, 8, 10, 12, 13, 14, 15, 17, 19, 21, 22 left, 23, 29, 36, 37 right, 42, 45, 47, 48, 50, 53 top, 57, 58 left, 59, 62 top & bottom, 67, 68, 72, 77 top, 82, 83 right, 88, 89 left & right, 94, 95 left, 97 left, 108, 109, 111, 115 bottom, 120, 123, 124, 125, 126, 129, 141, 143, 144 left, 145, 147, 148, 149 left, 158, 159,160, 161, 162, 163, 165, 166, 169, 173 bottom, 175 right, 177 bottom, 181, 183, 184, 185 right, 187, 189, 192 right, 193 left & right, 194, 195, 202, 211, 214, 216, 217, 218, 222, 225, 234, 239, 241, 245, 249 top, centre & bottom, Keith Hewitt: 248 top left & right, bottom left & right, Angelo Hornak: 37 left, 70, 86, 103, 104, 196 right, 243, Nadia Mackenzie: 20 right, 32, 33, 35, 46, 53 bottom, 54, 75, 76, 85, 93, 114, 135, 139, 164 right, 174, 182 right, 191, 192 left, 196 left, 197 left, 199, 204 left, 221 right, 228, 233, 235, 246 left & right, Rob Matheson: 71, 133, John Millar: 11, Robert Morris: 30 left & right, 31 left & right, 182 left, James Mortimer: 80, 97 right, 110, 172 right, 173 top, Brenda Norrish: 83 left, NTPL: 52 right, 56, 122, 215, Eric Pelham: 40, 41, 142 right, 144 right, Ian Shaw: 142 left, 179 left, Martin Trelawny: 117, Rupert Truman: 65, J.Whitaker: 127, 128, 177 top, 178 left & right, Mike Williams: frnt cover, 155, Derrick E.Witty: 52 left, 55, 60, 69, 78, 91, 98, 101, 107, 119, 134, 140, 149 right, 150, 153, 208, 221 left, 236, 238.

Acknowledgements: pictures used by kind permission of Upton House, The Bearsted Collection (The National Trust) p.37 left; Powis Castle,The Powis Collection (The National Trust) p. 50, 142 right; Kingston Lacy, The Bankes Collection (The National Trust) p.52 right; Ickworth, The Bristol Collection p.70; Blickling Hall, The Lothian Collection (The National Trust), p.88; Charlecote Park, The Fairfax-Lucy Collection (The National Trust) p.89 left, 193 right; Anglesey Abbey, The Fairhaven Collection (The National Trust) p.107; Bateman's, The Rudyard Kipling Collection (The National Trust), p.144; D'Oyley Carte Opera Trust Ltd, p.148; Lanhydrock, The Robartes Collection (The National Trust) p.249; all William Morris designs as Morris & Co now wholly owned by Arthur Sanderson & Sons.

All reasonable efforts have been made to identify copyright holders.

ACKNOWLEDGEMENTS

Special thanks are due to Angela Barrett, Grant Berry, Damian Evans, Sarah Evans, Oliver Garnett, David Kitt, Tina Persaud, Mark Purcell, Victoria Skeet and John Stachiewicz, and all those at the National Trust who generously offered their advice and expertise.